# DON'T MAKE
# ME GO TO
# TOWN

NUMBER TWENTY-THREE
THE M. K. BROWN RANGE LIFE SERIES

# Don't Make Me Go to Town

## Ranchwomen of the Texas Hill Country

RHONDA LASHLEY LOPEZ

UNIVERSITY OF TEXAS PRESS ✧ AUSTIN

Requests for permission to reproduce material
from this work should be sent to:
Permissions
University of Texas Press
P.O. Box 7819
Austin, TX 78713-7819
www.utexas.edu/utpress/about/bpermission.html

⊗ The paper used in this book meets the minimum requirements
of ANSI/NISO Z39.48-1992 (R1997) (Permanence of Paper).

Library of Congress Cataloging-in-Publication Data

Lashley Lopez, Rhonda, 1961–
Don't make me go to town : ranchwomen of the Texas Hill
Country / Rhonda Lashley Lopez. — 1st ed.
p. cm. — (The M. K. Brown range life series ; no. 23)
ISBN 978-0-292-70929-4 (cloth : alk. paper)
1. Women ranchers—Texas—Texas Hill Country—Pictorial works.
2. Women ranchers—Texas—Texas Hill Country—Biography. 3. Ranch life—
Texas—Texas Hill Country—Pictorial works. 4. Ranch life—Texas—
Texas Hill Country. 5. Texas Hill Country (Tex.)—Biography—Pictorial works.
6. Texas Hill Country (Tex.)—Biography. 7. Texas Hill Country (Tex.)—
Social life and customs. I. Title.
F392.T47L37 2011
976.4'31—dc22
2010035089

*For my daughter, Emily,*
*my mother, Linda,*
*and my husband, José*

I have chased wild horses in the Medicine Bow mountain range, chased goats in the Fort Davis Mountains, sheared goats during staggering hot summer days in a Texas barn, docked lambs on the windy, dusty, high plains of Shirley Basin. I have seen the evening dances of purples, pinks, and oranges that take place on a stage of clouds on the high plains of Wyoming. I have seen the breathtaking, yet deadly, night storms that have hurled fiery lightning balls upon the land; and then the morning sun as it warms the skin after a cold, crisp morning rain; the sky as it turns the color of spring bluebonnets, and the land as it gingerly perks up to feel the warmth.

How do you explain these marvels to people? I hear people say that soul-searching, psychological phrase, "I am trying to find myself." People spend their working lives in New York or Houston, to someday buy a small, quaint place in the country, to own two cows and watch the birds.

Well, ladies and gentlemen, I have always known who I am and what I want. I want to ranch for a living instead of living to ranch.

AMANDA SPENRATH GEISTWEIDT,
*in a speech to the Riverside and Landowners Protection Coalition*

# CONTENTS

# PREFACE

Ranchwomen seem as much a part of the earth as the grass they depend on. Their lives are entwined with the soil and sky—they are subject to nature's whims. They do not often seek company other than the natural world that surrounds them. And they love their lives.

I have lived on a ranch in the Hill Country, but I'm not a ranchwoman. I was for a time involved in "weekend ranching." I know how it feels to walk through scrubby brush, herding scatterish sheep. I once pulled a calf from its mama's womb, and I've warmed orphan lambs inside my coat. I've scraped the murky slime from water troughs and helped mend fences.

But my experiences don't compare with those of a woman who rises every day with the sun and works outside until she's physically too tired to go on, knowing that her work feeds her family.

A ranchwoman gets out in whatever weather the day gives her and tends to her animals. She rides out in nighttime thunderstorms to bring goats in to shelter. During extremes of icy cold and scorching heat, a ranchwoman spends more time than ever taking care of her livestock.

To her, ranching is not a hobby. It is not a weekend affair. Ranching is day-to-day, year-to-year, relentless labor. It is sowing, plowing, hauling, checking, fixing, counting, feeding, defending, and nursing. Ranching is life. It is a dance with nature—an intimate relationship that few people these days experience. It is recognizing the red hues of the agarita berries—knowing when to make the tiny berries into jelly and when to eat them fresh from the bush.

My brushes with ranching and my fondness for older ranch people I'd met piqued my curiosity and led me to this story. I wondered about the women on Hill Country ranches and I began asking people—county extension agents, friends, ladies in the beauty shop—if they knew of women ranchers. I was surprised by the responses. It seems just about everyone around here knows a ranchwoman. In fact, I've begun to wonder if it's mainly women, not men, running Hill Country ranches.

I set out to find women of different generations living in various parts of the Hill Country. I told myself I had two aims: to provide a historical record of their ranching practices, and then to go beyond the facts to draw out their personal thoughts and experiences. More simply, I wanted to communicate their lives to others, to tell their stories.

I began working on the ranchwomen project in the spring of 1993, when my daughter was one year old. I was living in Kerrville and working on a graduate degree in journalism/photojournalism at the University of Texas at Austin. The project started as an assignment for a class on documentary journalism taught by J. B. Colson, who started the photojournalism program at UT, and Bill Stott, then a professor of American Studies who is considered an expert on the documentary work of Walker Evans and James Agee. At that time, I interviewed Lorelei Hankins, Joan Bushong, and Marguerite Stevenson.

After being encouraged to expand the project into a book, I interviewed and photographed other ranchwomen, and I revisited the original three. As I learned more about ranching, I realized I was documenting a way of life that was vanishing before my eyes. Each new generation signifies further subdivision of family ranchland. Sometimes the land stays in the family and the next generation continues ranching, but on a smaller scale. Sometimes people from the cities who want places to hunt buy the land. And ranching has become an arena for bigger players. These factors mean that young people who hope to earn their living ranching will probably not be able to do so on inherited land as their parents did. They will have to buy more land, but how will they afford that? Several of the ranchwomen I interviewed predicted that small ranch operations will soon be a piece of the past.

Through the following years, my work on the project was sporadic, displaced to the back burner by the chore of making a living, the absolute joy of being a mother, and even the inconvenience of cancer. But going out to the ranches and visiting with the grounded ranchwomen always renewed me. It was being out in the rugged land, away from people, and hearing the sounds of birds and wind and even the cattle and sheep that helped me know something of the peace ranchwomen seem to find out on their land. And I discovered for myself why they are able to work so hard for so little

money. I believe that every day, when they feel the dry, clean Hill Country wind and see the sun rise and set in a glory of colors, they feel renewed. I think their spirits are nourished. And that's why they live the hard lives they've chosen.

As Amanda Geistweidt Spenrath so eloquently explained, they are women who know themselves and know exactly what they want from life.

## THE TEXAS HILL COUNTRY

The Texas Hill Country is located in the middle of the state, near San Antonio and Austin. Although the region's precise boundaries are described differently by various sources, in this book the Hill Country refers to the lower part of the Edwards Plateau, bounded on the west and northwest by an imaginary line from Uvalde to Rocksprings to Sonora to Eden to Fife, and on the north and east by the Colorado River, with the southernmost border along the Balcones Escarpment (inside a line from Del Rio to San Antonio to Austin.)

Many people believe the Hill Country is the prettiest part of the state. Its elevation ranges from 750 to 2,700 feet, and the air is often drier and cooler than in surrounding areas. The terrain is mainly hilly and rocky, with an abundance of rivers, trees, and wildflowers.

## METHOD

I felt the truest way to document ranchwomen was to let them speak for themselves—to take myself out of the text as much as possible.

I used a tape recorder during interviews and transcribed the conversations word-for-word, to the best of my ability. I arranged the text in commonsense order and then fine-tuned it.

At first, I planned to leave the oral histories exactly as they were spoken. But William Stott read them and urged me to edit. "You'll be doing your readers a favor," he said, citing Janet Malcolm's *The Journalist and the Murderer*:

Only the most uncharitable (or inept) journalist will hold a subject to his literal utterances and fail to perform the sort of editing and rewriting that, in life, our ear automatically and instantaneously performs.

When we talk with somebody, we are not aware of the strangeness of the language we are speaking. Our ear takes it in as English, and only if we see it transcribed verbatim do we realize that it is a kind of foreign tongue.[1]

Now, I certainly did not change any speech into prose. I think the ranchwomen spoke very well for themselves, and I love hearing their voices come through in their words. Instead, I did very minimal editing to clarify sentences that would have been confusing. I did not change or add any thoughts, ideas, opinions, or intent. I did, however, correct a few grammatical errors.

When people see their spoken words written on paper, they usually are taken aback. This was the case with several of the ranchwomen, who were dismayed when they saw their words written down. In speaking, they had been less "correct" and formal than their written words would have been. But it's the same with everyone. And I assured them I would explain this in the introduction so the readers would understand.

In the text, my narration is given in brackets. My questions are in italics.

J. B. Colson and Walker Evans influenced my thoughts regarding the ethics of documentary photography. Evans viewed documentary photography as a way of recording reality, without undue manipulation by the photographer. For his portraits on migrant workers for *Let Us Now Praise Famous Men,* Evans reportedly set up the tripod and let his subjects arrange themselves in front of the camera.[2]

I set out to record ranchwomen in this fashion. Consequently, the photographs in this project were not set up, except by the person I was photographing. I did not tell them where to stand or where to look, as a portrait photographer might. Sometimes, for portraits, I told them I was going to take a close-up shot, and then watched them do whatever they chose to do for that photo. Some smiled, some didn't, some looked at the camera, some did not.

A person presenting herself, rather than being posed by the photographer, makes the photograph richer with meaning, I believe, and more honest.

I used a 35mm camera—a Canon EOS 630—and Ilford black-and-white film. I processed the film myself. High-resolution drum scans of the negatives were made at River City Silver in San Antonio. I then edited the images using Photoshop CS4. The editing of photos was restricted to the kind of editing one can do in the darkroom without drastically changing the meaning of the photo: cropping, burning and dodging, and adjusting contrast.

## ACKNOWLEDGMENTS

The title of this project, *Don't Make Me Go to Town*, was inspired mainly by Joan Bushong but the sentiment was echoed by others. I extend heartfelt gratitude to the ranchwomen who graciously shared their time, images, and personal stories with me, some of whom do not appear in this book: Joan Bushong, Tempie Butler, Amanda Spenrath Geistweidt, Lorelei Hankins, Rosita Hollar, Lena Kothmann, Milda Kothmann, Elizabeth Langston, Robin Luce, Dot Miller, Lemae Higgs, Mona Lois Schmidt, Karol Schreiner, Lilly Shanklin, Sharon Spenrath, and Marguerite Stevenson. I owe a great deal to two extraordinary teachers whose encouragement and guidance led me to this project: J. B. Colson and Bill Stott. I would also like to thank the world's most patient editor, Theresa May, and digital editing guru, Dan Burkholder. Finally, my warmest thanks go to my family and friends who encouraged me to finish this book, especially Emily and Mom, and, at last, José.

### NOTES

1. Janet Malcolm, *The Journalist and the Murderer* (New York: Vintage Books, 1990), 154–155.
2. William Stott, *Documentary Expression and Thirties America*, 2nd ed. (Chicago: University of Chicago Press, 1973), 269.

# DON'T MAKE ME GO TO TOWN

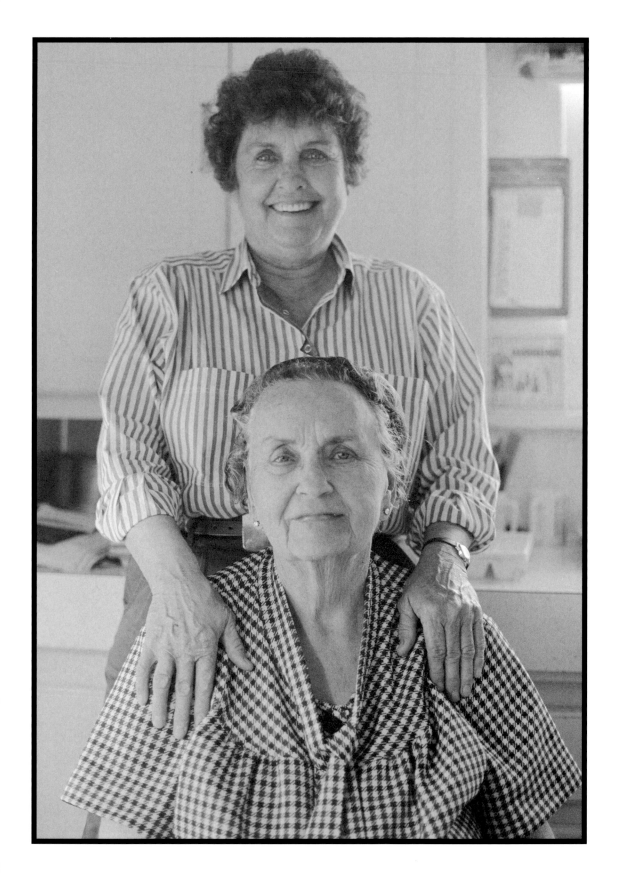

*Lorelei and Mrs. Hankins*

# Lorelei Hankins

*with mother, Sarah Hankins*

**ROCKSPRINGS, TEXAS**

**B. SEPTEMBER 2, 1933**

Sometimes I get up at 4:30. Then, I'm so tired when it's dark, I go to bed early. I'm always saying, 'Now, Daddy, what are we going to do tomorrow?' He says, 'Don't worry.' A doctor told him one time, 'Don't worry about what you're going to do tomorrow because you can't sleep good. Don't worry about tomorrow until tomorrow.' But I like to know what *I'm* going to be doing tomorrow.

### WD-40

I call my horse WD-40. When he was a baby I named him Silver, because I knew he was going to be gray. I kept him out at Alpine. But he is so flexible and movable that I renamed him WD-40.

He isn't beautiful, but he's a real rock dude. But one day I was going to go straight across a rock and then turn. He saw the sheep and I guess he decided to turn on top of the slick rock—and he fell on me. Really, I caught myself on my hands, but I had a big bruise in the calf of my leg.

### AN EARLY START

I was born on the ranch where I live now, twenty-four miles from this place. When I was growing up there were no school buses. So school was a problem.

Daddy found this smaller place and bought it. We've lived here ever since I started the first grade—or Mother and Daddy have lived here. He would just drive back and forth to run the other ranch.

I don't have any brothers, so I've done the boy stuff. My sister plays the piano. She stayed in the house with Mom and I'd stay in the pasture with my dad.

When I was in the third grade, which would make me nine years old, I was responsible for the goats we shedded at home. I can remember one day, being at school when it started to rain. My teacher said, "What in the world are you crying for?" And I said, "Daddy's gone and I'm supposed to pen the goats." So she called my mother, who came and got me.

I rode a Shetland for a long time. I had an extra-good one—most Shetlands are mean. I didn't even use a saddle. She had a little round, soft back and I rode her bareback.

When I was ten or eleven years old, I would drive the pickup while Daddy pulled the sucker rods out of the wells and releathered them. I learned to drive the pickup just so I could pull the windmill.

## BITTERWEED

Most of the people in Edwards County raise goats because the bitterweed is so bad. Goats don't seem to get on bitterweed like sheep do. Sheep eat it and die. It doesn't hurt cattle. But when I was growing up we started pulling the bitterweed. And Daddy never let it get away on his country. On all three ranches, we kept it pulled off.

The neighbors all have bitterweed, so we'd pull twelve feet on the other side of our fence, in the neighbors'. I remember we'd take one jug of water and we'd pull from eight o'clock in the morning until dinnertime. Then we'd go in. I can always remember how I thought, "That water's going to run out. I know we're not going to have enough water to get finished."

It would usually be getting hot in spring. We'd have just enough rain to make the bitterweed start up again. We'd have to pull in the draws that wash into our pastures, then along the fence line. Deer jump the fence and they usually carry seeds on their feet. So, you've got to keep pulling it in your pasture.

We don't ever have country that gets covered with bitterweed. And the draws down here at our aunt's place—we just fenced one of them out because it's such a big draw that we couldn't keep it pulled out of there. We have to cross it to get to the pens, but we don't ever cross when it's muddy. If the sheep walk through muddy bitterweed, they'll carry the seed over into the pastures where you don't have any.

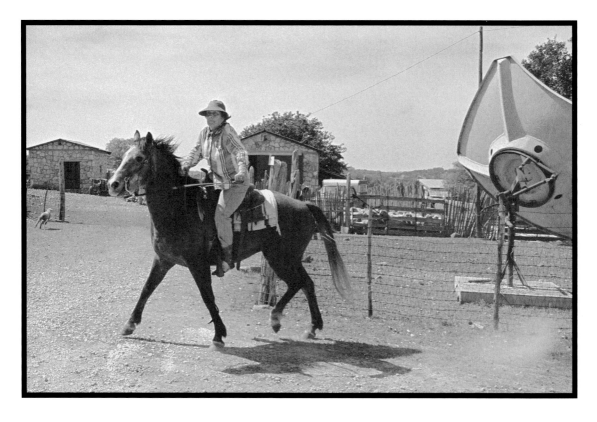

*Lorelei Hankins*

## HISTORY

I graduated from high school in Rocksprings and I went to Texas Tech to college. I married and lived out of Ozona, close to Iraan. My daughter went to school in Iraan through the sixth grade. Then we moved into Ozona into a little rent house during the week and went back to the ranch on weekends.

My kids would occasionally stay with my mom, but I didn't leave them much. I didn't have anywhere to go. I lived thirty-eight miles out in the country. And I worked very hard.

We ran sheep, goats, and cows on our ranch. But I wanted a little bit of something of my own. Daddy helped me buy a little bunch of cows, twenty-six black Angus. Of course, pretty soon I had more than we had room for, so I just started pasturing them at different places, everywhere.

I had them up at Bronte one time on the Colorado River. My daughter went with me to work them. We were trying to get those cattle out of the riverbanks and you've got to have a good buddy on the other side. It really takes two people to work stock down a river. And she said, "Mother, I've always heard you'd 'do to ride the river with.' And now I know what it means."

But she said, "Please, the next time you're going to pasture cattle or lease a ranch, let me approve of it first." She didn't like some of the country where I went.

She's an excellent rider. She was on the rodeo team at Texas A&M for six years and went to Bozeman, Montana, for the finals every year.

*Did you marry a rancher?*

Yes. He died year before last. I have a son and a daughter. My daughter works at a bank in Ozona. My son sells feed and has a little ranch leased in Big Lake. He was a schoolteacher. He went to Sul Ross and then was a schoolteacher for about six years. Teaching is not all that much fun. There's more paperwork than there is teaching.

I substituted a lot in Ozona. It just so happened my first two or three jobs were in special education. Once those little children that really have problems get acquainted with someone, they would rather have that same person come back.

We've had a place leased in Alpine for about ten years. About three years ago we were having a lot of calving problems out there. So I moved out there and stayed in a little trailer on the ranch. I checked heifers three times a day and if any of them were having problems, I'd take them to the vet.

But I didn't have enough to keep me busy. So I got a job with Early Childhood Intervention. I fell in love with those children. We had some Down syndrome children.

When I go out there, I go see most of them to see how they're doing. They're real special. We worked with children from birth to three years old. It was a STEP program, Senior Texas Employment Program, that I was working through.

After that, Daddy and Mother needed me to come on home. And I'd finished the heifers. I was there for over a year and didn't need to be there that long for the heifers. But I'd made a lot of nice friends in Alpine and joined a church out there. My friends call me about every other day, wanting me to come back. We are going back to mark calves there pretty soon.

I have four grandchildren. There's two nine-year-olds, a six-year-old, and a five-year-old. Three boys and one girl. We stay so busy, I don't get over there to see them enough. My granddaughter, she's nine, is playing basketball.

Last year during spring break they stayed with me in Alpine for a whole week. Then this year on New Year's Day, instead of eating black-eyed peas, we had Beanee Weenee on the top of a hill in Alpine on a big rock: my daughter's two children, Lana and Jake, and I. And they just had a ball, and I did, too.

That time of the year there wasn't any danger of snakes. The trailer's out in the middle of the ranch. So I just told them to take off and they did. I won't be able to do that in summertime for fear of snakes. I've heard they're already out, too.

My friends I made in Alpine, one of them's a ranch girl, but the rest of them are not. A lot of times they'll go with me. These ladies are a little older than me, but they're just a delight and I love them all. They'll go with me to feed and they'll say, "Let me open the gates." One day, I'll never forget, one lady got out and opened the gate and when she got ready to shut it, she shut it with her on the other side. I asked her if she was going to crawl over. She nearly died laughing.

My grandfather came down here when my dad was about seventeen. He had some land in East Texas and he'd sold that. He loved this country and he bought a ranch for each one of the boys. He had three boys and a girl.

My aunt's husband didn't care anything about ranching. He was in the service. Anyway, Daddy leased their ranch and helped my uncle get the postmaster job. He was the postmaster here for years and years. He died of cancer six or seven years ago. My aunt now lives here by herself.

Daddy's had her place leased about forty years. He takes care of it. So we run stock on three places. The problem is, they're all scattered. If they were all together, it'd be a lot simpler. We spend a lot of time in the pickup.

My daddy's pushed cedar in my aunt's country, but we left some. A lot of profit in the Hill Country ranches is hunting. So, you don't want to get rid of all your brush because that's where the big deer hide. But, oooh me, it is a booger to round up in.

5

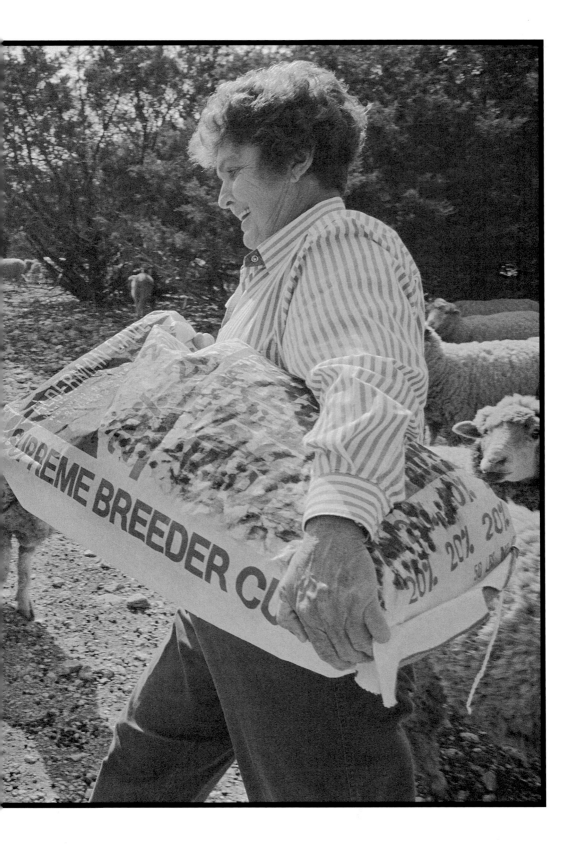

*Feeding the sheep*

I really wish he'd pushed a little more. And the cost is too astronomical to do it again. Used to, when you had [migrant] labor, you could do it by hand and the Soil Conservation Service would help you. I think a bulldozer tears up the country too much.

### THE TRUTH ABOUT GOATS

We've had the goats down here sheared for twenty four days. By now they can stand a rain. But if it gets cold and rains, or it hails too, they'll die.

[Gesturing toward a neighbor's pasture]: See, they've left a little bit of a cape on their goats. If goats get cold on their backbone, they'll die. But if you leave just that little bit, about four inches across their backbone (they call that a cape), then they won't get cold when it rains. Most of the ones we just sheared, we left with capes. The kids, we sheared slick, so that's what I've been penning. But I didn't pen them last night, and this morning I thought, "Oh, that wind is cold. I hope it doesn't rain!"

*When the weather warms up, do you come back and shear the capes?*

It's gotten where the shearing expenses are so much that it's not always economical. What they say is, just lay them down over a barrel and then you can shear their backs pretty easy. But with mohair not being worth very much, it's not worth the trouble.

[After Lorelei counts the sheep, she pinches off a certain amount of feed from a fifty-pound sack and pours it along the ground in a huge circle. When she's back I ask how much she feeds each one.]

We've had enough rain that we're beginning to cut down now. We've been feeding at least half a pound a sheep and a goat. But now we're down to a quarter. And we'll pretty soon quit, I hope.

Aren't those kids precious? They're so cute when they're little and they get so ugly when they're older. I think ewes are prettier than nannies. The nannies sure do have a lot of milk—look at them. The reason they're making lots of milk is the feed has got cottonseed meal and salt and rice bran in it. Cottonseed meal makes them give more milk.

We had always kidded the nannies out in the next pasture. But in recent years we haven't been raising a very good kid crop; the hunters said they thought they heard coyotes.

*Do you have a bad predator problem?*

Yes, we do. I'm fixing to set some snares. It works. But maybe moving them out of that hilly pasture into this smaller place, we can keep an eye on them better. So far, it doesn't look like we've lost any.

We were caking these, but after they start kidding, you don't dare call them. They'll come away from their babies and they don't always go back. I said something to Daddy one time about how ewes were better mamas than nannies and he said, "About ten times better!" A ewe just won't go off and leave her lamb. A nanny will go off and leave her kid and sometimes go back, and sometimes not.

That's why so many people kid them by hand, in a pen. We're doing it in a pen at the other ranch. That's what Daddy's doing today. And he's spraying them for lice.

Talking about which animals you like best: the cattle are less work. "If you have a balance," my grandfather said, "if you try to stick with several kinds of animals, the market's going to go up and down on all of them. If you try to just run to whatever's worth the money at the time, well that price may go down and the next one go up and then you don't have any of those animals." So Daddy's always tried to run all three: sheep, goats, and cattle. And he wants the very best of breeding stock of all of them.

Sheep, Daddy has always said, year in and year out will always make some money. But wool prices are so bad right now. They had just put in a new lamb slaughtering plant the other side of Austin, and everybody was excited that would help our product, that we would have a market for it closer to home.

*Lorelei's favorite boots*

The plant went under. I went by it going to Elgin the other day and it was closed. It really is sad. Since wool has fallen off so bad and we don't have that good a market for our meat, sheep are not as profitable as they were.

## RACEHORSES

My dad's raised racehorses for years.

We took 18 head of horses to a Shawnee, Oklahoma, sale last April and we had six two-year-old stud colts. And there were only two men and myself and Daddy getting them ready. We had to put them in stalls. About three times a day, you had to shovel manure out of the stalls and clean the horses, clean the pens, feed and water them and walk them, exercise them and brush them. We kept blankets on them, and during the day when it got warmer we'd have to get those blankets off. They did look beautiful.

About the first week we had them in, I went down there early one morning. About 6:30 we'd start cleaning stalls. And Juan met me and he let me have it: "If you're going to clean stalls, you be sure you shut the gates." He said I left the gate open that night and the two-year-old studs got together and crippled one of them.

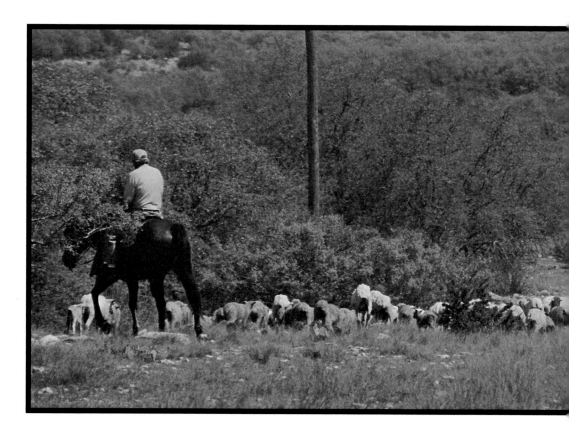

Juan was crushed because those are his babies. He's tended to them since they were born and was very proud of the way they looked. He was very perturbed at me for not doing it right. I don't remember leaving that gate open. But I guess I did, I was the last one through. So, for the next ten days, I ran water on [the horse's leg] about two hours every day. His ankle was all swollen. It didn't make it go away, but it helped.

*How long has Juan worked here?*

There's two brothers. The other one's been with us about twenty years and Juan's been with us fifteen. We're working now to get his wife and children over. I feel sorry for him, with his family not here. He doesn't leave here often, when we're so short-handed and there's so much work to do.

## WORKING HORSEBACK

I work in the pen horseback. When we put the cattle through the chute, I do that. We have a cutting chute for cattle that's really wonderful. My son is a welder and he built it. At first I thought I could do this so much quicker on foot, with a stick. But when

*The big sheep roundup*

we finally got the cattle trained to know when they went down that chute they could get out and keep going, then we could cut them from horseback. And we cut the calves out through the chute. I do all my work in the back pen horseback. That little gray horse is real good at that.

We're going to eat lunch now and then we're going to load those stud colts. We're taking them to the other ranch.

## LUNCH CONVERSATION

[The following is excerpted from our lunch conversation. When Lorelei and I arrived at her mother's house, the kitchen table was set for three and covered with dishes filled with roast beef, potatoes with cheese, fresh cooked spinach, and fruit salad.]

My mom's slowing down. She's one who's always cooked and done. She took a big pot roast and potatoes to the church dinner yesterday and we have all of that left over and I'd just as soon eat that as go to town.

*Tell me about going to town.*

LORELEI: I really don't. Daddy sends me to town sometimes to get feed. As far as going to town just to get groceries, we don't. We just pick them up while we're there. We do go to Sam's when we're in San Antonio.

MRS. HANKINS: Has she been out to the lower ranch? See, we always call that Lorelei's ranch and this is Louise's ranch. We have two girls. One of them lives in Kerrville. And Lorelei—we've always called that her ranch, down there. Well, she was born there.

When she was born, we didn't have a doctor here. He had left all of a sudden. Anyway, we love it down there. It's a real pretty place.

Lorelei keeps the old ranch house real nice. We have some redoing that we're going to do there. There's a big old cabinet that goes in the kitchen. She's kind of had to stack up some pans.

LORELEI: I told her I liked it that way. I can just sort of pitch them. They don't demand that I keep clean because there's no shelf.

We normally just have sandwiches for lunch because when we're working we're usually not at the house.

MRS. HANKINS: Lorelei, the biscuits.

LORELEI: And Daddy's had to do his lunch today because I'm not down there to cook.

MRS. HANKINS: I fixed him a lunch.

LORELEI: One of the places we have to go on the back side of the ranch is six miles and it takes an hour to drive. It's just a two-rut ranch road—rocky. We'll put caliche on it and it washes off with the first rain. I really think I can do it faster horseback.

MRS. HANKINS: This is a real good place to live. The people in this little town are real cordial to each other. They have organizations that work all the time. It's a real nice place to live. And down yonder at the lower ranch it's nice, but it's so far. It's twenty-six miles?

LORELEI: Twenty-four. Twenty miles to the turnoff and four miles off the highway. [Then she checks the biscuits.] Almost ready.

MRS. HANKINS: Just turn it off.

LORELEI: Mother, when you and Daddy married, you were seventeen?

MRS. HANKINS: I was seventeen. He had kind of helped me through school and my family was so used to him. But we were both real young.

LORELEI: You've been married sixty-three years?

MRS. HANKINS: We were married in '30. We have been married sixty-three years.

LORELEI: March 11. In fact, they decorated the church with redbud, no, not the church, the home where they married. So every year when the redbud starts blooming, Daddy knows it's time for his anniversary. A little warning. To wish mother a happy anniversary, he'd bring her a bouquet of redbuds. Finally he decided to just plant a tree here.

MRS. HANKINS: Easier.

Did you know I read last night that teaching had kind of got into the doldrums, that they kind of quit going in and teaching, but now they're coming back. They are making more money. Isn't that right Lorelei?

LORELEI: [to me] Go ahead and butter your biscuit.

MRS. HANKINS: Yeah, go on, darlin'. Anyway, it's good to know that teachers have a future. They do.

I'm going to say a blessing.

Father, we thank thee for this beautiful day. We thank thee for all of our good fortune. We thank thee for interests that are sweet and fine and wholesome. Guide us, keep us, take care of our little children. We ask in thy name. Amen.

And our little children are in Ozona and Big Lake, isn't that right, Lorelei?

LORELEI: Mine are. My sister has three girls. One of them's not married. She works in a bank in Florida. The other one . . .

MRS. HANKINS: Lorelei, I don't believe she ever will marry, do you?

LORELEI: Probably not. The oldest one is a calculus professor at Baylor . . .

MRS. HANKINS: Smart, smart.

LORELEI: The middle girl is a teacher in Sonora.
Now Mom, come on, I want you to eat.

MRS. HANKINS: [rummaging in the freezer in the other room] Lorelei, where is that jelly I always like to have?

LORELEI: Well, Mom, I don't know.

MRS. HANKINS: Here it is.
My husband's eighty-one and acts like he's thirty-one. Doesn't he, Lorelei? I think Daddy has a lot of spirit.

LORELEI: He keeps saying if he quits he might die, so he won't quit. But he wears me out! But, now, Mother, we've decided you've got to start making hot rolls again. Before you forget how.

MRS. HANKINS: All right. Well, I didn't get fresh bread because the bread man didn't come.

LORELEI: When we're in Alpine working, Mother fixes cornbread nearly every day. We'll have butter beans or red beans and cornbread every day. It's wonderful.

MRS. HANKINS: Does she know about our place at Alpine? I bet she'd like to go out there. It's beautiful. It *is* beautiful. Have you ever been out there at all? We have a trailer house out there.

LORELEI: Travel trailer.

MRS. HANKINS: It's so nice. It has a big room that has two beds. That's where Lowell and I sleep.

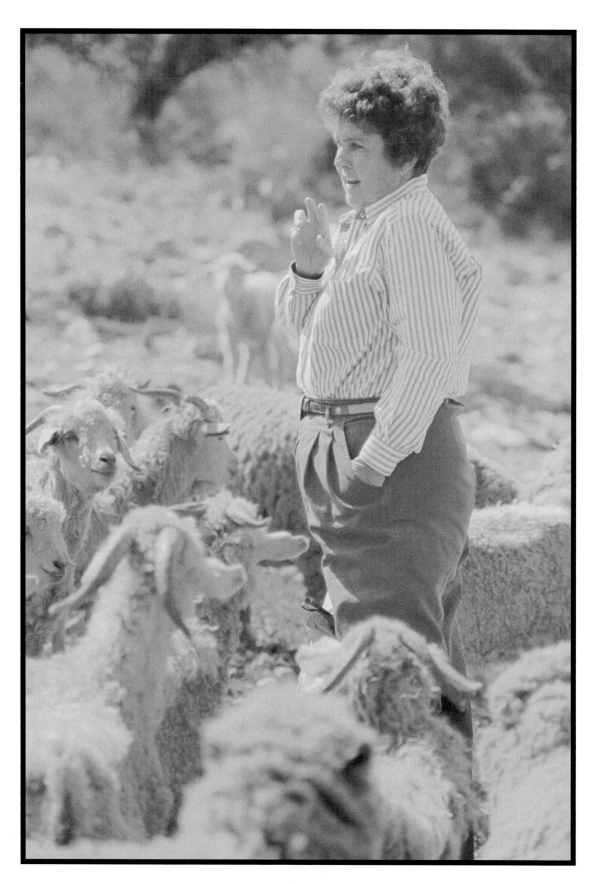

*Counting the Angora goats*

LORELEI: Now, Mama, I wouldn't call it a big room. A bedroom. It has two twin beds in it.

MRS. HANKINS: Then it has a living room with a couch on it. Lorelei sleeps there if she needs to.

They put a fence around it and I don't think anybody's ever bothered it, do you, Lorelei?

LORELEI: One time somebody went in it. When we had the other trailer we never did lock it. Daddy said he'd rather they would just go in it rather than tear up the door. But now, this new one has a microwave, so we keep it locked.

But one time, somebody went in and got my peanut butter. That's the only thing that was missing. And I could tell they came in because they tracked mud all through the house. But that's really the only time anybody ever bothered us.

The other trailer was out there three years and this one's been out there two. So for about five years altogether we've had a house.

This food is wonderful.

MRS. HANKINS: Well, it's just leftovers.

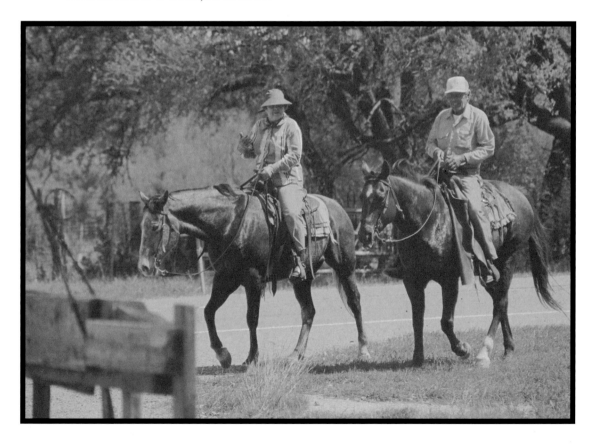

*Lorelei and her right-hand man, Juan*

*Thank you for sharing your meal with me.*

MRS. HANKINS: My goodness, I didn't go to any trouble.

Louise was always our music girl. But she never was much of one for livestock work, was she Lorelei?

LORELEI: Well, she did it anyway, because we made her.

*Who is older?*

LORELEI: Louise is two years older. She says, "Lorelei looks the oldest, but I am." Because I'm more sun-wrinkled.

Mother, that's the best fruit salad I ever ate. It's wonderful. What did you put in it? Bananas, apples, strawberries, and whipped cream?

This is the best food I've eaten in a long time.

MRS. HANKINS: [to me] Do you ever take your lunch when you're going out?

ME: Yes. I have a banana in the car. I thought . . .

MRS. HANKINS: If I get in a jam, I'll eat my banana.

I put some sauce on that meat, but it's hotter than a firecracker! Did you get any of it?

LORELEI: What kind of sauce did you put on it?

MRS. HANKINS: It's called meat sauce.

Lorelei, Daddy wants me to say whether or not we're to keep that lease out at Alpine. And I don't know. What do you think?

LORELEI: We'll worry about that later.

MRS. HANKINS: I like to go out there and he does too, don't you think?

LORELEI: It's just hard on y'all. 'Tain't easy, it's a ten-section pasture [6,400 acres].

MRS. HANKINS: [to me] That's enormous, did you know that?

LORELEI: You just have to go over half of it in the morning and the other half in the afternoon.

MRS. HANKINS: A big lot of work goes on there. Of course, Lowell has some boys hired to see about the feeding, doesn't he, Lorelei?

LORELEI: One man is taking care of the feeding right now. Well, the secret is, our cows are gentle. Daddy honks the horn and gets in front of them . . .

MRS. HANKINS: And here they come!

LORELEI: A couple of us get behind. That last year it seemed to me like right before we marked the calves, they'd gotten to where they'd quit coming. This year, I don't know if there's any grass at all. If there is, they get kind of wild—then they're not chasing the feed wagon. I usually go out a few days ahead and bait them, you know, feed them a time or two. We're not feeding them cake in this one pasture. And if they're wild, it's hard, because it's so big.

MRS. HANKINS: I mean to tell you, we have some horse history. We had one horse that won thirty-seven races out at Ruidoso. Lorelei, what was his name?

LORELEI: Special Hank.

MRS. HANKINS: Special Hank. And when he died, they buried him in the infield. And there were only three horses buried there.

LORELEI: He's an 8-70 horse.

[Mr. Hankins calls Lorelei on the phone, needing her at the other ranch.]

LORELEI: Daddy said they ran out of spray and they're only half through.
It's going to be kind of tricky this afternoon. We have two stud colts that are two years old and two stud colts that are one year old plus two geldings that are three years old. And we're fixing to throw them all together.
The fur may fly. We just don't have anywhere else to put them. We can't leave them here because they're riding the fillies and really causing problems.
Daddy said he looked down there yesterday and there was one walking along on his hind legs, straight up! Daddy said if he'd gotten closer to those picket fences and come down, he would have been *there*, he just would've been *there*.

MRS. HANKINS: When's Daddy coming home?

LORELEI: It'll probably be middle of the afternoon. I kind of want him to be there when I turn those colts loose. Then I may have to haul something to the vet. But they've got to be turned out, that's all there is to it.

MRS. HANKINS: Lorelei is real acquainted with vets.

LORELEI: One of the horses is a real pill. He's a gelding. We thought when we gelded him that his temper would change. It didn't. He just fights everything, he runs at us, rears up, paws, and kicks. He just acts like a little stallion all the time, and he's not.

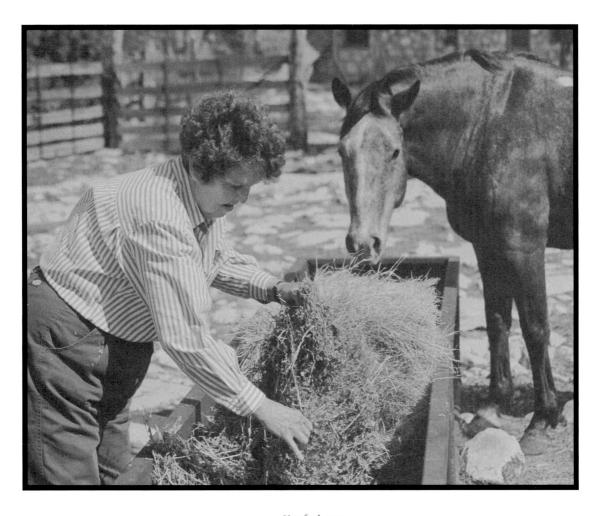

*Hay for horses*

I told Daddy he's ornery enough he's just going to run a hole in the wind. He's a thoroughbred. I'm real anxious to see him race. Do you ever go to Bandera? I'm going to go when he runs his first race.

MRS. HANKINS: Well, Lorelei, we still haven't heard what our horse did yesterday.

LORELEI: That means he didn't win. This horse that did so well in Ruidoso won the Governor's Handicap five years in a row in Albuquerque. But every time I'd go to watch him run, he wouldn't win. He'd run and win. But then the next race back, they'd handicap him with a lot of weight and he'd lose. And then they'd take it off and he'd win. Then they'd put it back on him and he'd lose.

He was a little horse, but he had a big heart. He'd try every trip. He wasn't temperamental. He really wanted to win.

MRS. HANKINS: When Special Hank was running all those years, thirty-seven races (that means a whole lot), why I'd always, while he was running, go down to the winner's circle because I knew he'd win. And he did. I didn't want to miss it.

LORELEI: He was nine years old when he died. He was kind of like the thoroughbred horse John Henry. He was a big gelding up in Kentucky. He ran until he was nine years old and he was still winning when they retired him.

## POSTSCRIPT

When I caught up with Lorelei at her ranch in 2004, she was running three ranches and still riding her horse. She'd had a knee replacement that made getting on the horse more difficult, but said four-wheelers were too noisy an alternative. "You can't hear the sheep."

Besides, Lorelei has quite a horse history. Her uncle Jess Hankins owned King, the legendary quarter horse. Her father, Lowell Hankins, and his two brothers were famous in the quarter horse world. Lorelei carries on the family tradition, and raising horses is a big part of her ranching operation.

At seventy-one, her typical day began between 3 a.m. and 4 a.m. She had a big breakfast, saddled up her horse, and was riding by 7 a.m. Before lunch, she had rounded up in four pastures. Afterward, she communicated with hunters and then rounded up bucks while others were drenching the herd. She was in bed by 8 p.m.

Since I had first interviewed Lorelei, her mother and father had died. She had stopped raising Angora goats, but ran 1,500 or more sheep. She no longer took cattle

to West Texas. She leased land to hunters to supplement her income. "You have to," she said.

Lorelei has two children, Kay and Cliff, and two grandchildren. She said she encouraged her grandchildren to have a profession and do ranching on the side. "It's hard to make a living," she said.

By 2009 Lorelei was still getting up at the break of day and working on the ranch. She was raising racehorses; in fact, she carried their pictures in her purse.

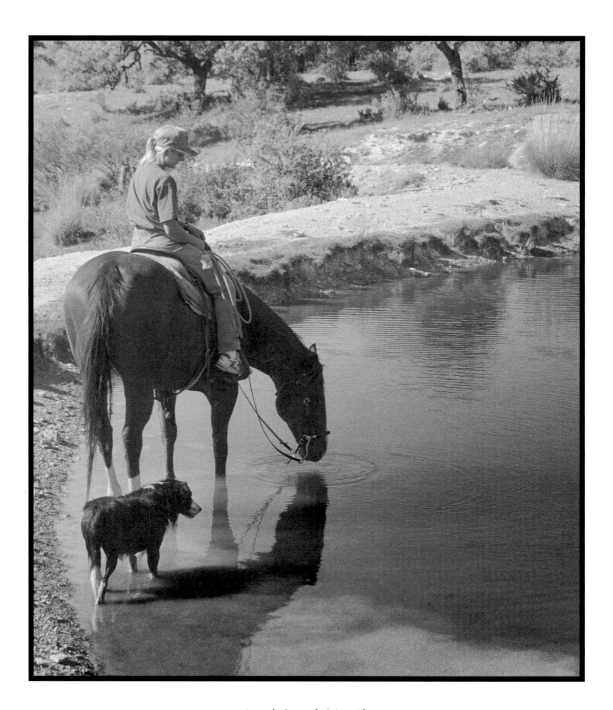

*Amanda Spenrath Geistweidt*

# Amanda Spenrath Geistweidt

*with mother, Sharon Spenrath*

**COMFORT, TEXAS**

**B. FEBRUARY 23, 1972**

### WHY RANCH?

I love what I do. It's real hard to explain the thrill you get from chasing a bunch of rebel goats and outsmarting them, or watching a good stock dog work goats—it's beautiful. Then again, gathering a couple hundred stocker calves and trailing them in, you may look miles ahead of you and there'll be stocker calves strung out. I even enjoy working sheep.

It's hard to explain.

We had this leased place out in the Davis Mountains, and I had never ridden in such rough terrain. I had never ridden *mules* in such rough terrain. It's bad. There's usually one way up the mountain and one way down, if you're lucky.

We rode about three hours up one mountain—it was a real cold, crisp morning. Once we got on top, you could feel the sun and it started warming up and it was green because it had rained. And you could look from the Fort Davis Mountain range and there was the big Valentine Valley and a whole other mountain range back there. It was absolutely beautiful. I asked Mom, "How do you explain such a thing?"

### BEN THE DOG

Ben's my dog and I wish you could meet him. He's the man in my life.

I trained him—well, we trained each other.

I took him to Wyoming with me and didn't have a way to bring him back. So, he's still up there with Dad.

Ben's quite a character. He's my right-hand man. I don't really know how to do anything without Ben. But I have to learn to—he's getting so old.

When we were both a little younger, we had these wild cattle out of Arizona. They were so wild they'd run and hide under bushes like goats do. They were on a leased place.

And there was this outlaw steer. Dad couldn't get him in. I was up there looking for the sheep one day and I jumped him. Ben took out after him. He ran that steer about two miles down to a creek bottom—I couldn't keep up with him. All I could hear was Ben chasing that cow. I tried to call him back but he wouldn't come.

Ben's quite a cow dog. He's mean and most of the time he can take up for himself quite well. But all of a sudden, all I could hear was this howling. I was sick to my stomach. I thought, "If the steer hurt my dog, I'm going to shoot the steer!" I tried to get closer to the howling—it took me thirty or forty minutes to find them.

Ben had gotten that steer all the way down to the corrals. There's this little alley going up to the corrals and right in the corner of the alley is the gate. He had that steer pushed right opposite the corner of the gate and he was standing right where the gate latch was, pushing on it and just a' howling, trying to get me to come open that gate.

Isn't that unbelievable? He's my hero! He's something else.

Old Ben—he's getting a little meaner in his older age. We were putting some stocker calves from the field into the pen and they were wild. They were a group that had come out of the auction barn, and weren't used to dogs. We had about 180 in the field and we got them all in but one. He did not want to go in that pen.

We had five dogs out working those cattle over. We'd spent about an hour getting them in, because they'd break and you'd have to send the dogs out. This one calf just wouldn't go in, so the dogs went after him. He was fighting them. Finally, it was kind of like Ben had enough. He jumped up and grabbed that steer by the nose and the steer went to its knees in the dirt. Ben let go and I'll be darned if that steer didn't run straight to the pen! Good old Ben.

Of course, Ben had a couple of hard lessons himself.

He's a big sturdy dog. When he was young, we'd be trailing goats along a ridge, and he was supposed to be watching the front. Well, he'd find a little goat off somewhere and he'd run it down in the draw and bite on it. This went on for some time, and I had scolded and scolded him for it. Finally, I had to put a roping rope around him and hang him from a tree. I put the rope around his flank area so it wouldn't break anything, just to scare him real bad. That sounds really mean, and it is mean, but he was tearing up the goats. And he's never done it since.

Some of the lessons are a little harder than others.

Age has something to do with it. When those dogs get old, they really get smart. [We drive up to a border collie tied with a long rope to a tree.]

This is my project. This will one day be Ben's replacement. He doesn't know anything. I mean, *anything*. For him to get on a truck in the morning is a feat.

*Are you training him yourself?*

Yes.

*So you think he has potential?*

He has the genes. His mama's a smart dog and his dad's a smart dog. He shows some instinct and that's what's important. He likes to chase goats. He looks at them and pays attention to livestock. The only thing I'm scared of is he doesn't like them. But since he's a puppy I haven't been real hard on him—I want him to like to come with me. I think he'll be all right.

[To the dog]: Get on the truck. Get on the truck. [The dog complies.]

*How did you learn to train dogs?*

From my dad. My dad has always trained his dogs, and he's had some pretty good ones.

*Ranch dog training young cattle*

## FAMILY

I was born in Kerrville, but I've always lived in this house.

My dad inherited this ranch from my grandmother, whose maiden name was Allerkamp. Her parents originally settled this area. They were German (and my mom is German). My grandmother got a portion of the ranch when it was divided. The ranch has been in the family over a hundred years.

My dad's mother was Isabelle Allerkamp Spenrath. Her father was quite the rancher, and they speak of my father being a lot like him. My dad has a great instinct for livestock and for market changes. He's done real good with predictions. He has a real good feel for the land and a real good feel for livestock and how to put both together.

His dad is quite the farmer. The family has a neat working relationship. My grandfather is the farmer and my dad's the rancher, so they complement each other. It's kind of like that with me and my brother.

My brother is good with livestock, but he's extremely mechanically inclined. He loves tractors and farming. But me! If you give me a truck for a whole day, I'll usually break something on it. But I can take care of livestock real well. So, the whole family works together.

That's what's important to me and I think that's what makes family-owned businesses work. There are a lot of different aspects to ranching, and everybody's unique and can do something really well.

My brother will probably come back to the ranch. It might be quite a big ranch someday.

*As far as livestock on this place, you have your grandfather's, your father's, your brother's and yours?*

Right.

*How old is your brother?*

He's twenty.

*Do you and your brother agree on things?*

Yes, we do. When it comes to business, we get along well. When I was in college, my brother was in high school. Then he didn't go to school for almost a year. So he looked after things when I couldn't come down every weekend, or if we had a problem during the week with water gaps. Now he's at school and it's my turn to fill in for his end of the deal.

When we were young, my parents every year put a cow under our names. I don't know how many years, maybe five or eight. And we just kept building our herds. I would sometimes trade or sell cows for a horse.

My parents always told me, "It may only be one cow, Mandy, but it'll make a difference." And you think, "One cow." But it goes to show they're right.

My mom and dad always tried to help us make wise decisions with our money and help us start building something. They were steering us in the right direction and that's the reason for what I have today.

I guess what I really contribute to the ranch is spending most of my days on a horse. In Wyoming I usually get on a horse by seven in the morning and come in at 8:30 at night. I'm usually on a horse all day, checking cattle, herding sheep.

When I'm here in the spring I ride cattle every day, checking the stocker calves. In the heavy winter I do a lot of feeding. If we know something is killing, like coyotes or dogs, I do a lot of snooping around early in the morning to look for kills so we can call the trapper. I spend most of my life on a horse.

I come back different than a lot of ladies. I come back with the ability to do more specialty work. I do a little more management. I do a lot more riding and overseeing livestock, whereas I'm not necessarily responsible for grinding feed like a lot of ladies probably are. So that's a real lucky and unique part of coming back to a family operation.

I'm not strong enough to carry bales of hay around—I can load it on my truck. But there's a lot of heavy, heavy work that a lot of ladies have to do.

I don't do a lot of farming. We plant oats and wheat to graze our livestock on. I do more livestock work. And if it's something mechanical . . . well, I'm not very mechanically inclined.

People get a real romantic thought when they think about people ranching or owning land. They think we're wealthy.

When we first went to Wyoming, the kids used to ask me, when they heard we were from Texas, "So you own an oil well?" They think we live on Southfork. It's really not that way. I mean, it's a wonderful life. But it's not because of the money you make.

I just sold ninety-five stockers in Wyoming and that's quite a few, I thought. But you know how cattle prices are. I have cattle and Angora goats. Mohair is at $1.50. That's bad cheap. It should be at $3 or $4. A goat you can buy for $15 right now when they should be bringing $35 or $40. At one time, when goats were really what they should be, a goat was bringing $50 or $60. It isn't easy right now.

People in ranching, a lot of these old ranchwomen especially, have made it by having different products. When one market is bad, they have something else. They have

goats when beef is bad. Being diversified is really important in the ranch industry.

My parents didn't always have it easy and I'm sure a lot of the older women you've talked to didn't have it easy. They know what it's like to live on meager means, don't they?

I wonder about people my age. I think it will be harder for us to make it because we don't know what it's like to live through hardship, like a world war. I don't want my generation to go through a hardship like that, but we will, and I don't know if we'll be as successful as our grandparents were.

Dad is fifty-four and Mom's forty-seven. They're both workaholics. Mom just got elected as Texas Cattlewomen's president. And my dad is, well, I just think my dad's a great man. My dad's my idol and my mom's my best friend. That's kind of how it works. My dad is, in my opinion, quite a rancher.

He started out with one calf—a steer. His uncle gave it to him. He sold it and bought twelve old, raggedy sheep. And he started a herd from that!

*What does he have today?*

Today he runs around 1,500 sheep in Wyoming, 150 mama cows, probably 2,500 goats, and he'll run anywhere from 500 to 1,000 stocker calves. Then, on top of that, he'll buy several truckloads of roping cattle. He buys them in the winter. That's how my parents have been making a lot of their money, by buying roping cattle to send to Wyoming. He sends several truckloads a year. Roping is the biggest recreational sport there. I give my father a lot of credit for finding a niche in the market.

My father has taught me a lot. He taught me how to manage grazing systems and livestock. Really, he's the one who taught me how to put together rations for livestock (your mineral rations or supplements). He's really a good steward of the land. He's well known for treating the land well and using good grazing management.

And Mom. Something that's really important to me that people sometimes don't realize is that, even though she's not out here every day riding with us, just as important to the ranch is what she's doing inside: keeping the books. She's the one who comes to us and tells us, "Okay, this method of feeding your lambs out with these rations actually brought this amount of money. Your feed cost this much."

She really is the financial advisor, and you can't have one without the other. My mom does a lot of the kidding [the birthing of goat kids], too. She is really good at that. Talk about time consuming!

My father's taught me about gathering livestock—where to expect them at certain times of the day. He'll understand that if you're gathering goats one morning, and it's a little bit cooler than usual and there's a wind out of the north, they'll be in a certain corner of the pasture.

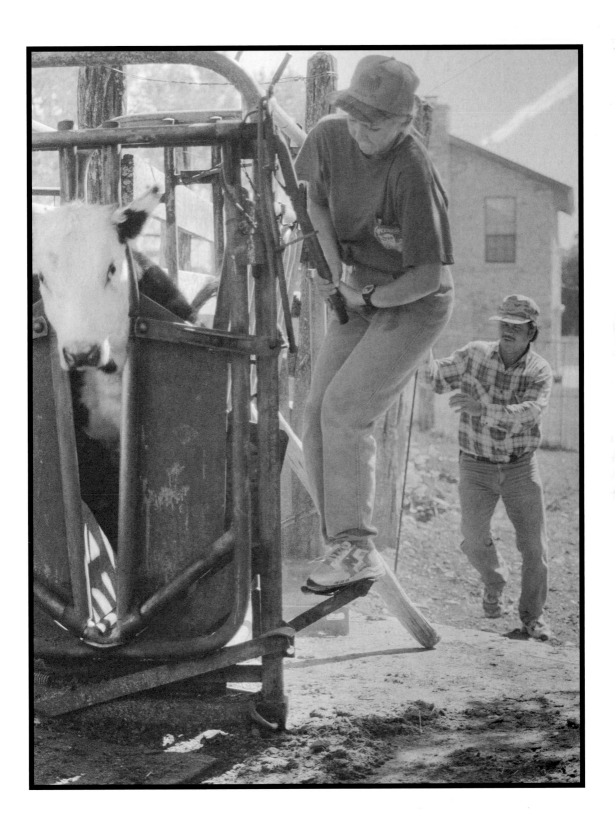

*Wrestling the squeeze chute*

I can't always learn from my mother and father. One day my dad will be too old, or God forbid, something might happen to him, and how am I going to learn these things? Taking care of livestock and the land isn't just something you read in a textbook. It's something you grow up doing. It's a feeling.

## THE WYOMING OPERATION

When I was twelve or thirteen, my parents decided to buy the ranch in Wyoming. It was always my dad's dream to have a large ranch.

They tried to look for land they could pay for by ranching. We didn't inherit a lot of money and we're not wealthy.

They found a place in Wyoming they thought would work and started paying on it. It's still not paid for, but it's getting closer.

These days, if you want to continue to ranch and if you want to continue to be successful, you have to grow, you have to be big. Small numbers don't matter anymore.

That's one reason I came home: to help the family business grow, and continue paying for the ranch in Wyoming.

We use longhorn steers in Wyoming. They get real old and we use them as lead steers. As we go to different parts of the ranch with the steers or heifers, we'll put that longhorn steer with them and he'll just lead the way. All we have to do is ride behind and push them or stay a little to the side. They're smart animals. We have three now in Wyoming.

We used to run a ewe herd of about four thousand head in Wyoming. Now it's a little over one thousand. We sold a bunch last year as packer ewes in New Mexico. Sometimes we take in stocker lambs to summer on the operation. When we had that drought in West Texas so bad, we shipped about a thousand lambs up to summer. We did the same thing with stocker steers.

From our experience, the sheep do much better in Wyoming. So we keep that part of the operation up there almost year round.

A lot of people don't like working sheep, but I do. I didn't so much when I was young. You know what's interesting? A lot of the old pioneer ranches in Wyoming were bought and paid for running sheep. It was all sheep country.

A lot of the older ranchers' children have gone to cattle. They're easier to take care of.

*Do you think you'll one day live in Wyoming?*

I'll have to be honest with you: I have a real deep love for Texas. I love the people who live in Texas. I haven't traveled a bunch, but I've traveled enough to know that there's something really unique about Texas people. So I don't know if I'd ever live up there year-round. Plus, I do *not* like being extremely cold. And I tell you what, being in that snow the short time I was up in Wyoming had me satisfied for ten years.

I will spend April to October there next year.

*That sounds like an ideal setup.*

It's really the best of two worlds.

## HOW IT WORKS

We work our calves in late March, April, and May, when they're young. We give them some vaccines and castrate them. At weaning time, we vaccinate them again for different types of pneumonia. Then they winter on wheat pastures or on grasses. We supplement them with some type of heavy protein, like a cake.

These calves are healthy and they have been conditioned early. What I mean is, through the winter months we've watched them for sicknesses and they've gotten over those stages. They'll go to Wyoming the earliest, which is the end of April, first of May. Right before they go, they'll get their Ivomec and they'll be branded. Prior to that, if they needed dehorning they will have been dehorned.

So, they go through three levels, as far as their vaccines, before they hit Wyoming. Then they'll summer on grass on the rolling plains of Wyoming. It's unbelievable how the protein and the nutrients and the vitamins in that grass are so much better than in the grass here in Texas. When you walk through the fields there, it doesn't look like it. We have a lot of ground cover here. Up there the ground cover isn't as dense, but it's much more nutritious. You'll go up there and it will look like those calves have been in a feedlot somewhere, and there are no feed troughs around. They will be on grass until the middle of October, and then they're shipped to a feed yard. We don't feed them out after that. A lot of people retain ownership, but we don't.

Ranching in Wyoming makes the whole picture different. This is like a winter operation and that is a summer operation, yet we have our mama cows here year-round and our ewe herd is up there year-round.

When I look at these cows, I think of them as stocker cattle. A lot of people ask you, "After you wean your cattle, what's their weight when they go to market?" Well, I don't think like that. I think, "What's this calf going to weigh when he's a yearling in Wyoming?"

31

The real key to stocker cows, and one of the hardest things, especially if you buy them at auction, is conditioning them.

*How old are they when you buy them?*

Not quite a year. It just depends. Now, in October, we buy calves that weigh four hundred pounds—they would've been born in April. But if we buy this coming April we'll buy calves that weigh closer to six hundred and are older.

It all depends on the market. Cattle are cheap now. But the problem, and this is what's ironic to me, is that the price of grain is so incredibly high. Even on these cheap cattle, it's hard to make a profit.

We use the salt troughs and the mineral mixes to make the cows migrate to different places on the ranch to use the land properly, so they don't just stay in one end and eat all the grass there.

Cattle are the worst creatures of habit. If you start feeding cows in a certain place, they're liable to live there and not move and just die in that one spot.

The protein supplement is especially important as we get into the winter months because what you're beginning to see is really dry grass. It doesn't have those great nutrients any more. If you give the cows cottonseed meal they'll better utilize all this dry grass. It helps them digest it.

*How's your rain this year?*

It's been a decent year. It's a little dry right now. You wish that the planted oats and wheat would have a good rain to help them come up. But it's not a year to complain.

You know it could be a drought one year and sloppy weather the next.

We had the wettest year we've ever had in Wyoming. The old-timers say they haven't seen anything like it since the '20s or '30s.

### THE PLAN

*What's your degree?*

Range ranch management.

I took a lot of criticism, when I came back home [after college], from people who had helped me build my resume—they thought I was letting them down. I had nice job offers. I was working for the university, in the realm of education. But my background was in agriculture.

I was a legislative intern in Washington, D.C. I met Bill Clinton and Newt Gingrich and heard them speak.

My intent is to ranch for a living. However, I don't plan to remove myself from the political world. To me, politics isn't a four-letter word like it is to some people. Politics can be used and abused. But I think the problem in agriculture is there aren't enough ranchers and farmers in politics. The reason is ranchers and farmers work so hard they don't have time. And I understand that.

But I think what we're going to have to do in my generation is get more involved in politics. That's our only means of fighting the fallacies. Some people think I've drifted away, but I just have to spend a couple of years building a foundation and participating more in ranching organizations.

When it comes down to it, I can enjoy doing this day to day (and that's why I'm doing it—I love the land and I love livestock), but the bottom line does matter.

In college, I traveled around so much, speaking, and my parents were real good supporters of me doing that and not just spending every weekend on the ranch. They feel that if I want to continue ranching, we've got to get out there and educate people, and fight for private property rights and talk about the golden-cheeked warbler and how he really doesn't live here.

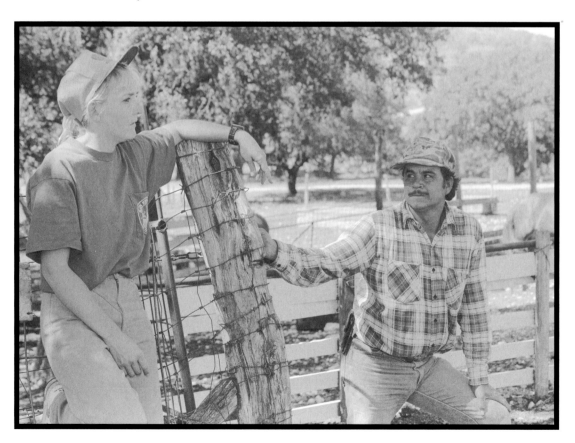

*Setting the afternoon agenda*

My underlying goal is to have a small base herd of Angus cows here. From them, I'll get my black baldy cattle (a Hereford and Angus cross). My large herd will be all black baldies. Then I'll use a Charolais bull on them, and I'll have hybrid vigor—a mix of three different breeds.

My dad has always told me to produce small, economy-sized cows. We've never run these huge cows that he calls "grass stompers." And he runs a lot of the smaller black Angus cows. You just put a good bull on them and produce some good, growthy calves.

Anyway, I came up with this little cow. This is one of the cows that I kept when I was first starting out and trying to keep all the heifers I could. She's the ugliest, God-awful thing. But she's the most economical cow. She is a fertile little animal who produces good, growthy calves. So, I have to give my dad credit. He's right after all. But she's not much to look at. Don't take a picture of her.

We put this number on their hips. See that eight? She was born in 1988. There's a seven. There's a two—she was born in 1992.

When we go to market with cattle, the ears are one of the biggest factors. When I say a lot of ear, that means Brahman [colloquially pronounced *brimmer*] blood and that means no hair. The stocker calves have got to have a lot of hair. When we go to sell them in Wyoming, if they see a lot of ear, feeders don't want them—it's too cold up there. They can't gain weight because they're shivering the whole time.

I always keep some replacement heifers. This year I have about five that are what I think is just right. They're a black baldy and yet they've got a little bit of Brahman to them. They call it an eighth of an ear—just a little bit of ear that puts a lot of heartiness to them. They'll produce some really good calves, I think. I'll put them with my Charolais bull. I don't own one right now, but my father and I have an order in for two.

When I was thirteen, cattle prices had hit bottom. I bought a cow for $230. She was an old white Brahman cow—a real good mama. My cattle with a little bit of ear like the Brahman cattle—the red cow over there, and the one right there with the little white on its face—are her descendants.

All the red-tag cattle, or the cattle with the left notch in their ears, are mine. The black-tagged cattle with the right notch are my brother's. I really like my cows. I only own about 35, but I'm hoping, with cattle prices so cheap, to buy more and lease some more land. We have another leased place, my brother and I, and I have some more cows there.

## GUARD DOGS

We started out with Great Pyrenees and we didn't have good luck with them. People always say it depends on the string you get—I don't think we got a good one.

Then we heard about these Akbash dogs. They're a big, white dog with short hair. We took them to Wyoming.

In Wyoming, it's big, wide, open spaces. There are no trees; there are no houses twenty-five miles from you. It's that sort of land. We ran these dogs with the sheep.

They are remarkable. They'll kill out of their area fifty or sixty coyotes. We won't lose any livestock, because of those dogs.

Used to, we had a pair running: Jack and Jill. They were littermates. If you rode up horseback or you'd come up with another dog, they'd warn you. If they knew you, they were kind. But if you ever saw them chasing a coyote or a fox—that was the most vicious thing you'd ever seen. They were very protective and real emotional dogs.

When Jack and Jill were puppies we took them out to a meadow with seven hundred lambs. We were herding the lambs and taking care of them. We had a couple of ewes in there that were broken down for some reason. One of the old ewes fell in the river and drowned. We pulled her out of the river and laid her on the bank. One of those puppies went over and licked her face and pulled her hair, and sat there for hours, whining. That was the first herd they had to protect. When we got those lambs up and loaded them on the trucks, those dogs followed the trucks out of there, following those lambs. Then they just lay around the camp howling for days.

The mom of the dogs we have now, or the old grandma, was supposedly a bear chaser as well.

We brought three dogs home to Texas to try them here. One crossed the interstate and didn't make it, one went on to a neighbor's place and pulled down a deer they had hanging in a tree and they shot him, and the other one we don't know what happened to. But everything is so confined here. And the dogs are used to running on twenty thousand acres. Here, they may have only one thousand acres in a pasture and they just don't work well.

We've had some problems in Wyoming with people stealing livestock and they've taken three of our Akbash dogs. They took Jack and Jill and another dog. We lost three in two years, along with about three hundred and fifty sheep. The problem is, the ewes are out there on twenty thousand acres, so you don't see them all every day. You may not even see them all for a week. So it's pretty easy for thieves to go out there and round up three hundred and get away with it.

35

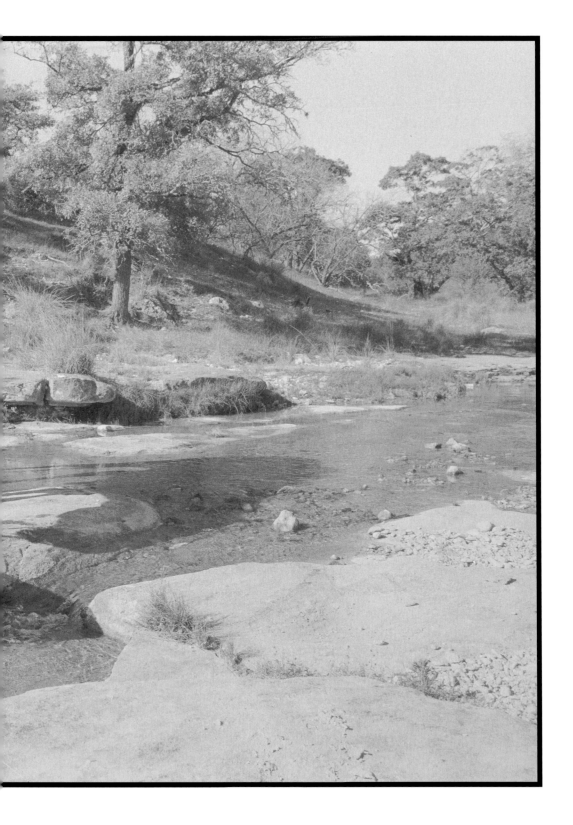

*Taking a drink*

*Like the old rustling thing?*

Yes. It happens a lot in Wyoming. I mean, *a lot*. It's something that's not old-time any-more. It's going on big time.

They've done an investigation there, but we don't know how the rustlers do it. We still haven't found them. And we haven't found the dogs.

One gentleman who is a native of Wyoming said he thinks it's all professional people who live upstate and watch you, watch your houses for maybe a month or two, and then come in one night with some horses and load up. Maybe they have an 18-wheeler, maybe they loaded up a couple of gooseneck trailers, I don't know. Then, this is the saddest part, this is what kills me: Probably, they don't even want the dogs. Probably, they just shoot the dogs.

We've done some things to try to correct the problem. The scariest part about it is, we have some neighbors (when I speak of neighbors, they could be one and a half or two hours off) that brought out some of their stocker calves and put them in a pen overnight. It snowed some.

The next morning they got down there and saw 18-wheeler tracks and there wasn't a calf left. An 18-wheeler drives in and drives off with your cattle and you never even know who it is. Somebody's doing a pretty good job of hiding the stock. It's really scary. We can't afford to lose a truckload of cattle. We can't afford losing three hundred and fifty sheep. That's a lot of money!

*Do you have any of that trouble in Texas?*

No, we don't. I tell you what makes a tremendous difference here: this is all private land. Ninety-seven percent of the state of Texas is privately owned land. In Wyoming, in amongst land you own is federal land. So you can walk out in one of your pastures one day and see someone camped in a little section out there. And they'll know it's Bureau of Land Management land and they can camp there. Not to say they didn't have to cross twenty acres of yours to get there.

*Can they legally cross your land?*

Yes, they can. It's hard to control who's on your land and who's not. I think that has a lot to do with the cattle rustling. Here, you have your gates locked, you have a pasture fenced off, it's all right there. Up there, it's hard to tell where one ends and the other begins.

## HORSES

I have ten horses and I love them. I'm horse poor. Every now and then I'll sell a horse, but I don't make nearly enough money on them. This is my weakness.

They said I was sitting in a saddle when I was six months old. When I was a couple of years old I used to ride right here by the saddle horn with my dad. He'd take me out in the pastures. So I was riding when I was really young.

We never were allowed to ride with saddles when we were young. My parents were afraid they wouldn't see us if we got hung up. So we'd just fall off instead of getting hung up.

When I graduated from college, my brother and my aunt bought me this saddle. I was excited. I thought I'd never have a new saddle until I was sixty years old.

When I was young, my parents leased a place in Oklahoma because of the bad drought here. These people in Oklahoma had two horses. They weren't broke and they were two years old.

I had grown up with different horses, like Bandit—no one had ever ridden him besides me until he was four. I'd grown up with him. He had never bucked, and I had several horses I did that way. So I thought I could break horses.

I made a deal with these people that I would break their two horses. So these two big, bronco mares got shipped down to Texas. Nothing had been done to them.

So, Dad helped me get on one day and I got bucked off bad. The biggest pain was me having to say I wasn't able to break them. That was my first horse deal. I was thirteen and a wheeler-dealer. I got my parents into all kinds of things.

I still can't ride bucking horses and break them straight out. But after someone's been on them and maybe bucked them out a couple of times, then I can ride them.

One time I was riding a young horse in Wyoming. My dad always told me, "If you're going to ride a bucking horse, ride it up a hill because it can't buck going uphill." But when this horse started bucking, all I could see was clear blue sky, no hills. I got bucked off and hit my head and got knocked out.

For extra income, when Mom and Dad were first married, he used to break horses. He was the one who taught me to ride and work with young horses.

I like the smell of a horse. Sometimes, like when I was an intern in Washington, D.C., I would just wish I could smell a horse.

This is my old brood mare. She's not pretty to look at, but please don't think we mistreat her. She's twenty-three years old. That is ancient. She has had twins before and she's raised a foal every year. Most everything I've shown you, except that gray mare over there, is out of her. But this is her last colt. She'll be put out to pasture. She's my old lady.

39

[Amanda pats the horse.] The summer was really hard on her.

[She gestures around the corrals.] All these horses are part of my clan. Then I've got two in Wyoming. The others are turned out. My dad and I co-own a stud.

*Where is he?*

We lease a lot of land and he's on one of the leased places.

*Is he a quarter horse?*

Yes. He actually was on a racetrack. He comes out of Native Dancer, a winner. He's more thoroughbred, but he has quarter horse papers.

## CHANGES IN RANCHING

[We drive from the family ranch to one Amanda leases down the road.]

This is the Lucky R Ranch. A doctor from San Antonio owns it. It's hard to see all these places go to these wealthy doctors and lawyers because they buy up the price of land. I can't buy land now and pay for it by ranching. The land has become too expensive. It's disappointing, but at least I have the opportunity to lease it.

My parents went to Wyoming to buy land because they couldn't afford to buy land here and pay for it ranching.

It's going to be really hard in the future to ranch in the Hill Country of Texas. People are moving out of the cities and the Hill Country is being subdivided. Well, the whole society is changing. They're just not agricultural minded.

I'm not saying it's going to be impossible to ranch here. I hope I'm able to do it. But so many people are moving in and trying to control the surrounding area.

In the last two years, six people have moved in around us. And sooner or later, they're not going to like the smell, they're not going to like to hear the 18-wheelers driving up in the morning to load.

It's hard to watch the land becoming urban sites, like these mobile home parks. Right behind us, the land has been divided into six places in the last year. That's a bed and breakfast and an RV park you're looking at to your left. People just don't understand—they tear up the land.

Some people from Houston just bought the old Allerkamp establishment where my grandmother's parents lived. That hill right there is for sale—some people from Arizona are looking at it. Right before you drive up to the house, there are two homes going up. People have subdivided it.

It's hard to explain the feelings I have. I can understand how the Indians resented people taking their land. Here, I've been used to these open spaces and this beautiful land and now you have traffic and people tearing things up. It's really hard to watch.

It makes it really hard to ranch. People bring in their dogs and they don't tie them. We are one of the only people who own goats from here to about a hundred miles to the west. We have packs of dogs that come in. You're not able to run the livestock like you used to.

There are people here, and even in Wyoming, letting other people come in and dig rock off their land. It's good money, but it tears up the land so bad. It makes the land ugly. They tell you they can put the land back to its original look, but they can't. When they're digging all that up, they're messing up the topsoil.

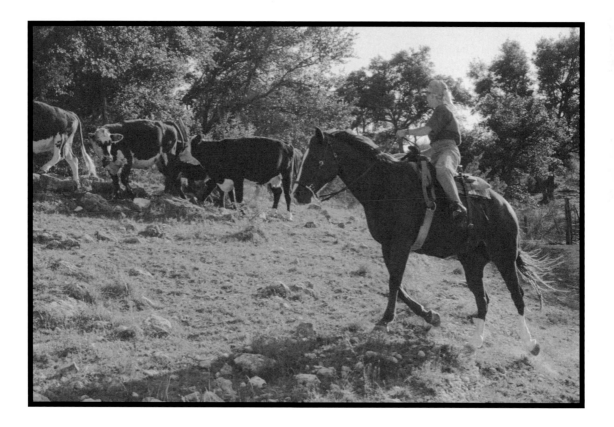

*Rounding up cattle*

In Wyoming, the whole community is still very agriculture minded. There aren't all these people out there. What is so positive about having land up there is that it will never be heavily populated. People won't spend the winter snowed in. Dad's going to be snowed in at the ranch for a couple of months.

The only thing that's scary in Wyoming is that the federal government owns so much land. Their rules and regulations are sometimes hard to live with.

A lot of people are starting to look into exotic game operations because there's money in it. You used to not think of ranching as necessarily involving deer. But now, when you think of ranching, hunting is part of it.

On the Lucky R, the owner is trying to develop an exotic ranch. So after a year or two of putting exotics in there, he won't want cattle any more. So, ours isn't a long-lasting lease.

*Is hunting a part of your operation?*

No. We don't have hunting at all. We have some family members that come out to hunt and we always have some meat in our freezer. We don't have hunters.

*Why?*

It's just never been a priority. It gets a little tiresome, people coming on and off your land. Sometimes they're people you don't know.

In Wyoming, there's a drawing to hunt lot 47, by our land, and everybody wants to hunt there. We don't know who they are, and they don't have to have our permission to cross our land.

*They must cross your land to get to the hunting area?*

Yes. It's not right. But people don't see it that way. People think they should have a right to come on our land and hunt.

Most of the presidents until now lived on a farm or a ranch, or at least visited their grandparents on a farm or a ranch. And the congressmen did too. Now, they are so removed from agriculture. And I think that's why agriculture is being treated as a stepchild.

Don't get me wrong. I don't think the government should be providing subsidies like the wool and mohair subsidy. My stand is, I believe in free enterprise and I will until the day I die. And if I believe in that, I believe government should be removed from our business and therefore should be removed from the wool and mohair industry.

The only problem I have with the subsidy is knowing the money that paid the

subsidy did not come from the taxpayers, it came from a tariff on imported mohair. There were bumper stickers in Austin, one of my friends told me, having to do with mohair costing taxpayers. People don't have information. They just don't know.

But in a way, I can't say I'm not at fault about that. Because I as well as other people in the industry haven't done a good job at advertising.

I like to look at the beef industry. My mom is extremely active in education in that industry. They have done a great job of marketing beef. I look at the commercials and I think they're fabulous. They are a united industry.

And look what the cotton producers have done.

What has the mohair industry done? I haven't tried to get on the industry boards, so I can't criticize the people up there. But I think there are some underlying problems with unity in the industry. Some people have tried to start co-ops and others have fought against it diligently.

Mohair is an extravagant natural fiber, like silk. I think it's thought of as a pricey market for people who'll pay it. But we as the producers are asking, why isn't that funneling down to us? We're told that it's because there are so many steps between sending the raw material in bags to the warehouse to getting it on the runways at style shows.

*How do you envision the ranching industry twenty years from now?*

Ranching twenty years from now will be a lot different. I don't think a small family operation will be an option anymore. I think if you want to ranch you'll have to be into mass production. But I also think that, especially in beef, just having quantity isn't going to matter. With advancements in artificial insemination and embryo transfers, the quality of beef is increasing every day. You'll have to have quality as well as quantity.

It's a whole new world for ranchers right now. We have to learn how to produce a cheaper product yet have the quality, but we can't use chemicals and treatments that they use in Mexico and other countries.

The government, as well as the American citizens, don't seem to realize that wolves do kill baby lambs. When I was young, I found so many dead animals that had been killed by predators. And the bald eagles. Have they ever seen a bald eagle pick up a baby lamb and rip it to shreds? Have they ever seen a wolf slay a baby calf? One of the biggest problems for the future is predators.

I'm not opposed to trade with other countries. The negative aspect is that it isn't a level playing field, as far as predator control. We used to be able to use certain sprays, like herbicides on weeds and for lice control on mohair and wool, and we can't use

them anymore. Now we have to use more expensive things. Ivomec—it's very expensive here but not in Mexico. There are a lot of vaccines that we can't use here in the states that they still use in other countries.

We have to be very careful, but many other countries don't have any type of controls. We have the safest, cleanest product. Regarding foreign products, I think we should have more respect for Americans and the products they're getting. And you don't know the difference when you buy food at the grocery store.

## ANGORA GOATS

I love Angora goats. I was Miss Mohair, so you'd expect it. And it's not because of the way they smell or look! It's because they control brush. There is no other animal that will eat cedar like a goat.

*Throwing out hay*

When I went to college, the professors would tell me, "Goats don't eat cedar." I can talk and preach about this a lot. We have turned goats out on nothing but cedar brush—of course we supplemented them—but you could definitely see where they ate the trees. And that's what's so unique about the Angora goat.

I think there will always be a place for Angora goats. I'm not saying mohair is going to be the most profitable thing, but Angora goats will be valuable. Their niche in the environment is brush control.

But a lot of these people who have money come in and bulldoze the cedars. Well, that gets rid of it for a while, but it goes right back. You've got to run an animal, or keep cedar choppers out here, or keep bulldozing (the costs of that are so high, it's not economical). If you turn an Angora goat out year after year, they'll eat the baby cedars.

*How many goats can you run per acre out here?*

In the Hill Country, where there's brush, to one acre you could run about five goats year-round. That's in a really brushy area.

Goats don't do as well on rolling, grassy plains or in fields. In places where they're confined, there are a lot more parasites. But if they're out in the rocks and the brush they do amazingly better.

We lease a place in the Davis Mountains. It's all rock, catclaw, and cholla cactus, but those goats are fat and healthy.

I don't know if, when I'm forty years old, I'll be selling mohair. I wish I could have a good optimistic argument for mohair being around. But, realistically, mohair is a luxury fiber. Americans can live without mohair. But I don't know if Americans can live without meat.

On the other hand, I don't know if I can live without Angora goats. What would I use for brush control?

## STORMS

One time a storm came up and we had just sheared a bunch of goat kids. We had been concerned about the weather, but we couldn't see anything in the sky, we didn't see anything on the weather channel. A little past sundown, there was very little light and these big clouds started coming up. Here we were at 9:30 at night, in the pasture, Dad and his little goat kids (and little goat kids are stupid). There were probably three hundred to four hundred of them. And we had to get them in that night. But we did it, we walked them in.

When I was young we did that a lot. I remember Daddy and me riding and it was just pouring down rain. One day it was hail. That kind of hurts.

Once we were at this place, it was really storming bad, and lightning struck behind me. It struck so close to me I could see the sparks and smell it burn. Scared the tar out of me!

That's the biggest fear in Wyoming. Sometimes you're caught out in a storm—in the spring or early summer there's a lot of them. I saw for the first time in my life ball lightning. That was the most wicked thing! Those storms come so quick. They'll blow in fast and you'll be on horseback and you'll just have to find a little ditch to crawl into. Get down off your horse and hide for a couple of hours.

People tell the stories about the lightning dancing on the cattle—you hear old-timers talk about that. I've never seen it. I think that would be something to see.

We lost three horses in one spot to lightning. And we lost cattle. They say varmints won't eat animals struck by lightning. Those three horses were never touched. Not even by buzzards.

## THE ARMADILLO IN THE SWIMMING HOLE

46

[During a lunch break, Amanda's mom, Sharon, tells this story about her brother's three little girls from Pennsylvania and their visit to the Texas ranch.]

SHARON: We took them to Amanda Falls to go swimming.

AMANDA: An old man who lives up there always said he could hear the waterfall, and that it made a lot of noise like I did when I was a baby. So he named it Amanda Falls.

SHARON: The three little girls were in the water. Amanda was working on the campfire so we could roast some hotdogs.

The two dogs that went were Mandy's cowdog, Ben, and my little Neesa—they love armadillos. They found one close to Amanda Falls and Ben got a hold of it and was shaking it. The armadillo was hurt and confused and it took off, straight for the water.

Talk about those girls being sissies! I screeched because it landed right in the water and looked like it went right between their legs.

The armadillo wanted to swim, but it sank. Mandy took off her clothes—she had her swimsuit on—and jumped in the water. She was looking for it, there was mud all over her face, and air bubbles started coming up. She found that armadillo and grabbed it, tossed it out, and played with it a little bit. Then it took off.

AMANDA: Those kids just thought they were going to die. You couldn't see the armadillo, you'd just *feel* it.

*Would it have drowned if you hadn't saved it?*

SHARON: Well, armadillos can swim a little and they can walk along the bottom, but I don't think it realized how big a pool of water it was in.

AMANDA: Armadillos are a novelty to people who aren't from Texas. That armadillo was still pretty stunned and my uncle held him up beside him for a picture.

You can picture that poor armadillo crawling in his hole and saying to his wife, "I had a hell of a day."

## FEMINISM

I'm not a feminist by any means. In fact, I usually don't talk about the issue because preaching feminism is counterproductive. I'd rather just go out there and work and be accepted instead of going on some kind of rampage. Action is better than words.

It is a little difficult. I expect to be treated with respect. I can hold my own in most situations. I'm never going to be able to load a gooseneck trailer with hay as fast as anyone else, I may not be strong enough to, but there are some qualities that I have, like conditioning calves. Women tend to be a little more passionate and a little more meticulous. So, I'm better at that than some men would be.

I expect to be treated with respect and I do them as well. I love to be treated cordially, having doors opened for me, being treated like a lady. And I don't mind walking into the house and cooking a meal at night. I don't have a problem with still acting like a woman.

Sometimes we're in a man's world. But it's those times, like if I'm out there working the headgate as many hours as they are, and then expected to go in and make refreshments—*that's* a little bothersome.

I grew up working with my father and brother. I grew up working in the pens with men. I've never been told I couldn't do it. No one has ever belittled my abilities or has ever treated me unequal.

*What about being respected by other ranchers?*

For the most part, I have been. I've had a good response from people leasing land. They have been elderly gentlemen, and they feel comfortable that I'll make good decisions with their land through proper grazing and so forth. There are still those old German men and some others who still think a woman's only place is in the kitchen.

47

## BARBIES?

*When you were growing up, did you ever have negative feelings about ranch work? Did you think, "I want to go next door and play Barbies?"*

I hated dolls! So I never wanted to go play with Barbies. And I thought everybody with dolls was stupid.

I don't remember having any negative feelings about ranching. The only thing that was real different from the other kids was when I got off basketball practice, or before I went to practice, I had to come home and do my chores. Before I could go out on Saturday night, I had to finish my chores here. That meant sometimes I wouldn't leave the house until ten o'clock. The good thing about that was I had a girlfriend who grew up on a ranch and she couldn't leave until ten either.

I've always been real content. Not with all of life, necessarily, but content with living on the ranch.

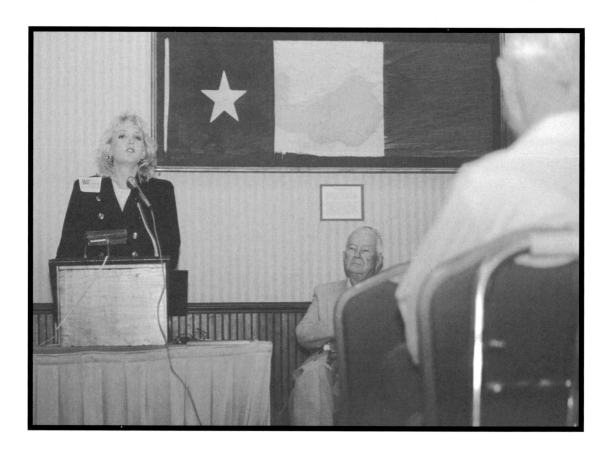

*Giving a speech about private property rights*

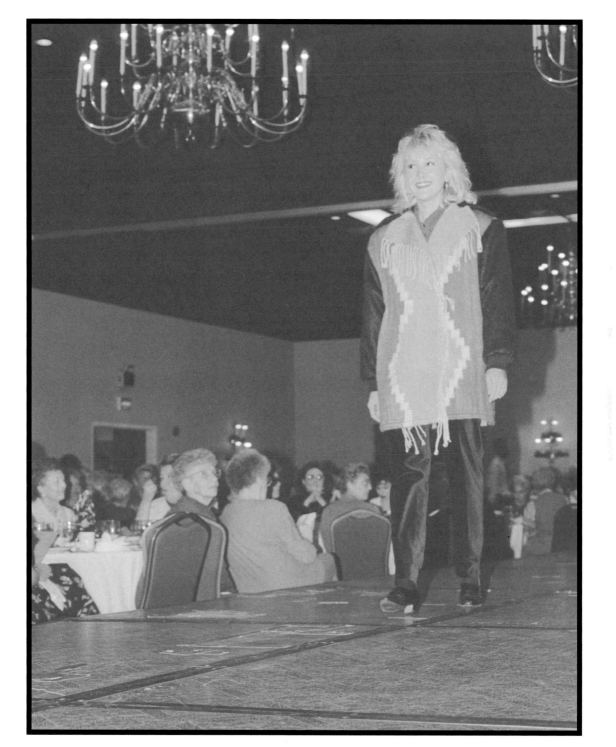

*Modeling for the Hill Country Cattle Women's luncheon*

*How old were you when you decided to ranch?*

When I was growing up, I knew I loved it. I never had a hobby other than working my livestock and my horses. So I grew up enjoying it. I knew in high school that's what I wanted to do, and that's what I got my degree in. My lifelong dream is to someday add on to the family ranch. But I've always wondered where I'll be in between point A and point B.

*What if something happened and you couldn't ranch?*

I guess what I'd do . . . I'd probably go . . . what would I do? Maybe I'd become a speechwriter or work on a campaign. If I had a way to go to work for some agricultural company I would. But I've never *really* thought of doing anything else. I guess I was real lucky when I graduated to have the option to come back to a family ranch.

*What if you marry a man who's not into ranching?*

Well, it would be really hard. They say that true love will take you anywhere. But I can't imagine any love being greater than my love for the land and the livestock. I don't have a problem with the man I marry one day having a job completely different, as long as he respects my decision to enjoy what I enjoy. I have a deep-rooted, vested interest in the family operation. I'll never leave.

It's hard to find young men who aren't, I don't know the right word . . . intimidated. They'll ask me what I do and I say, "Ranching." And they kind of look at me.

## POSTSCRIPT

Amanda was married in 1997 to Shaun Geistweidt. He was a rancher, too, and they pooled their livestock and started growing their herds.

They moved to the outskirts of Fredericksburg, where Shawn's family owns the auction barn. By 2004 they had two small children: Wyatt and Faith. Amanda was ranching full time, taking Wyatt with her on the four-wheeler or in the pickup truck.

"At three, Wyatt understands a lot about livestock and can help," Amanda said. Faith, at two, "thinks she can ride any horse."

"They're a true joy to my life," Amanda said.

She said her goal was to own a large ranch, and that she and Shaun spent every day working toward that.

They had a diverse ranching lineup that included Angora goats, a cow/calf operation, a stocker/backrounding operation, and a show sheep and show lamb program.

*Backrounding* means taking young, lightweight cattle and "straightening them out," or putting weight on them. They might start at three hundred pounds, and you take them to eight hundred. Not many people want to work with little cattle, so that's a special niche, Amanda said. She learned how to do the labor-intensive work from her dad, and it's something big cattle companies don't do.

Amanda was the only rancher I interviewed who was still raising Angora goats by 2004. She said the price of mohair was giving a worthwhile return at that time. Still, with three hundred nannies, only fifty kids had survived that year. She and Shaun did not take in the goats, but left them out with two Akbash dogs. "They were making the operation work," she said. But then the dogs were killed, and predators—coyotes, black ravens, and foxes—killed the kids, Amanda said. "It's a question how much longer we can do it," she admitted.

Amanda said she knew of a handful of young people ranching full time, including her brother. "Most young ranchers are second-job ranchers or hobbyists," she said.

A few big meat packers control the cattle industry, according to Amanda. If the board decides to lower the price of beef by 5¢, she could lose $10,000 to $20,000 in a day.

Amanda pointed out the labor problem, too. "Ranching is a dying industry," she said. "So much of what we love is disappearing before our eyes."

Still, she hopes to carry on. "My husband and I have an undying passion to ranch and live that kind of lifestyle," she said.

Amanda was still ranching in 2010.

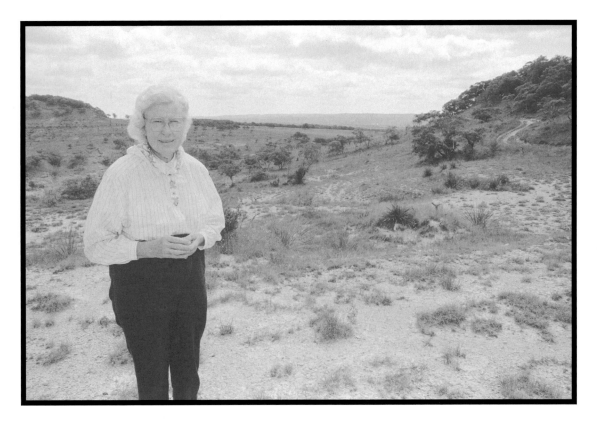

*Dot Foster Miller*

# Dot Foster Miller

*with daughter, Lemae Higgs*

**BLANCO, TEXAS**

~~~~~~~~~~~~~~~~

**B. JUNE 23, 1921**

### THE ROAN DURHAM

My grandfather, James Melville Foster, when he was only sixteen went off to the Civil War with his oldest brother, Samuel Henry. He lied about his age in order to get in. They were already living in Texas at that time, so they had to find the Confederate Army. In Kentucky they spent the night with a rancher who had roan Durham cattle. They had never seen roan Durham cattle in their lives and thought they were so pretty.

The rancher said, "I'll tell you what, boys. You're going off to fight in the war for me. If you survive it and come back through here, I'm going to give you a roan Durham bull to take back with you."

Well, they both went through the war and came back by. He gave them a roan Durham bull. They put it on the train from Kentucky to Texas.

The Foster descendants always have a roan. That first one was red. That cow you're looking at is crossed with a black Angus, that's why she's a black roan. We always keep descendants of that first roan Durham with our other cattle.

### FAMILY HISTORY

We were South Texas ranchers. I was born on a ranch in Jim Wells County. The doctors usually never got there, so Mother had ten children without a doctor's aid. My twin and I were the last of the ten.

I'm Dot Zella and my twin was Dimple Zarah. Mother, when she was a girl, played dolls with two other girls: one of them was Dot Wilkerson, the other was Dimple Peck. One day she said to them, "If I ever grow up and marry and have twin girls, I'm going to name them for you all."

So when we were born she said, "That's it. They're going to be Dot and Dimple."
We were born on a ranch, raised on a ranch.

We did everything by hand. We had no such thing as a tractor. The first few years
of my life we didn't even have a vehicle such as a farm truck.

All of us children had work to do. My twin sister and I had to gather chip for the
cook stove. We didn't have electricity. We didn't have running water. We had no in-
door toilet. We had no screens. First screens we had, I was sixteen years old.

A lot of places, like Europe, don't have screens. There are not very many in the
Orient either. They are just in America, because of our fly and mosquito situations.

Anyway, we had to gather chips, gather the eggs, feed the chickens, things like that.

One evening my twin and I decided we wouldn't gather chips. It was late fall or
early winter. At four o'clock the next morning, Mother just rolled us out of bed and
said, "I don't have any chips to start the fire. Would y'all mind going out and getting
them?" She handed us the lantern and it was cold, I remember that. We never forgot
to get the chips again. She didn't fuss at us. She just said, "I have to start the fire."

We usually ate breakfast by five o'clock every morning. The older children had all
the goats and the sheep and the milk cows and the cattle and calves to tend to before

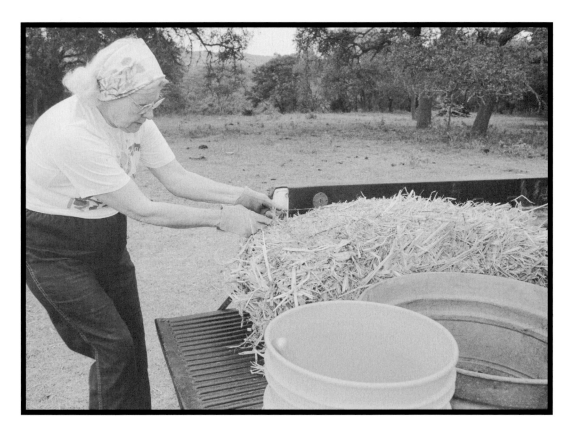

*Unloading hay*

we walked to school. Then we'd run home in the afternoons. They were the ones who did most of the work. I think my twin sister and I were petted and spoiled. We didn't work nearly so hard as our older brothers and sisters.

*When they were older and moved away, did you have to take on more work?*

None of us married until 1941. I married youngest in my family. I was twenty-six. So we were all more or less at home until World War II. That is what broke up our home situation.

World War II was a hard time for everybody because all the young, stout men were gone. We worked doubly and triply hard to keep things going. All four of my brothers didn't wait to be drafted—they volunteered. And that left my oldest sister, my parents and my twin sister and me with the ranches to run. We had three ranches in South Texas.

My oldest sister and I alternately ranched and taught school. My twin didn't teach. She stayed on one of the ranches. For a while she even ran our brother's dairy and milked by hand. We got a Mexican worker to help her, but I don't know how she did it. She milked around thirty head of cattle morning and night.

I stayed with her and taught at Palito Blanco, the first place I taught. I graduated in August of '42 on a Friday night and went to teaching on Monday: no time between.

But everybody was called on to do things then. We learned during that period of World War II how to take a tire off and mend it. We learned to run farm equipment. We had always known how to tend to cattle—I don't even remember when I learned to ride a horse.

But we had all of the herds of cattle on the different ranches that we tended to. Daddy was in very frail health at that time. Mother was in good health.

He and even Mother rode horses back then. And the cattle were wild. They weren't like they are now: I shake a feed bucket and they run over me! In pre–World War II days, they'd see you come out and that's the last you ever saw of the cattle. They were very wild. We had to chase them down horseback and run them in.

Mother hadn't been on a horse in years, but she went back to riding horses. Daddy sort of lived until all the boys got back. I think he just willed himself to live, because he died shortly after their return.

*So, all your brothers made it home from the war?*

Yes, thank God, they all came home to live a good life (there's only one living now). They all went to ranching. They had never really been away from home until World War II. That war changed the entire world. Things never returned back to their normal pre–World War II situation. Never did. That was it.

55

## HORSES AND BRANDS

*Was there a particular horse you rode when you were growing up?*

Yes, we had old "Pet." She lived to be twenty-one years old. She had her first colt when she was nineteen years old and we named it Will Rogers. She was the sweetest old thing. She'd lie down and we kids would get on her. If too many of us got on her she'd lie down and not get up. She couldn't have been sweeter.

*Did you ride very much?*

Yes, we had to. The cattle were wild.

Daddy had a mixed Brahman, just a mixed breed of cattle. You could tell his. You'd just have to see . . . pre–World War II cattle were an odd-looking bunch of animals. They were crossed on the longhorns, so they had the long, slim bodies. They didn't look like the cattle now.

All of the ranchers knew each other's cattle just from the looks of them. It was interesting. (I love Hereford cattle, usually a Hereford cross, with the white face.)

Daddy's brand was the LX and mine is the MX. He was a famous South Texas rancher. His closest friend was Adolph Meuse. I don't remember what Mr. Meuse's brand was, but Daddy's was well known in Jim Wells and Duval counties. You register your brands and they are yours, just like a trademark is yours.

I kept his earmark—*dos moches*, the Mexicans called it—both ears cropped on the end. That was our registered earmark and I have it. But my brother came to Blanco County before I did. He lives over east of Johnson City. He asked mother if he could use the LX brand, so he has it in Blanco County. Since my name's Miller, I just said, "Okay, M is a Roman numeral," and I made mine MX.

*Why did your dad use LX?*

The LX was just a brand Daddy picked out, the Roman numeral for sixty. Before that, he had his mother's initials, CF, for Cinderella Foster. Why he picked the LX brand I don't really know.

His cows that he called his "missionary cows" he branded with a CF. He sold those cows and gave the money to independent missionaries in Mexico or anywhere in the world. He supported one missionary for about 15 years with those cattle. Giushotte was an Italian who learned Spanish and went as a missionary to Mexico. He had been a Catholic priest for twelve years and then was converted to Protestantism. He went to Mexico and converted people, not necessarily Catholic people, but people who maybe had no church affiliation, to Protestantism.

*When you were growing up, your family had sheep and cattle?*

And goats—Spanish goats. Daddy had about 500 head of sheep and about 200 head of goats, plus all of his cattle.

## DROUGHTS

*Do you remember particular drought periods?*

The worst was the '50s drought.

But in South Texas, drought was a fact of life.

I can remember the pre-Depression drought. That's really what brought the Great Depression. One afternoon we had walked home from school (we walked four miles to school in Palito Blanco). Of course, we were hot and thirsty. It had been terribly hot and dry, maybe September or May. Daddy's sheep were coming up to get water at the water trough. The clouds of dust would hang in the air—it was the most unbelievable thing you saw in your life.

I saw the sheep coming from the southeast and the wind was blowing. I went on, kidlike, I never thought. I got caught in the wind dust from those sheep kicking up the dirt with their feet and I almost suffocated. I had to run because I had to get out of that. But I almost suffocated and I'll never forget that.

The drought years were just incredible.

*Did y'all lose livestock?*

No. Daddy was a pretty good rancher. He'd rather sell for nothing.

We went through a period when the U.S. government would come out to the ranches and say, "We'll shoot your cows and give you three dollars, or whatever it was, a cow." And Daddy said, "I raised these cattle without the government's aid and I think you better not shoot one of them." And he had his gun. The guy left, saying, "We're just doing it to help you out." And Daddy said, "I don't need help. I know how to run my business." So that government agent left.

But they came out and shot cows on other places. Then they wouldn't let starving people go out and skin those animals and eat the meat. They would shoot anybody who would try. That's how crazy it was.

*Why?*

Why? Why *does* our government do things that they do? It's sad. It really is.

Anyway, they didn't shoot any of *Daddy's* cattle.

The other big hassle we had with the government was a good one. See, the government doesn't do everything bad. They went through a dipping program because of the fever tick. If a fever tick bit a grown cow, the cow would die—there was no comeback.

The federal government decided to get rid of the fever tick. They mandated that everybody dip their cattle. They had ranchers dig down into the earth and dig a dipping vat and then fill it with water. The government agents would measure the amount of arsenic (that's what you dipped them in). Arsenic dip was black-looking stuff and smelled to high heaven!

Then you had to jump your cattle off in there. They had to fall in and be completely immersed. If an animal sucked any of that into their lungs, they died.

I was a co-teacher with a man whose dad was standing by the side of the dipping vat. A cow jumped on him and he went under with the cow and he died. The little boy was raised an orphan. He lived in Palito Blanco until he died.

But the dipping was a good thing. You had to dip or you were in trouble with the government—they forced people. And they did get rid of the fever tick. The federal government didn't do all things wrong.

But I thought that shooting the animals and then not letting anyone harvest the meat off of them, when people were starving to death, was unbelievable.

58

## QUILTING

My mother, in her late sixties and seventies, could work us to death. There wasn't anything she wouldn't do.

She made all of our bedding. I'm talking mattresses. She made all of our quilts. My oldest sister would card wool bats, little four-by-eight-inch wool bats. You buy cotton batting in rolls now. My twin and I had to clean the wool up by picking all the grass burs out of the raw, oily wool. Next, Mother would wash it until she got all of the oil out and would then hang it out to dry. Then my sister carded the wool into the bats and Mother would quilt. She had her quilting frames hung up in the ceiling at night because it was in the bedroom where we slept. She would quilt in the daytime and then put that frame up in the ceiling again.

*Did she make your clothes too?*

Yes, and my sister did. I learned to sew in later years.

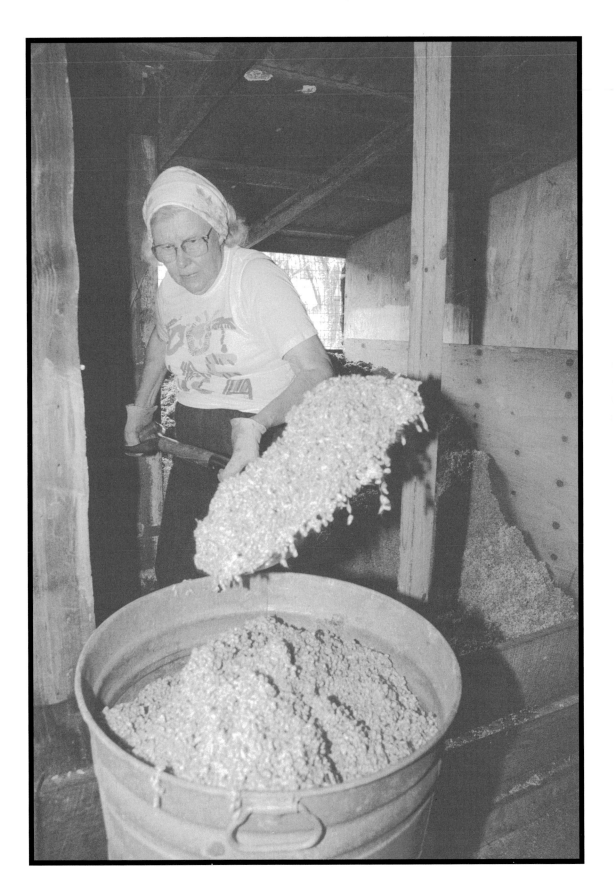

Shoveling cottonseed for the cattle

## BELLOWING RICE

My twin was an excellent cook; my mother, of course; and my oldest sister was a good cook. But she was mostly doing other work she was needed for.

My twin became a real good cook very early. When she was about twelve years old she began cooking the meals. Mother said, "You two are going to have to learn how to do the house and the cooking." That was our assignment. I didn't like to cook and Dimple just despised cleaning house. So we swapped out. I did all of the house-work and she did all of the cooking.

Well, Mother was too busy to check to see that one of us wasn't learning how to be a housekeeper and the other one wasn't learning how to be a cook!

When I had been away at school two years and two summers straight without coming home, one of my brothers said, "How about coming to the cow camp this summer? I need a housekeeper and a cook." The cow camp was a little one-room, shotgun-type building with a dirt floor and a fireplace. It had no cookstove. I said, "I believe I will." He said, "You've been in school long enough. You need to come."

So, I got my clothes and went. Next day he said, "I'm going to go out and burn pear and ride the cattle. I'll be in pretty near the noon hour, so you'll have to cook dinner." He put a bunch of wood on the huge fireplace and he said, "There it is." And there were the iron cookpots.

I didn't know how to cook. I put rice on and beans on and I knew how to scrape the coals under those big old iron pots and put coals on the lid. And that I did, and then went off to read a novel.

He stepped in about the noon hour and said, "The rice is bellowing!"

I never will forget that! He rushed to the fireplace and took those big old lids off (you had to use an iron poker to lift them off, they had coals of fire on the top of them). It was just burned up. I hadn't been back to look at it.

He grabbed the beans and they were burned. And I can see him today. He chewed tobacco. (You know how these old cowboys, there's always a streak of tobacco running down their faces.) He spat into the fireplace, looked me in the eye, squinted his eye and said, "I don't think you know how to cook."

So I told him what had gone on. He said, "Don't worry, I'm going teach you. And I'm also going to teach you enough Spanish so you can get into college this fall."

That was all I lacked. I'd just had two years of high school, both summers and winters. He knew how to talk Spanish fluently. He took a little Spanish grammar book and every day at the noon hour he'd sit down and discuss the verbs with me. He was so even-dispositioned, he didn't get mad. And I took the entrance exam in all the subjects. I passed the Spanish and all the rest of them and got into college. That was Jim, the second oldest. He was my favorite.

60

## THE PETRAFROST

*How did your family preserve food? Did you have a smokehouse?*

Yes, a smokehouse for meat. Mother made all the bacon we had and all the jerky. Of course we all worked together. But after it was butchered and cut up, Mother was the one who cured all the ham and bacon. She made sausage patties and cooked them and put them in a huge crock and poured hot pork grease over them. That was our pork sausage. By the time summer came, it would get rancid. But you learned to eat what you had.

Every time Daddy would butcher, he would cut up the meat and go into the village, Palito Blanco. He gave every family a little meat. That was the custom. You shared your fresh meat with your neighbors.

The first refrigerators we had were the old kerosene-powered Petrafrosts that Sears put out. But they could catch on fire. We had two of them blow up—almost got the ranch houses. Daddy built a concrete porch just to put them on.

## TRIPS TO THE COAST

*How did your family travel while you were growing up?*

We had a wagon. Really, we just didn't go anywhere. I'd say Daddy had a car by the time I was five. I don't ever remember going anywhere in a buggy, although we had a buggy. We had a wagon. Everybody did.

One of the things I remember was when Daddy's Aunt Stella died. I remember that funeral—going in the car. Of course, all cars were black so far as I remember. We were at first afraid of mechanical, moving vehicles. We just weren't brought up in that era. We had to get used to them.

My father took us in a car once a year to Corpus Christi to see Ringling Bros. and Barnum & Bailey circus, and then to swim in the Gulf. Corpus Christi didn't look anything like it does now. But I still love to go down there and just sit and feel that salty sea breeze and think about the good times that we had.

## LOVE STORY

*How did you meet your husband?*

I'd ridden a bus home from college. When we arrived at the bus station the driver said, "Let me get the others unloaded and I'll take you home." I didn't say anything more to him. He was talking to passengers and giving them their suitcases and I

*Baking cookies for inmates at the jail*

saw mine, jumped out, grabbed it out of the bus carrier and went running down the street. When he looked around I was gone. It took him about two months to find me. He didn't know who I was or anything about me. But I wasn't going to let him take me home; I didn't know who he was.

*How many children did you have?*

[Dot gestures toward her daughter, Lemae, who has joined us.] There she is. I didn't want ten!

*How long have you lived at this ranch?*

Since about 1947. I came up and lived with mother and taught in Blanco one year. Then I moved to Arkansas with my husband. We ranched up there for eight years. I didn't try to teach then.

In 1961 I moved back here and started teaching. I taught until I quit to nurse my husband. He had cancer. I nursed him until he died. So I've been here since 1961.

## RANCHING

64

*Did you always want to be involved in ranching?*

Yes, ranching I love. But I realized pretty early that if I could get an education, I would rather do something besides ranching because I could make more money. After World War II the ranching business never reached the status it had before. I think the Great Depression started breaking all that up.

And I wanted an education. But I still have the deep love for ranching.

I'm a teacher by profession. Of course, I'm retired. I taught twenty-one years. Mainly, I was a junior and senior high school English teacher. But I always lived on ranches. Here in Blanco I taught seventeen years. I taught in Freer, Texas, four years and before that in Palito Blanco. I taught in Wilson Elementary School in McAllen, Texas, and I taught one night class of veterans from five 'til ten o'clock at night in what is now called GED.

My dad bought this ranch in 1945, then passed away in '46. In 1950 Mother divided up the property. She let us pick, and I was to pick last because I was the youngest. I kept praying, "Lord, don't let them take Blanco." And none of my older brothers and sisters wanted Blanco. They picked the ranches in South Texas, in Jim Wells and Duval counties.

I think it's interesting I'm living in Blanco, Texas. I went from Palito Blanco to Blanco.

Blanco isn't really cattle country—it's only marginal cattle country. But it's so beautiful and a much more pleasant place to live, climate-wise. I've never lived under air conditioning. I've just lived with my fans. These ceiling fans are a recent innovation.

*Your ranch is beautiful.*

Well, I never have time to stand out and admire it. Isn't that the funny thing?

The ranch I loved most was the one I had in southwestern Arkansas, down below Hot Springs. It had the prettiest mountain on the south and the top of that mountain would be wrapped in mist. Just beautiful. I really loved it there.

But we just lived there eight years. Ranching in Arkansas is a loser's proposition. And we had this place. We had to come back.

*What do you like most about your ranch?*

I love the privacy, the elbow room. And just having animals. I love animals—always have. Like I love teenage kids. I don't particularly get along with young children, but teenagers I always thoroughly enjoyed teaching.

You look yonder and that's Red McComb's place. He's got a two- or three-story house he's built. And all of this other's been subdivided. People out of San Antonio buy ten or fifteen acres. My ranch is 1,100 or 1,200 acres, intact. Everybody around me, with the exception of the Webers, has sold. And now she's dividing up with her children; at least it's staying in the family.

## WATER

I have one eternal spring. It never has gone dry, not even in the '50s drought. I have it boxed up and it provides all the water for our houses and the water troughs on this part of the ranch.

In the past I drilled water wells. They'd cave in or they would get an oil residue on them. Evidently, there's shallow oil in this country—it will kill your cattle.

So I lost all of my water wells except this one in the back pasture. We had a windmill, but discontinued the well because there's no electricity out here. Maybe someday they'll bring electricity across. The well is extremely deep—387 feet—and still not drinkable for humans. The water is full of iron rust, ferrous oxide. But cattle can drink it. At one time this rock tank was a water holding tank.

We've got another little water well by Lemae's house and it's just total iron rust. It turns everything red. It ruins everything.

LEMAE: When my grandparents were here, there were a lot of cisterns. They used rainwater collected off the roofs.

DOT: They used it to make coffee and to cook.

We've got two big watering tanks here in the back part of the ranch that have the springs in them. And of course they catch the runoff from these hill slopes, so we've got good watering facilities without having to have a windmill or an electric well.

There is a waterfall; it's so pretty when it rains. The big falls are further down towards the end of the ranch.

66

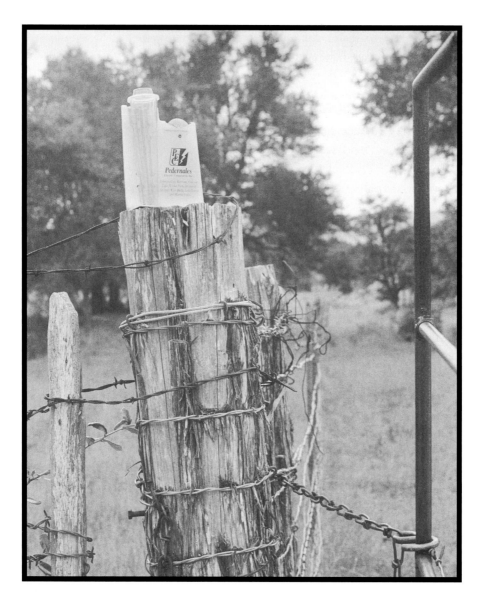

*Altar of the rain gauge*

And that green out there is oats we planted for our goats and sheep. But it's just been standing there. It should be triple the height it is. If we get rain now, we still would have some awfully good winter grazing. But I don't know whether it's going to rain or not.

It's an all-important part of the ranch, how much rain you get.

## RANCH DUTIES

*Tell me about your ranching activities now.*

LEMAE: She does everything!

DOT: I just keep enough cattle and livestock to keep me alert and interested. I don't want to sit down and do nothing.

In the fall and winter we plant a combination of oats and wheat and rye, although a bad-enough freeze will kill the oats. I just drilled in oats and wheat. While we were doing the oats we went out and hand-sowed vetch and clover. And we're reseeding rye. You can just throw it out and if it rains it will come up.

I put vetch in all of the orchards and I put clover in the brush piles and, of course, the rye grass in the yard. As soon as it rains it will come up and the yard will be green.

In the springtime we plant sorghum—a Sudan variety, like red top cane—for the deer. Cattle will survive on the same range that the deer will starve to death on. They need more protein than the cow does. We'll go look at the deer patch and see if it's ready to plant today.

There's a baby fawn. They're going to start dying if we don't get rain. I've got some corn here so I'll put some out. They're really suffering right now. Poor little fella'.

Lemae and I and the old Mexican that comes up occasionally from Mexico have to hand-catch and castrate and vaccinate calves. We castrate the male calves real young, make steers out of them. If they're older, it's hard to catch them and hold them down. We earmark them and vaccinate them with seven-way vaccine, which we use mainly for the blackleg that's in it because you lose them so easily from blackleg. You vaccinate them real young and when they reach four months of age you vaccinate them again. We do all that usually in a day, in springtime. I have my calf crop in February, so I guess the first of March we castrate and vaccinate. Then in June we do the second vaccination.

We haven't branded any of our cattle in years, but if you're keeping a cow, you eventually have to. You dehorn her to keep her from fighting the others, and brand her. To dehorn them we try to pick cooler weather. Then we keep the cow around and watch her to see if everything goes all right.

67

In the wintertime when we don't have sufficient grazing (and we rarely do) we feed a bale of hay to five cows every day. We feed cottonseed every other day, and if it comes a freeze or a cold rain we feed them daily. We put it in those long troughs. They love the cottonseed.

I go to Lockhart Gin and pick up whole cottonseed. Cattle get the oil and the bulk, the whole thing, when you feed the whole cottonseed. But it's a lot of trouble. You have to shovel it up into the feed troughs.

I keep out salt all the time and free choice mineral. In a dry summer like the last one, they eat that mineral till you think you're going broke buying it. And salt! They eat twice as much mineral and salt in a drought time than they do in a good wet time.

So, we vaccinate and feed. When I'm gone, Lemae feeds. I put up hay every year. We usually get one hay crop in and that way we've got our own hay to feed our cattle.

*Do you have sheep, too?*

And goats.

*Angora or Spanish?*

In times past I raised Angora goats, but everybody's going out of the business because the government isn't going to subsidize it anymore. I've just got four or five head of Spanish goats. We like the meat. I used to have a lot more, but we've cut down. They destroy your vegetation if you get too many.

What I raise commercially are cattle. And I lease most of my ranch to one of my former students, James Blackburn, who runs cattle.

I have a milk cow, so I don't have to buy milk at all if I don't want to. I milk my cow and James Blackburn milks her occasionally. He'll milk a gallon and that does his family a week. I just milk a quart or a half-gallon. If I get too much ahead I'll pass it on to the grandkids. They like it. My daughter's allergic to cows' milk, so she milks goats.

*And you raise a garden?*

Yes. We had corn, tomatoes, okra, and squash (I don't know how many varieties of squash) and peppers galore.

And we plant flowers in the garden—zinnias. A lady who's dead now gave me the seeds. She had the prettiest ones. I had put the seeds up and didn't find them the first year. This summer I found them and planted them.

I also have pecans, peaches, and apples.

*You seem very self-sufficient.*

LEMAE: You have to be in the country. And there are a lot of wild grapes, so we put up grape jelly. And dewberries, blackberries. In the creeks there are native walnuts, pecans, mulberries, and cherry.

DOT: They're very rare. And wild plums. I've got one growing by the side of my house and I have to spray it every spring or the bugs sting the flowers in bloom and then you don't get any plums. I put them up too, you know, make jelly out of them.

*What else do you put up?*

Peaches, dewberries, corn, tomatoes, okra. I haven't picked dewberries in two years, now, though. And the blackberries, we missed them this year, if they made.

LEMAE: They hardly made. I went down and picked but it was so hot and dry that they were stunted. Right when they needed the rain we just didn't get any.

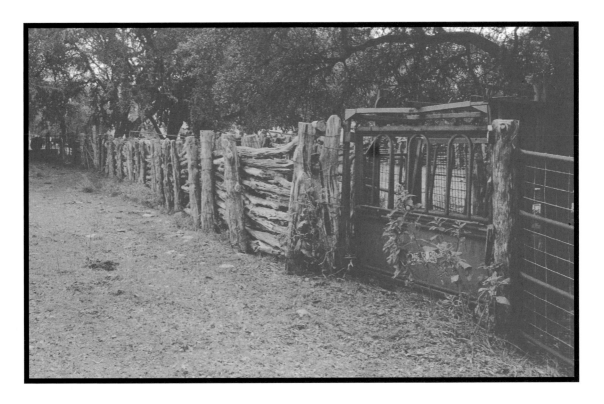

*A classic Hill Country cedar fence*

*Agarita*

## AGARITA

Let me tell you about the agarita. It's a member of the holly family. In the spring they have the most beautiful, bright-yellow flowers.

I eat the young leaves in the spring when they first come out. I snap them off before they get the thorns on them. They are just delicious. They're sharp, like a sour citrus fruit. And they are an excellent source of vitamin C.

Later on the fruit turns a kind of an orangey-red, and finally, a fiery red. And oh, the berries are good!

*You eat them right off the bush? Do you wash them?*

Oh no. I just eat them. They're nature's own, they can't be too dirty.

*Whatever you do must be good because you seem so healthy and strong.*

Well, I'm feeling my age, don't worry.

If you want to harvest the berries off the agarita bush for jelly, you put a sheet or a tarp down under it and take sticks and beat the bush, because it's so thorny. Then you winnow the leaves out. That leaves the berries.

Then you wash them to get all the spiders and little bugs out of them. Then process them and keep the juice and they have a very strong, lovely jelly flavor.

The Mexicans, from time immemorial, and the Indians, knew about agarita. The root of the agarita is a beautiful yellow color. You can boil it (use distilled water, of course) and make the best eye drops in the country. Murine is made from the root of the agarita bush.

*Tell me about winnowing.*

When there's a wind blowing, you stand up on a chair and pour the berries out so that the wind will blow the leaves to the side. The berries will fall straight down.

I watched people winnowing their corn and stuff over in Southeast Asia this summer. They've gotten modern. They take a floor fan and make their wind. But they winnow their stuff by the same old method. They stand up on chairs with willow baskets.

*Then you boil the berries and strain them?*

That's right. You have to strain all that seed; they're very seedy. Then you just follow your directions on your Sure-Jell: so much sugar, so much pulp juice, and so much Sure-Jell. And then you make your jelly. It's delicious.

71

*What does it taste like?*

Agarita! Very tart, very sour. But I love it!

## HUNTING

*Is hunting a big part of your operation?*

Yes. Hunting is the big money crop in the Hill Country now.
We have a hunters' lodge: a trailer. Last year and this year we have new hunters. We provide them with a place to stay. They really like it. But they're so busy working, like all of us. They don't get out here much.

We lease it to them year-round. They try to come out on weekends in the summer. They'll build a campfire and sit around it and talk.

LEMAE: They like to ride bicycles, too.

*Do they just hunt white-tailed deer?*

DOT: That's it. We have squirrels but they have never gotten plentiful since the '50s drought. We've got lots of red fox and gray fox that are getting to be a menace to all the little animals like the rabbits and the squirrels. There's always something that you have to worry about getting an overpopulation of.

*Are there any wild hogs here?*

No. There have been some come in, but we've shot them all. We didn't want them. They tear up your fences and the deer feeders.

We've got some Barbados bucks that we plan to let the hunters shoot this fall. They have those big beautiful horns. You have to keep one five years before he grows horns big enough to be a trophy. And they make good eating.

Here are some of the Barbados. This female is a half-breed. We raised her on the bottle and she's the sweetest thing. She's shedding her wool. Wool sheep rams like the Barbados ewes and the Barbados bucks love the wool sheep ewes. It's really hard to keep them separated.

## GRASS

[Dot points out grasses in the back pasture.] This is little bluestem and big bluestem growing along here. It's got the tufts and is a wonderful cow feed.

There never was much bluestem in the goat trap. It's always had Indian grass and the other native grasses, like grama.

See those little seed heads? They call that sideoats.

I knew the South Texas grasses pretty well. But I never went out for studying the Hill Country grasses like some of the ranchers here do.

*Do you have a problem with bitterweed?*

Yes, you can see it out here. We're having to do a bunch of weed control and it's so expensive. And we've started killing this ragweed—the funny-looking yellowish plant with the yellow top—that's taking the country. We tried the goat trap first and the spray worked. We'll have to spray all of this next spring and stamp it out and let our other grasses grow. Ragweed would ruin the land. It covers the native grass, blocking the sunlight.

*Feeding sheep*

*Did you learn about the spray from the agricultural extension agency?*

Yes. I took the applicator's renewal license. We have to go to 15 hours of school. They tell you all of the laws and regs and all of the types of sprays that are out and how to use them. I had to take one class in Johnson City, one in Taylor, and the last one over east of Austin.

## TREES

We systematically chop cedar, juniper as they call it, because it ruins your land. It is the worse thing you can have.

The cleared land you see is all mine. We cleared the cedar every three or four years. But in 1966 this back pasture, all of it, caught on fire and it burned all of the cedar off. That's why it's as green as it is.

That was one of the worst fires you ever saw. All of the fire departments and the ranchers came out and fought it for three days. A lot of them wouldn't go home at night. It came to this road and never jumped the road. That's all that saved the ranch. But it burned at least 400 acres. It was really an inferno.

I rang the bell at my house to call for help.

LEMAE: The neighbors said, "That bell's ringing, something's wrong!" And they all came.

DOT: They wouldn't hear it these days. The TV has caused people to not listen.

LEMAE [pointing out neighboring property]: That's a good place to show the problem with cedar. You see, they haven't cleared their cedar and you see they have nothing but rocks and bare hillsides. Compare it to the grass and soil we have on this side.

DOT: And the deer and the birds carry the seeds over. You can see little cedar growing here. So in a couple of years we'll have to have it all chopped off again.

*Tell me about these brush piles.*

They used to be a lot bigger but they're rotting gradually. They provide shelter for the quail. Then they go back to soil again and replenish it.

LEMAE [pointing skyward]: There's a lovely red-tailed hawk. We see a lot of eagles and hawks in this back pasture.

*How do you feel about the eagles? Some ranchers aren't very fond of them.*

DOT: If you have a bunch of goats and sheep, eagles will kill the babies. But the buzzards! If a cow gets down and can't have her calf right away, the buzzards will come up and peck the calf when it's being born. They'll start in on that calf and kill it and eat its tongue and eyes. Then they'll eat the mother's rear end down because she can't fight them. They're awful!

*Do you have wild turkeys here?*

LEMAE: Yes, but the fire ants are giving us such grief. There are few quail now. We used to have a lot of quail. And you don't see snakes any more. The only positive thing is that there are no ticks on the cattle. We don't have to spray for ticks any-more—fire ants eat them.

DOT: They eat anything.

LEMAE: They eat all your ground-nesting birds. We left one of our little hens down that was nesting and she got eaten.

DOT: They'll eat the mother hen. The legs and the whole deal. They're really a threat.

*Have you seen fire ants' effects on your fawns?*

DOT: I picked up a fawn that was eaten up. I tried to save it, but it didn't live. It was too badly bitten.

*What kinds of trees do you have here?*

This is Spanish oak and it doesn't last very long. It sheds its leaves in the winter and it's very brittle wood. It's affected by the oak decline.

There's post oak.

We've got the naked Indian tree—the madrone.

And crabapples. You'll have to come back and get pictures of the little crabapples when they're in bloom in the early spring. We put a fence up to protect them. They're very rare, very delicate.

LEMAE: They just don't seem to be reseeding. They're studying them at the universities to try to figure out a way to reseed them. You'll plant the seeds and they'll grow up to be about three feet tall and then die.

DOT: They're such a rarity. The madrone are beautiful too. They're such a unique tree. I know where some of them are, but we can't get there by truck.

75

We have some hackberry trees and a few willows. After you farm fields, if you let them go fallow the willows take over and are really rough on your land.

Of course, we have the live oak. But with the oak decline we're going to be a prairie before long. It's a disease that has hit the oak trees and no one can get it stopped. Like this beautiful old oak here; it will die. It's a beauty. My big one in front of the house is at least 150 or 200 years old.

*These red vines I've been seeing are beautiful! What are they?*

[Dot laughs.] They're poison ivy!

## STRIKING A BALANCE

*What do you think about the government's not wanting ranchers to cut cedar?*

DOT: You can't dictate to people how to use their resources. You can set aside areas as parks. Buy the land and set it aside as a refuge for the golden-cheeked warbler and the black-capped vireo.

But the truth of the matter is, man didn't live here when the dinosaur was here, and the dinosaurs are gone. I think species come and go without man's interference.

I love things natural. You're sitting here on a hill that was under the ocean once. You can see the oyster shells. Man didn't have anything to do with that.

I think you have to use common sense. I believe in preservation of what is really good and natural. We should do it.

But species have come and gone, whether we killed them or not.

LEMAE: I think most ranchers try to maintain their land. They love it. They want to have as much diversity as possible.

We want everything to be healthy here. We could go out and shoot all the squirrels and armadillos, but we don't do that. You try to keep a good diversity of plant and animal life.

DOT: You keep a balance. If you let it all go to, say, coyotes and foxes, then you're going to lose your rabbits and your squirrels and all your other little animals. I think all ranchers love their land and they respect it. They wouldn't survive if they didn't work right and use common sense.

## CATTLE

[We go to feed and check her cows. Dot calls them loudly with a two-syllable, drawn-out "woo-oo."]

Come on old girls! Woo-oo! Come on babies!

[She pours cottonseed into a long, narrow trough.]

Here come our two babies. They love their seed.

We've got some really high-strain Herefords. I'm getting back to the Hereford cross. I love Herefords. They make such gentle mama cows. When I rounded up, all I had to do was come out here with hay. They followed me all the way down to the pens and I didn't need a horse.

[She carries bales of hay and spreads them out for the cattle.]

Woo-oo! Come on girls! Come on babies!

I want to take a real good look at my cows. There's one I thought would have had her baby by now. The seven that are dry are heavily expecting right now. This cow here, you can see she is already beginning to dilate. 1, 2, 3, 4, 5, 6, 7, 8, 9, 10. They're all

*Dot's cows*

here. All of these except the ones with babies should be having their babies no later than December.

Boy, they've got flies on them! Well, everything looks all right.

*What do you think about the efforts of some to bring back the Longhorn?*

I think we ought to always preserve original varieties of anything, whether it's in the grain industry or whatever. Everything we eat now is a hybrid. Every grain that we eat is a hybrid variety, which is great. Science has fixed it so that you get more production.

But when you go back to the original grains, like the kamut, the original wheat, it has a better flavor, just everything about it is better, except it wouldn't produce like your hybrids.

And that's why very few people in the Hill Country have registered full-blood cattle. They'll get a Brangus, a cross between Brahman and Angus, they'll get Brafords, a cross between Brahman and Hereford. And then they have all these exotic new bloods, the Limousin and the Simmental and the Blonde d'Aquitaine (one of the newest ones).

We usually use the Longhorn bull on our heifers because then they have such ease calving. You just don't have any problems.

LEMAE: Until they get a little bit older. Longhorns are so wild. You'll get one and keep it to breed, but you don't want to keep it until it's too old, because they're so hard to handle.

DOT: Well, they break fences and fight.

*Even when they grow up with the calm cows? It's in their genes?*

DOT: Yes.

LEMAE: Tell her about that *one.*

DOT: The one we were trying to load?

LEMAE: No, the one that, when you were out feeding all the cows, decided that he didn't like that.

You know how all the cows are so tame now, you honk the horn and they come? But when Mother was growing up you only saw them disappearing over the horizon. You'd have to chase them with the horses and rope them.

Mother was out feeding and this Longhorn bull decided, "No, something's wrong." And he whipped this whole herd of Hereford cows in a circle and drove them up over the top of the back hill and wouldn't let them eat. He was so suspicious. Now, that's the Longhorn for you.

DOT: Yeah, they're the only bovine that does that. You'll see goats sometimes that will do that.

It was hilarious. They came back later and ate the cubes I had thrown out.

*What color is your Longhorn bull?*

I don't have one now, but he was red and white. I love the red and white. I have a full registered Hereford bull right now. I'm trying to go back to a heavier Hereford cross for my mama cows.

*Dot's house*

## BARBADOS AND TRAVELS

[We head out to feed corn to the Barbados sheep and lambs.]

I'll rattle the bucket. They've eaten all my oats—I guess they pulled them up.

The old sheep that has that black lamb went completely blind, and then her eyes healed of themselves. She can see now. It's really interesting.

DOT [as I'm trying unsuccessfully to photograph the Barbados from the side]: You know, the gazelles in South Africa would never be broad side to you or face you. They would walk away and just barely turn their heads. These Barbados remind me of that.

I went to South Africa when Lemae and her husband and children lived down there. I would find all kinds of excuses to go.

I never stayed more than two months. You just can't leave a place like this for so long. That was enough for me to get to visit and see the parks. South Africa has the most beautiful parks in all the world. The animals! I was just amazed.

In Southeast Asia, I saw one dog while I was there, no cats. I heard birds chirping one day and they were on their way. A leader had told the people he wanted them to kill five birds each a day and get rid of them. And they had! The ones I saw were just little migratory birds, moving through. I saw two herds of cattle. Water buffalo were all over the place. I saw one little horse, a Mongolian-looking horse, at that ancient tree, the banyan tree, the oldest tree, they said, in Asia.

But in South Africa you go out to those parks and you see herds of buffalo. You see so many different varieties of birds, your eyes are bloodshot at the end of the day from looking and trying to identify all of them.

## OTHER TALENTS

*You're going to church this afternoon?*

I'm a Methodist and teach one of the older senior citizen Sunday school classes in Blanco United Methodist. We're having one of our Sunday school get-togethers.

I play the B and C bell in the handbell choir, because it's a split clef bell and everybody has trouble reading the split clef.

[She asks if I want her cookie recipe before I leave and says she'll copy it. Expecting her to sit down and write it out, I'm surprised to see her walk to a copy machine in her study.]

I'm the reporter for our new chapter of the Delta Kappa Gamma society. I do the newsletter five times a year for them.

POSTSCRIPT

When I interviewed Dot again in 2004, she was living in a retirement home in Fredericksburg, but still driving to her Blanco ranch twice a week to take care of the animals. She'd moved to town after taking a few falls, worried she might one day fall in the pasture and be killed by fire ants. Those familiar with fire ants in the Hill Country understand that fear was not unreasonable.

With the help of her daughter, Lemae, she was running about ten cows, seventy-five head of Barbados sheep, and ten goats. She was changing to Boer goats. She leased half the ranch to her former student, James Blackburn.

In the retirement home, Dot enjoyed her exercise classes, hymn singing, and sewing. I asked her if she missed living on the ranch, and she said, "I thought I would miss it. But I'm happier here. I'm spoiled now!

"I just wish it were in Blanco."

The year before, Dot had been in charge of the sesquicentennial celebration of the Blanco United Methodist Church. She'd spent a lot of time doing historical research and then had written a play, "A Church that Molded a Town's History," that drew a standing-room-only crowd. "It was a busy year," she said. "I think to turn your interest to something else besides yourself is good medicine."

She showed me a handmade quilt—perhaps the prettiest and most intricate I've ever seen—that she designed and made while she visited her sister Doris in a nursing home. Dot said it took her a year to make the "Doris Quilt," but her sister got to see it before she died, and it won Best of Show in the Blanco County Fair. "Out of great tragedy always comes inspiration," Dot said.

Lemae had returned to seminary, and then was ordained as a Lutheran minister and appointed to a church in Swiss Alp, Texas. She has three children, but Dot said none of them planned to become ranchers.

When I saw Dot again in 2009, she had moved to an assisted living center in Schulenburg, near her daughter. She was eighty-eight, and still seemed to be enjoying life.

81

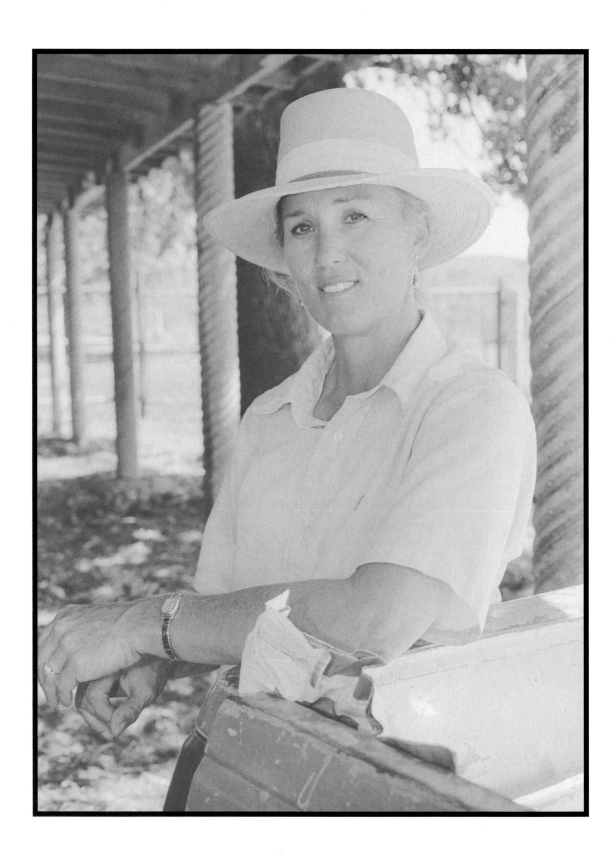

*Robin Jernigan Luce*

# Robin Jernigan Luce

*with sister, Tempie Butler*

BARKSDALE, TEXAS

B. NOVEMBER 19, 1953

To me, a rancher has to be an awful hardheaded kind of person. Someone was telling me the other day that our grandfather was a hardheaded old codger and my aunt was sitting there and she said, "Let me tell you something, that is a hard-to-come-by trait."

You have to be hardheaded or persistent or tenacious, or you don't accomplish what you need to. You'll give up. Ranching is very discouraging. It's not one of these things where no matter what happens, it's no big deal. It *is* a big deal.

There's lots of things that hurt you in it. But you learn to just go on and grit your teeth.

## HISTORY

My husband and I started ranching in about 1982, as our business. Now of course, *I've* been ranching since I was born. My parents were ranchers. We didn't have TV, we didn't have neighbor kids, we were way the heck and gone out there, twenty miles from civilization—we ranched.

For entertainment, the three sisters got together and rode horses and played together out on the ranch. We went swimming in the stock tanks. If we got bored doing those things, we'd gather up some of the stock and rodeo a little bit—things we weren't supposed to do.

I remember many a time when we'd be cutting calves off from the cows and playing with them a little bit. I don't know why, but Daddy always knew it. He'd say, "Have you been chasing your grandfather's cows?" or "Those old cows sure do act a little bit restless." And we'd all look at each other like, "Don't you tell."

*Were y'all born on the ranch?*

No. Uvalde Memorial Hospital.

*And your parents?*

Our mother was from California and our father was from here.

TEMPIE: She was 101 percent city—from San Francisco.

ROBIN: She had relatives down here. She moved down here to work, right out of high school. She was working as a waitress and my father met her at the cafe. That's how it all got started. Before we were big enough to help, our mother helped our father. She'd get on the horse and go with him. But after we got big enough, she kind of turned that over to us.

She must have been a very adaptable person. When she moved out here, they did not have TV, electricity, or any modern facilities. We didn't even have a hot water heater when we were growing up. We would heat our water on the stove and take it to the bathtub.

I would not trade my childhood for any other childhood that you could figure out. I think probably that was the best childhood any kid could have. You really learned to use your imagination.

TEMPIE: We'd leave in the morning on our horses and not come back until that evening. We built forts all over that ranch. We thought they were forts.

## HORSES

ROBIN: We had a ball just playing and riding. We always had plenty of horses, so that kept us occupied. When Daddy had to have something done, there were three of us. That was expected, for everybody to do his part.

We all had our own horse. Tempie, being the youngest, had a hard life.

TEMPIE: They used me for the guinea pig. "Let's put Tempie on, she'll do it."

ROBIN: We had a huge thoroughbred mare that was just as sweet and gentle as a dog. She was our mother's horse. That mare was where most of our horses came from. She was carrying one or had another one attached to her all the time. She was Tempie's horse when Tempie was growing up.

We probably rode a saddle one out of a hundred times that we rode. Our tack was just a bridle and hide, and we took off. Tempie would walk up to that old mare and,

bless that old horse's heart, she'd stand pretty still, and Tempie would jump and grab her mane and use her leg to shin up the side of her.

We were always a' blowin' and a' goin' and a' dashin' around and Tempie wanted to do the same and the mare would not cooperate. So Tempie'd be sitting around ninety percent of the time screaming her head off, mad that the old horse would not go like she wanted her to.

Dynamite was her last colt. When she had her last colt, that poor little fellow was not very big. We were catching him so Tempie would have a horse to ride. We broke him to ride before he was probably four months old. Tempie wasn't very big herself. It wasn't an unmeasurable pair. They fit each other pretty good.

He didn't ever know he was not supposed to be ridden. He came out being ridden.

After Dynamite, everybody had a horse.

*What was your horse's name?*

Chihuahua. Which one was Zayne's? Snaps. Later came another colt, Hombre. That was the one that ran her through the fence and cut her up real bad.

## FAMILY TIES

We've always been real close, the three of us. We've pretty well always tried to keep in touch even if we all got married and moved to different corners. We always tried to have a Christmas together, or some other holiday. We're pretty much a close family, even though we may not see each other for . . . days.

We all three live here close. Zayne works for a rancher who bought my parents' place. She works out there.

It's always hard to work for somebody who has their own ideas, when of course you have your own ideas. You know pretty well, when you were born and bred in that kind of environment, what's going to work and what isn't going to work. A lot of these people that have the financial means to do ranching nowadays do not realize that a lot of the things that used to work do not work any more.

But even though Zayne is working for somebody else, she still thoroughly enjoys it.

Tempie's been in and out of ranching. She was in it a few years ago and they lost their lease, so they were forced to sell out. They couldn't keep what they had been building up. Usually when it's like that there's not a thing you can do about it—not a thing. Just let it happen.

A lot of people would be discouraged and not want to get back in it. Of course, if you are stupid enough, and hardheaded enough, you're like her, you get right back in there. Do it again. If you were born and bred to it.

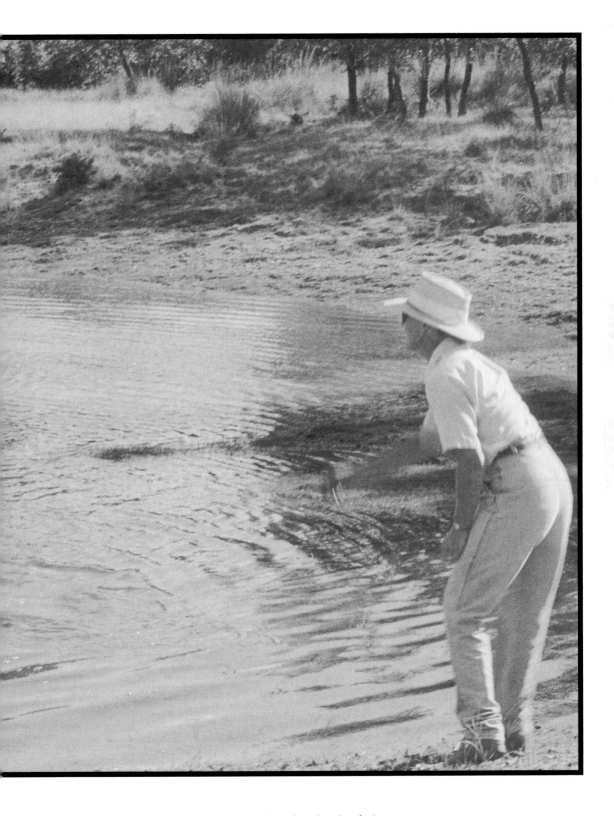

*The working dog plays fetch*

## THE LAND

*Do you all still have the ranch you grew up on?*

No. That's where Zayne works. She works and lives out there. We're around, anyway.

This place here was part of our grandmother's. And across the road.

My dad's family were settlers in this area. Our great-grandfather was thirteen years old when he came to this country. Sam Raney. He had eleven saddle horses when he came here. That's all he had to his name.

He camped one night and the Indians stole all of the horses, including his own saddle horse. Best of my understanding, he was also barefooted.

Neal Jernigan Sr., my grandfather, ran away from home and went to work for him years later, right across the river over there. They took him in and he worked for them for quite some time. After a while he showed lots of interest in our grandfather's daughter and they got married.

He was a saver. Every penny he made, he saved and bought little bunches of land as it came available. He finally ended up with this whole valley—with our grandfather's help. The two ranches connected.

Then they got a divorce and he remarried. Our grandmother didn't, but he did. He acquired five ranches, counting the one in Uvalde, and had a large sum of land at his death. He was a very productive person.

But, you know, that's the sad part of ranching, and so many people don't realize it. As families expand, the land decreases, because each member gets a portion. Whether or not they keep it, that's not the point. It is decreased.

At one time, this whole valley belonged to our family. But it no longer does. I've been as guilty as anybody. We had two hundred acres here. You can't take two hundred acres and keep it and make a living off of it. So we sold it. You've got to have it as a volume, a whole, or you're not going to get anywhere. It's sad that we can't make it work somehow.

And inheritance tax! It's gotten to where you have to sell it to pay the stupid thing. Therefore, you can't keep it, again. It's a catch-22, as they say.

## BEING A WOMAN IN RANCHING

As a woman, if you muscle your way around in the business, they don't like it and you're going to get stepped on. You act quiet about it and do your thing and earn the respect that you want.

To me, we can't go out there and be like the guys, act like the guys, and expect to be treated like the guys. I think we have to work harder and do a better job before we

88

earn their respect. I'll be the first to admit, I want to fit. So that's why I work real hard at doing what's right.

A good example of that is: we sell bulls for a living. Buyers call the house and ask, "Is Mr. Luce in?"

"No, he's not, could I help you?" I say. "Would you like to leave a message?"

"Well, I am interested in some bulls."

"Well, you're talking to the lady who handles the bull department."

"Oh . . ."

You know he's thinking, "I'm not so sure about this now that I've got the woman on the phone."

I act like it's no big deal. I act like I didn't hear the overtones and just go right on and say, "What day would you like to see them? What are you interested in?"

I'm real careful what I say until I get the feel of who I'm talking with and all. Usually, if I'm careful, sidestep a little, am real polite and wait for them to lead the conversation, I'm better off. So, I just let it go and eventually they're comfortable.

But I have to earn their respect. It's not that easy.

Then I've had some that never came to look at the bulls. I've had a few say, "Well, I'm not sure about my schedule, I just kind of wanted to see what you had."

And of course I knew exactly what we were doing. I feel like, if that's the way they feel, then fine, I'd rather not do business with them. Buy from some Tom, Dick, or Harry.

Most of the men my age or younger don't have any problem with it. It's the older fellow. I think they're kind of embarrassed, and rather than handling the issue they just don't do it.

However, I've had some trouble with men my age. I do business with one older businessman, I think he told me he's seventy-one, who's been buying bulls from me since I started. He has a son my age. His son is usually the one who buys the bulls, or they're getting the bull stock for him. But he won't come over. His daddy comes over and buys the bulls. But the older gentleman, when he first started, wasn't too sure either. But once he got to know me, I couldn't have a better customer or a nicer person to do business with.

*What do you all think of the idea that women are gentler than men when working livestock?*

TEMPIE: Oh, gosh, yes!

ROBIN: Yes. We take a little more time. When we work cattle, I don't want any men around.

TEMPIE: I don't either.

ROBIN: And I get furious! The next thing I know I am fighting with the men.

TEMPIE: My husband and I don't work cows together. He swears that one time I threw a rock at him. I might have. We didn't talk for two days. I have learned.

When I cut calves, I can go and call forty-something cows with their babies into the pen. I can get out there and never say a word, and I can cut cows.

But if Steve's out there, we yell, we scream, we get real mad at each other.

ROBIN: Cows start jumping over the tops of fences . . .

TEMPIE: I'm never in the right place in his books.

But I can sit here and do fifty head of cows by myself, even though it might take me a little longer.

ROBIN: I don't think it does, Tempie, I really don't. By the time you pen them twice, or three times, because they jumped out when y'all weren't getting along—it probably would have taken you less time by yourself.

The other day when I got ready to ship calves, Bill [her husband] said, "I'll send Leonardo up to help." I said, "I don't want any help! Do not send me anybody! I think better by myself."

TEMPIE: You know, when I get mad that I don't have a man around is when I have to move a panel or something.

ROBIN: Oh, well, yeah, then I get mad.

TEMPIE: Because there's never anybody around to help you with the panels.

ROBIN: These are one-man pens here. On these places that we lease: I can't see putting a lot of money into them building new pens. So I've gotten to where I just haul panels. Anywhere I need to do something I just hang my panels.

*Can you do that by yourself?*

ROBIN: Yes. Well, like this panel here. It's sturdy enough and handy enough that you can handle it. All you have to do is pick it up off the ground a little more. We don't run animals that jump fences. If it jumps the fence, it goes to the auction. I don't want it if I've got to put up with that kind of nonsense. If it's that wild, I can't work it by myself anyway.

## ON ENVIRONMENTALISTS

I don't understand these environmentalists. I hesitate to call people names, because that's not right, but "environmentalists" is the only other word for them. There's so many of them who think we don't do things right, that we are abusing this and abusing that. Well, I'll admit there are some of us that do. I know several that I could point my finger at and say, "My goodness, what a mess they have made." But that isn't the case with everybody.

Most of us, if we had the financial means, would clean up our act even better than what we're doing. I look at my husband and me; I'd like to think we're doing as good as anyone as far as trying to take care of the environment.

Yes, we cut down the cedar trees and do things the environmentalists say are bad. Well, I'm afraid I don't understand that either. Because if you take away your

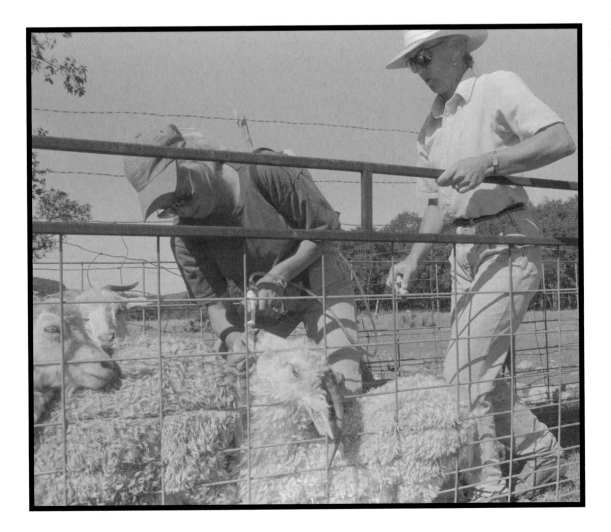

*Drenching Angora goats*

grazing—your grass—by not cutting cedars, how are you protecting your wildlife? It doesn't make sense.

In this pasture, we've done a lot of work trying to get grass to come back. I think we've done an exceptional job. It looks pretty. There's lots of grass out here—good grass. If you're out here working, you'll see lots of wildlife.

I don't think the rancher is the one doing the wrong. I can go to any water crossing where people come to the river to congregate and play and whatever, and it's a mess. During the summer, at the water crossing right down here below Barksdale, there are always some people. Before the summer is over it is the trashiest looking place. They don't "take it with them." What they bring, they leave. And it's a mess.

[A deer runs across in front of us.]

When I see things like that, I don't care what anyone says, I'm proud of it. It gives me a good feeling to think *that* is something we have helped.

## LIVESTOCK

*What kind of livestock do you raise?*

Angoras and cows. We have had sheep, but we've gotten rid of most of our sheep. They are just so hard on the country. Cattle and goats complement each other. Goats browse. They eat brush and little grass, a little bit of everything. And cattle, of course, are grazers—they're a ground forage feeder. In this area in here, you almost *have* to have some goats, or the brush will just take over.

I can take you to several places right now that haven't had goats on them and you can sure tell the difference.

We try to get everybody to have their babies in the spring so they can maintain them through the summer while they have something to eat, and then wean them in the fall. That way the mama doesn't have something to sustain while she's in the hardest of the months. In the winter here, once we get that first heavy frost, these pastures are through. Then everything that they get pretty well comes from supplementing with grain or hay.

We don't keep animals that aren't cooperative. Tempie's down here calling goats right now. If they won't come, and they won't work with us, the minute we do get them in, we don't keep them. Therefore, most of our animals can be worked with from a feed sack.

But in reality, the way those old girls [the goats] are going, Tempie can take them right to the pen, pour some corn in the pens and, with some time and patience, they'll go in.

It works good. It's not hard on your livestock, it's not hard on you. The key to this whole doggone thing is patience. If the stock know what you want, you can forget it. Who in their right mind wants to go to the doctor and get a shot, anyway?

That's the way we do it. You can get a horse, and we have done it that way, and we still do it in some places. But you're going to come up short.

We always know how many we have put in a pasture. I'd say out of a hundred times we get our stock in, maybe 99.5 percent of those times we get every single one, or can account for every single one. You have a death loss occasionally and that's just the way it is. Anyway, if you can get that kind of percentage into the pen, you're tickled to death.

## THE DAILY SCHEDULE

We usually get up at six o'clock. We eat breakfast and do our usual kitchen and house chores, and leave the house no later than a quarter till eight. It takes me about fifteen minutes to get my daughter to Barksdale. When I drop her off and get everything done, it's about ten after eight.

I leave town and make my rounds this direction. I have to feed the bulls every morning, and then I check water. A lot of places have water, but I drive through the pastures to make sure there's not anything wrong.

About twice a week I call up everything—cows, goats—and just feed them all a little bite, just so they'll be used to coming when I want them.

But my day usually consists of checking on everybody. Driving through the pastures, making a quick swing through there, and making sure that there's not anything wrong.

There's always something wrong. There always is. So you just plan that there's going to be an extra two hours spent correcting whatever it is. You may have cows out in the neighbor's pasture. You may have a water trough broke. You may have some animals that need to be moved to another location. There's always something that has to be done.

There are basics to follow. That is, you have to make sure they have plenty to eat and plenty to drink. From there, what happens, happens.

*What about your lunch?*

Dinner may come and go and, I feel it, yes. My stomach tells me to eat. But I sure don't let it bother me. I could spend a lot of time going to the store for snacks because I'm hungry all the time. I have a very healthy appetite.

We have enough little places scattered out so that just checking the water takes a couple of hours. Every pasture has at least two or three gates that you have to go through. And all these little details: flat tires. You have all these unforeseen little things that happen in between.

When my husband and I meet in the evenings, he'll say, "Well, what did you do today? Did you have a good day or a bad day, let's start with that first."

If it was a bad day, he'll say, "Well, what went wrong?"

Well, I'm not sure I'll want to talk about it. We have a mutual understanding that when we have this frown on our face, maybe we better be real quiet.

One time we were running about twenty thousand acres. It kept us real, real busy. We had some country down close to Uvalde and we had land in this direction. My husband would go south and I'd go north. We wouldn't see each other until late that night.

## DOGS: DON'T CALL THEM PETS

Most of this country is not really able to be gathered horseback. Helicopter, maybe. That's why we have these little rascals—these dogs.

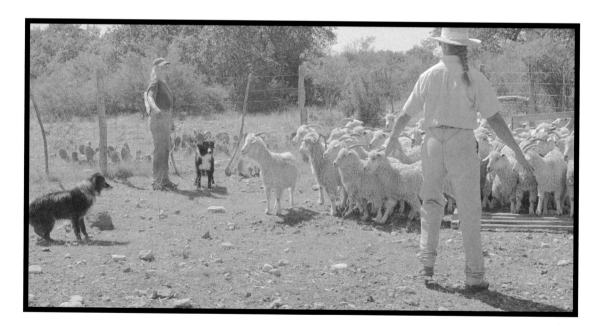

*Standoff*

We don't buy ours. I feel like if I can raise and train my own, I have a better animal. He already knows me. He trusts me. We just have a better rapport. A lot of people say, "What a cute pet." Whoa! Wait a minute, that's not a pet. That is a hired hand, and one of the cheapest hired hands that you can have.

Our dogs are border collies. They are a sheep and goat dog, but they can and will definitely work livestock of any kind.

I can assure you, dogs are scary, scary things to goats. That's why those dogs are so good. You can sit right here and talk yourself black in the face and the goats won't respond. But you let a dog, any kind of dog, get out of the pickup and you will get a response. Maybe not the exact one you want, but you will get a response.

## LIMOUSIN CATTLE

That red cow is a crossbreed. We started putting a Limousin bull with our cows. A lot of the ranchers like that. On the underline, the belly part, you don't want a lot of leather hanging down underneath. Because if there is, they'll get stickers in it or go through some brush and make scratches on it. Eventually the flies go to picking at that, and then the cows go to scratching because it itches, and the next thing you know they have a bad sore. Then you could put her in the pen, or him, and doctor the sore and hopefully they get well. And then you might be right back to square one, because a lot of times it makes a scar and then that tends to catch on things again. That's why so many people like the cows where they're real clean underneath.

Limousin adds that; that's why we went to that breed. There are reasons. The Limousin puts a real beefy carcass on your Brangus. It's more of an eye appeal in a lot of ways, but that's all right too. Just so it sells. That's what you want to do, sell the product.

## THE GAMBLE

A good example of selling our product: for years, we have been breeding and improving and buying and spending, trying to improve our herd to where we had something that was in high demand. And everybody that sold their Angora kids this year took a beating. The market is so bad, they either didn't make any money or they broke even on the sales.

We have worked so long and so hard improving our herd that we got ready to sell ours and we were just crying in our soup: "Everybody else has been getting $15 or $20, that's all we're going to get for ours. We just know it."

95

But we had to sell them. If you don't have a place to keep them, you have to get rid of them. So we finally decided, okay, we've accepted it, we're not going to make any money off of them this year. If we can just break even. What we'll do is keep all our females, our nannies, and we'll sell all the males because we do not have a place for the males. We were commenting to ourselves, "Oh, these are the prettiest things we've ever raised, we hate to get rid of them."

When we were unloading them off the trailer, several people said, "Oh, these are absolutely gorgeous." Of course, we knew this. In our hearts, we knew. This is what we have been breeding and working for. And we thought, well, just maybe. And by golly, we took them to the auction ring and they brought $10 more than anybody else's. It made us feel good that all that work and money we had invested paid off.

But you never know. One year you may rake in the pot and the next year you give it away. You have to have foresight enough to put what money you do make away. Leave it alone. That's hard to do.

You can make money. If you have any sense, you'll go invest it in something else. Ranchers, we don't have any sense. We'll go invest it in more livestock. You're not going to get anywhere that way.

## DRENCHING

We're mixing up some drench. This is for what we call stomach worms. Goats, sheep, and cattle pick up larvae out of the grass they eat. There are several kinds, but we just put them all in one category and call them stomach worms. They deprive the animals of their nutrition. The animals just get sicker and sicker and sicker until they die.

*How often do you drench?*

It depends on the weather and the place. If the people before you haven't maintained a good health program, then you need to do it probably every twenty-one days until you feel like you've got your pastures cleaned up. You'll drench them and send them back out and they'll eat and then you drench them again, until you kill the cycle. Then after you feel like your pastures are clean, you can cut back to two or three times in the summer. If it's dry, you don't have to drench as often. But if you have a lot of rain, that's when your larvae really hatch out.

## ANGORA GOATS

*Do you put bells on specific goats?*

Yes, if you have one that's giving you trouble when you're trying to get them in. Eventually a dog will, when you're out in the pasture gathering, hear that bell and go to it. So, bells are a good thing. You can follow the sound. If you can't see it, at least you can hear it. If you just keep on, you'll finally get the animal to a place where you can get it. A lot of people don't use bells, but we believe in them.

TEMPIE: I've had goats get away within just a few feet. You know you just saw them! You're in the brush, and you look up and you look behind you and they're just truckin' as fast as they can the other direction.

ROBIN: And you're out of breath.

TEMPIE: There was a ranch toward Uvalde. Robin and them had most of it. We had two of the hillier parts. And there was one we called the mountain pasture—a big, long, rough hill. You could hardly get around on it on foot. Horses were out of the question. You'd take your dog up there.

    You'd just run, thinking you were behind them, and you'd look back and they would be heading the other direction. I'd say, "They won that one, I'm not going after them."

*The bells sound beautiful.*

TEMPIE: When you hear them going toward the house—*that's* beautiful.

*Is the government's doing away with the wool and mohair subsidy going to hurt y'all?*

ROBIN: Yes, it will. But, on the other hand, it's one of those deals: if we learn not to depend on it, we can tell the government to go . . .

    Once we learn.

    We've done it before.

    Everyone thinks the taxpayer was the one paying the subsidy. It wasn't! It was a tariff on imported wool. It was strictly with the wool and mohair business.

    That's where we made the mistake: we did not get it out to the right people as to where that money came from.

TEMPIE: We don't get out enough public information.

ROBIN: We don't have the time!

97

*Do you know of any ranchers who are getting out of the business as a result?*

ROBIN: Oh, yes. A lot of people. But a lot of them weren't your true ranch-bred, ranch-raised ranchers. A lot of them were your little hit-and-miss guys. You know, maybe they did come from a ranching family, but they didn't depend on that as their living all their life. They kind of dallied in it.

If this was the only income we had, we would be in trouble. Right now we are depending on the meat industry. This mohair—you can't sell it. The market is dead right now.

What we're having to do is depend on the meat they will produce. Your people on the East Coast are big goat-meat eaters. We ship a lot of meat that direction.

People are beginning to realize these Angoras are goats too. Just because they have hair growing on them doesn't mean you can't eat them. I guarantee, I can take one of these and a Spanish goat and skin them and cut their heads off so you can't tell what's what and feed pieces of meat to you from each animal, and you couldn't tell me which one is which. I can't, and I eat it all the time.

If we can continue to raise kids, and we don't depend on them for a living right now, we'll probably be all right. Because, eventually, there'll be a market for it. This is a luxury fiber. This all has a way of cycling. It'll all come back. And hopefully, we'll all have a few head of seed stock that we can take and expand with. And when it does, we'll be in the driver's seat.

But we sure have to be patient. And we have to keep people educated. You don't want mohair to die because the market's bad. You have to stay out there and continue to sell the product: those beautiful sweaters.

## THE BIG GUYS

Today, I'm going to run up here and feed these bulls. I have three different sets of bulls I'm going to put together and spray so that maybe they'll like each other a little better. They always want to fight when you put new bunches in together.

This is not an everyday thing but it's something I have to do on a pretty regular basis: work with the bulls. I try to keep them fairly gentle. I try not to have any knuckleheads or idiots that are hard to work with or work around. I want them as gentle as possible.

The people that buy them don't want a two-thousand-pound idiot running through their pasture, and I don't blame them. You get something that big, it has to be something that will cooperate. So I try to keep them gentle and easy to work with.

*"Gentling" the bulls*

*Robin and the big guys*

They're all so different. You get to know each and every one of them. There's not anybody here that's mean. I don't want any of those.

*What exactly is a Brangus?*

It's five-eighths Angus and three-eights Brahman. That's how they first got the breed.

Word of mouth, if you're careful, will take care of more things than you could possibly ever do by getting-it-out-in-the-public advertising. I've been real careful about the bulls I've sold. I've always said, "Look, if you've paid your money and you want it back, don't go spreading it around that I don't have what you're after. Just bring the bull back. I'll give your money or another bull that suits you." And I've had to do that on a couple of occasions. But, so far, I haven't had to do it any more than the next guy. To me, that ought to say something. That tells me that probably I'm doing something right. That's what I'm after. I just want them happy with what they get.

## HUNTERS

*Do you lease to hunters?*

We do. In fact, most ranchers probably make most of their money from hunting. Your hunting doesn't cost you anything; you don't have any overhead. So you're going to make your clear money from that. It's just putting up with the hunters, and sometimes that's hard.

One of the things we've found is that if everybody has a clear understanding and the communication is left open, you can tell them what you want and usually they're going to try to do it. *If* they'll just listen to you.

The first things that I say with any new set of hunters are: "What you bring in with you, goes out with you. And PLEASE shut all the gates." When I say shut the gate, I don't mean leave it latched open this wide, because if an animal can get her head through it, she's gone. I mean, SHUT THE GATE!

You have to be real plain.

*Do you advertise?*

It's amazing how they find you. Hunters, if they are really out to hunt, will find the landowner.

Now, you also get the undesirables that come with that, and you have to be on your toes and know your people well enough to know how to pick good ones. You can still make mistakes. What seems like Mr. Nice Guy may be the real heel. After one year, you usually know if you want them back.

Normally, the people that give you the trouble are the people that drink. And you can pretty well tell them, "We don't want that stuff on the place. Just don't bring it on the place."

But so far we haven't had but one or two parties that we had to get rid of. We didn't run them off, but we have a deal worked out that pretty much weeds out the knuckleheads. We make them put a deposit down in the spring. They have to pay half of the lease. Then in the fall, when they get ready to come hunting, we make them pay the other half. During that time they're going to come two or three times and do things that will pretty well tell you if you want them around.

Therefore, they'll know if they want to stay with you. If they decide they don't want to stay around, they've lost that first payment. If we don't like each other and we decide we don't want to do it, it's our prerogative to give them the money back or keep it, depending on what makes us decide we don't like each other.

## THE FUTURE OF RANCHING

*What do you see in the future for ranching?*

ROBIN: The little guy is pretty much washed out.

TEMPIE: There's no way my husband and I could go into ranching full time and depend on it for a living. We don't have that kind of money to get set up. So he has another job and I ranch. But I still have to work for somebody else.

ROBIN: Our ranching, as far as the way we have done in the past, is about over. What we are working toward is trying to get our place deer-proofed on the outside, and then we're going to have game and that will probably be our income: exotic game.

It's an up-and-coming thing. There are always going to be the people who want to get out of the city.

Ranch work is hazardous. There are lots of things you do that you can get hurt doing. So many of these people you could get to help you nowadays are just waiting for that opportunity to hang it on you.

This way, with Tempie and I, if I get run over, she'll say, "What are you doing down there?" We don't have to worry about getting sued. You get hurt? We accept it. That's just the way it is.

Workman's comp is out of sight. I'm not saying we don't need it. It's the people who are using it and don't need it. I know several now who are on workman's comp and there is nothing wrong with them.

TEMPIE: There's that, and there aren't many ranchers around who can afford workman's comp.

ROBIN: They barely have the liability insurance that is absolutely required on their pickup!

TEMPIE: I'm thinking, "Golly, I do good to take out any type of accidental insurance on my family." Then, if you get some worker and he gets sick, what have you got to give him? I'd say, "You can have this little herd of goats over here and you can have my horse."

ROBIN: "No, I don't want that. I want money!"

TEMPIE: You can have my Toyota. I'd give you the dually, but it's not in any better shape than my Toyota. Whatever you get from me, you can pretty well figure you're going to have to work on it!

ROBIN: I think that the rancher will persist. But I think all of the little guys are going to be gone. I think it'll all be your bigger people with financial capabilities. And a lot of those people will not be born and bred into the industry. Therefore, I don't think they're going to have the persistence to stay with the issues and fight for what is right. I really don't. That scares me. Because when you get to that point, then I think the government might get control of ranching.

I look at other countries and the government has eventually controlled their food producers: farmers and ranchers. And that's what scares me. I think that's what's coming.

Of course, we all think of government as the bad guy, and in most ways they are the bad guy. They are not out here having to do this. This is not an eight-to-five job. It's twenty-four hours a day, seven days a week.

If they can't see it from our side, they have no idea what we are talking about. We don't need the people behind the desks telling us how to run our show. No one

*Enjoying the ride home*

knows better than the poor guy who is sitting out there at two o'clock in the morning waiting for this cow to have a calf. He has a real feel for what it's all about. And it's not always nice. I don't know why, but cows always pick when there's frost on the ground or there are icicles hanging off of the roof to calve.

Lots of days you have something planned that you want to do and it's canceled because old Bossy over here, the jersey heifer, has decided that she is going to be in the family way today, and it's not going right. So you're going to have to stay and help her along. Mother Nature dictates your time. You don't have any say over what happens.

The only time you take off, you just have to close your eyes, shut your ears, and say, "Okay, I don't hear it, I don't see it, I'm going." And I'll guarantee it, the minute you drive through the gate, something is wrong. It happens every time! That's how it is with any business that deals with animals.

We don't have to answer to anybody except ourselves, but in the long run, that's pretty harsh. When that paycheck comes in and you didn't do your part, there's no one to blame but yourself. Then you say, "If we had stayed home and sprayed or drenched or something, then we wouldn't be getting just half of what we're supposed to be getting here."

*Do you ever take a vacation?*

Yes, we do. We go on them. And when we do, thank goodness, Tempie is my replacement or I am her replacement. It takes a load off your mind. You can get someone else to do it for you, but they don't really know the pastures or the water situation. But if Tempie fills in for me or I for her, we know what's going on.

TEMPIE: And we can't afford to hire somebody full time when we leave.

ROBIN: It's fifty a day. Whether it be a man on horseback or a man to just feed and water, they just don't go for anything less.

The thing is, if you do get somebody for less, you get what you pay for. He never sees anything that's gone wrong.

TEMPIE: You may come back and half your equipment's missing—you find out it was auctioned off.

ROBIN: That's true.

I try (not because that's the way it's *supposed* to be) to leave Sunday as a day of nothing. We don't do anything. And if we can, we'll let Saturday evening, from dinnertime on, alone.

Our daughter is one of these who tries to do everything in school. We encourage it; I wouldn't have her any other way. That is one of the reasons we have cut back on a lot of things we're doing now, so we'll have time to be with her. She's an athlete. She goes to doing it all and we just try to be available to go do it all with her.

She's a sophomore. She's doing cross-country right now, which takes up every weekend we have. Every Saturday we load up and go. The girls run two miles, the boys run three. Tempie's son is in cross-country, so she tries to leave her Saturday mornings free from ranch work. A lot of times when you leave your Saturdays open, you have to make it up on Sunday.

But I wouldn't have it otherwise. That's the way it needs to be for your kids. So many of us just raise kids; we don't spend the time that we should.

*Do your kids like ranching?*

ROBIN: Ti [Robin's daughter] loves animals.

TEMPIE: Ti could sit out in the pen for hours.

ROBIN: Yes, she could. We have been to all the stock shows in our area that could possibly be attended. And she has done well. When she does it, she dedicates heart and soul to it.

This year is the first year that she was old enough to show and didn't have an animal, and it wasn't by choice. We were off in Des Moines, Iowa, at one of her athletic deals when the animals were offered for show and we just couldn't be here. So she didn't get anything to show.

Not that we don't produce. But she likes lambs and we don't have them.

She showed goats for years. I think we saturated her with goats. We were at the height of our goat raising and we had some awful good animals. And she was our shower. We stuck her in everything we could possibly get her in, and she had had enough of it.

So when she got old enough to choose what she wanted to do, lambs were her thing—of course, the only thing we don't have.

She's fifteen—a sophomore. She loves her livestock and works with them hard.

I don't expect our daughter to be a rancher if she doesn't want to be. But if she does, I'm for it.

105

## POSTSCRIPT

When I revisited Robin in 2004, her ranching operation had changed drastically. She and her husband, Bill, were no longer raising Angora goats or sheep, but still raised bulls. In 1995 she'd sold the home ranch, part of her family's place, to non-ranchers and started reducing her goat herd. She let go of the leased properties the next year, and in the fall of 1997 sold the rest of the Angoras and the sheep.

She continued to raise bulls, and then started an entirely new operation: raising white-tailed deer for hunting. "It's a very interesting venture," she said. "The purpose of raising deer is to improve the genetics—either for your own herd or to sell."

Her sister Tempie had gone back to college to earn a teaching degree.

An anthrax outbreak in 2001 had devastated Robin's deer herd. She "quit counting carcasses at seventy," she said. "The mommas would die and you'd go out and find the babies standing there starving to death. About a week went by and I said, 'I've had enough.'" The veterinarian assured her the fawns probably did not have anthrax, so she started bringing them in and trying to save them. "Some of them were too far gone, and they died anyway," Robin said. "It was a horrible experience." The outbreak began in June and lasted until August.

Anthrax lives dormant in the soil, but can be activated by a long drought followed by rain, Robin said. Her father told her when she was six or seven to keep an eye out for anything that looked "charbon," by which he meant burned. *Charbon* is another word for anthrax, and it means "coal" in French.

"He swore that when horseflies got real bad, that's when to look for it," Robin recalled. "When it hit us, the horseflies were terrible. They'd be all over the porch ceiling at night." And then the deer started dying.

An outbreak of anthrax had not occurred in the Montell area (where Robin was ranching) for two generations, she said. Anthrax kills livestock, too, but Robin's animals were vaccinated. Other ranchers in the area weren't so lucky.

Still, she had to deal with the dead deer. She was instructed to wear rubber boots, gloves, long sleeves, and a mask to burn the dead animals. Afterward, she was to bleach the boots and bag the clothing. It was summertime in Texas. "It was hot," Robin said. She followed the protocol for the first animal, and then found two more carcasses. That was the end of the hot gear, though she did continue to be careful.

During the outbreak, Robin was interviewed for CBS and other news outlets. "Another media guy came out in the fall and wanted to see the carcasses," she said. They were standing at the burn site when she looked over and saw he'd picked a blade of grass and put it between his lips. She was not impressed by the journalist's ranch sense.

After the anthrax epidemic, Robin started rebuilding the deer herd. They began raising deer in pens and vaccinating them.

They also branched out into another new area—"people ranching"—which Robin said is more trouble than working with animals. She had cyclists and hikers on the ranch for the first time in 2003. She believes that's the way of the future for landowners: catering to tourists.

The small Hill Country ranching towns and traditions are dying because of the loss of the Angora goat business, she said. Many of the old ranches have been turned into what she calls "play ranches," for hunters only. "The small ranchers are nearly gone," she said.

Cattle prices had been high enough to sustain that operation in 2004, and it was the first time that had happened in many years. "Mother Nature has been good to us," Robin said.

Robin was still actively ranching in 2010, continuing her work with white-tailed deer and Brangus cattle. She and Bill had been commended for their responsible land management by the Texas Natural Resources Conservation Service. They rely on breeding and genetics, not hormones, to produce healthy animals, Robin told me.

Their daughter, Ti, is a full-time rancher.

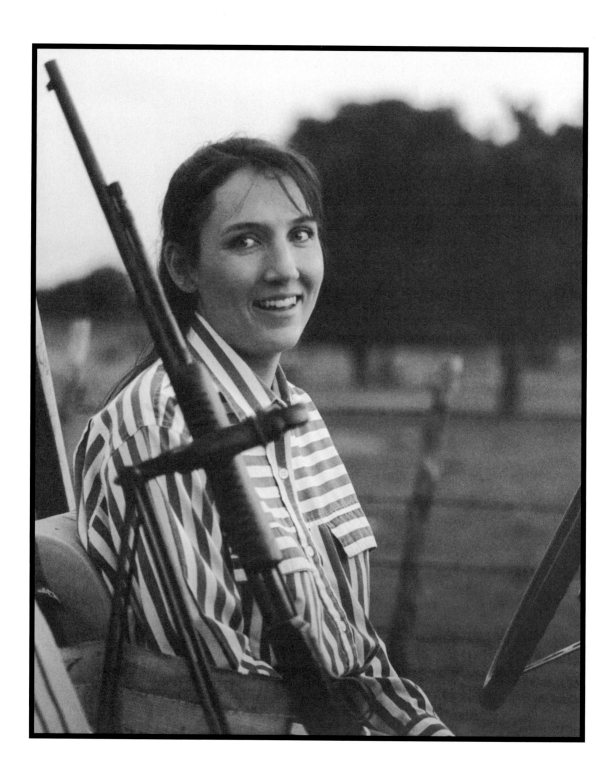

*Mona Lois Friday Schmidt*

# Mona Lois Friday Schmidt

## MASON, TEXAS

B. APRIL 10, 1970

You know how you have dreams before you get married about how things are going to be? This is what we planned on doing: ranching and working together. And we hope financially we'll be able to do it.

I guess someday I might have to do something else. I hope not. I really love ranching. I wouldn't be married if I hadn't found a rancher to marry. I wouldn't want to do anything else.

We got married in 1989. My husband had another year left at Texas A&M. We stayed at A&M and we drove here every weekend and worked stock. When he graduated with a range science degree with a ranch management option, we came back here. We've been here six years.

*Do you expect to take on more ranching duties when your kids are older?*

Yes, I plan on it and James Kelly [her husband] is expecting it and planning on me being a very active part of it. For one thing, when his dad moves to town, he'll need another hand. His dad does a lot of work.

I miss the work a whole lot. Before I had Havana I went every day with James Kelly and rode and worked, going and doing what needed to be done. A lot of ranch work you really can't do with your kids. You don't want them to get smashed by an animal.

Havana rides in front of me on roundups. When she was younger she'd just sit in front of me and if she got tired she'd turn around and face me and lay her head on my shoulder and kind of fall asleep.

I'm hoping all my kids will enjoy the ranch and riding. We plan on raising them where their lives are set up around it. To me, it's really the greatest heritage. I guess if you got your heritage from something else, then that would be yours. But to me,

the ranch, wide-open places, the animals—livestock and wildlife—and just about everything else that goes with it, is the greatest heritage. That's what we hope to give our kids.

## FAMILY

*Did your in-laws get married and move out to the ranch like y'all did?*

Yes. They lived in the house we live in now.

*Whose family owned the ranch before that time?*

It was my father-in-law's family. They came here, German settlers, and built a homestead.

*Were they the first ones to settle this ranch?*

Parts of it. Some of it belonged to other people. My father-in-law had two brothers, so it's been divided into three. He owned a lot of land all around here.

My mother-in-law came from East Texas. They needed schoolteachers. So she was teaching school in Mason, and that's where she met my father-in-law.

She's sixty-six and my father-in-law's in his seventies. They're going to be moving to town.

I grew up on a family ranch. My mom and dad are living in the house that my dad grew up in. And they ranch.

## ON RANCHING

I get worried because the life is getting more and more difficult to hold on to. When you work for yourself, no matter what you do, you work harder than most people. James Kelly's out, he works all day long, he doesn't come in until eight or nine o'clock. Just always going, always working hard. And it seems like you're just holding on.

The cost of everything else has risen. But we aren't getting more for our product. Ag prices haven't changed in the last forty years. But if we want to buy a new truck, well, the price of a truck has skyrocketed from twenty years ago. Or the price of a refrigerator.

People think ranchers are rich. But I'd bet ninety-eight percent of ranchers are scraping by. And that's us. A lot of money might flow through, but that's what it does. We just go, "Bye."

It's a hard profession. It's hard on you physically.

I think it's almost depressing now, because we are being attacked by environmentalists and animal rightists and a lot of people who benefit from us and don't know it. They think we're bad. They've decided we're bad.

Every time I give a speech in a class, I do it on ranching. I think, well, that's thirty or forty more people that know better.

*What kind of responses do you get?*

They're all very curious. Because the media is very negative about us. I tell them, "Anytime the media reports on something you know, are they accurate?" And they go, "No." And I say, "Well, what makes you think they're accurate on something you don't know about?"

When I was in high school, when I was going to write a research paper, I would decide what I was going to write on and how it was going to be, and I'd write the paper and then I'd go look for quotes. And I think that's what the media does. They decide what they think, and then they go look to prove their point. And that's not the way it should be done.

Every once in a while I've seen a story where they actually change their minds, because they say, "I went in expecting . . ."

111

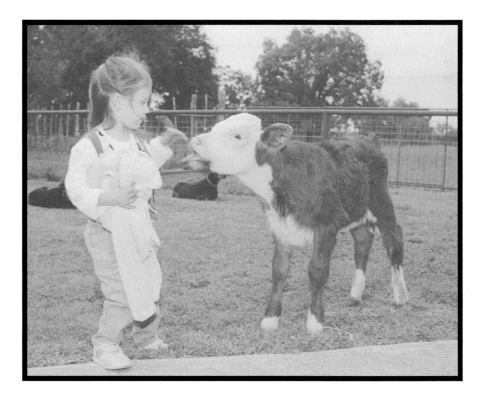

*Orphan calf licking Havana*

## HORSES

I was always interested in the ranch, always on my horse, always with my daddy. Of course, we lived way out in the middle of nowhere. I was the only girl. The closest neighbors were my cousins and they were about fifteen miles away. And they were boys.

I showed stock: sheep and horses. I won a lot and loved it. I always wanted to rodeo but my dad didn't want me to. That environment's bad.

*When did you start riding a horse?*

Actually, I don't remember *not* riding a horse. I can remember going on roundups with my dad when I was about three. I had my horse and he grew up with me, and he just bumped me around.

He was a chestnut quarter horse—a hobo horse. We'd see them everywhere. They're not paint horses necessarily, but their faces are real white—most of their heads, not just a strip.

Now I have Juan. He's a real good horse.

*Sleepy Hollow*

HAVANA, HER DAUGHTER: He's a bad horse, Mommy.

MONA LOIS: Let's just say he's a little quick. You'll be riding along and in a few seconds he'll be standing over there and you just hope your heinie goes with him! He decides to spook about something and you just never know.

*I* know. I've ridden him since he was a two-year-old, so I know what he's going to do. He's funny. He's got a great personality. He'll tip an ear back at you and you know he's fixing to do something.

I prefer not so fancy of a horse. I don't want one whose sire was a such-and-such, stamping, prissing thing. I want people to say, "Well, his daddy rounded up cows every day for ten years."

That's what type of horse I want.

## LIVING OUT

I grew up five miles back on a dirt road. Up until my freshman year there were five gates to open. It got real old. I know when I have Havana in school I'm really going to hate this road.

*What about being isolated?*

Actually, if I want to see people, I'd rather go see them. I prefer living out. I grew up further out than this and loved it.

Occasionally, I get lonely and would like to talk to somebody. But it's not like I don't have a car or a phone. It's not like the Wild West where you had to harness up the wagon and take five days to get to town. It's a thirty-minute drive.

I hate hunting season because there's people out here. Sometimes they'll come up to the house and I'll hide. They'll be knocking on the door.

My mom and I did that, too. We'd hide from people. Just didn't want to see them. We might not see people for days.

## HEREFORDS

When we got married I didn't know anything about the Hereford business. My parents were commercial ranchers. They ranched down between Uvalde and Camp Wood on the Nueces River. They ranged seven thousand acres down there, mainly commercial Angora nannies and commercial cattle. I never thought about it until I came up here, how different commercial and registered is.

*Herding the six-foot-tall Hereford*

*What is the difference?*

Paperwork. Lots of paperwork. You know everything there is to know about registered stock. With registered, normally you spend quite a bit more on your breeding stock.

*What are the numbers etched into the cattle's horns?*

They're horn branded. That's how we identify them. They have ear tags. But the horn brands are nice because sometimes they lose their tags. It's nice when we're calving just to ride out and you can see that horn brand real good and clear.

*You don't brand them on their sides?*

We do. We put the ranch brand, SR, on their hip.

We're trying to get them fed up so they'll rebreed this fall. If they eat good, they'll come back into heat better. They were first-time heifers.

## ANGORA GOATS

We hand-kid our goats. We have about two hundred registered Angora nannies. We have a similar commercial herd that we don't register the babies. But we hand-kid them all.

We put them out in this trap in the morning, and in the evening we drive out and pick up all the babies, drive the nannies in and put them in the kidding barn. Then we write down their birthdays, who the mama is, who the sire is. That's for the registered.

Sometimes it's real cold and you're freezing half to death and you're sitting there with a pencil and a book going *d-d-d-d-d*. Sometimes you might have twenty-something goats on one day.

But I really like it. Havana loves it—she goes out and picks the babies up.

*They're tiny, aren't they?*

Yes, and the mamas are bad.

I'm the bookkeeper. I keep all the goat records. I help with the registration and all the records, so we know what every little animal's doing, how they're producing, how they're performing.

We want to keep our goats and we've been having a horrible coyote problem. We've called the helicopters twice. My husband flew with them once and they got one male.

116

In the early morning you blow a siren. You hear the coyotes yelp and locate them. Then you call in a helicopter and the helicopter has a gun. They go out to where they think they are and the helicopter scares them out and they shoot them. All the ranchers around here do it. They got five one time.

*There's a company that does that as their business?*

Well, I'm sure it's just somebody who has a helicopter and does this occasionally.

## GUARD DOGS

Since I've been here, we haven't lost but one or two a year to coyotes because of our guard dogs. We're about the only people that really run guard dogs. But this year the coyote population, for some reason we don't know, boomed.

In this area, there's just us and a neighbor that raises goats. It became too expensive to have goats and sheep because of predators. Everybody went out of the

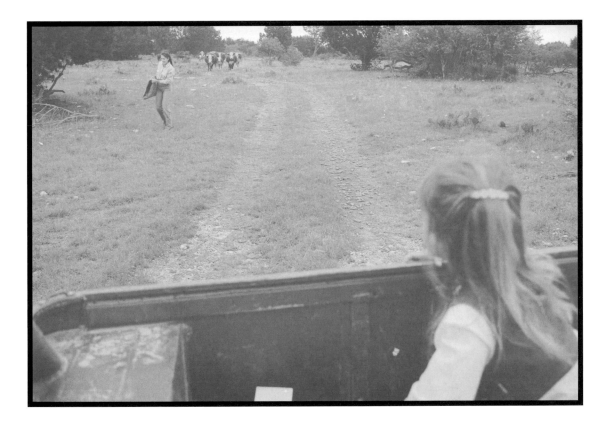

*Keeping an eye on Mom and the cattle*

business, unless they wanted to drive around every other day and find their goats and guard dogs.

*You train the dogs to take care of the goats?*

We do, we train them. We get them when they're about six weeks old, just off their mama. (This one's mom was a working mom. She had him out in the pasture.) Then we put the puppy in a pen with a big goat, so the puppy can't pick on it. The puppy becomes attached to the goat. They kind of grow up with the goat.

Then, when we think it's about time, we put the dogs in a pen out in the pasture and feed them out there for a while. We put them in a pen by goat blocks or the stalls or the water where the goats come and walk around. Then one day we'll just open the gate. I won't say this works with every dog, but we've had real good success.

*Do they naturally fight the coyotes in order to protect the goats?*

I guess all dogs were something before they became pets. That's what our dogs—Great Pyrenees and Anatolians—were. They were guard dogs.

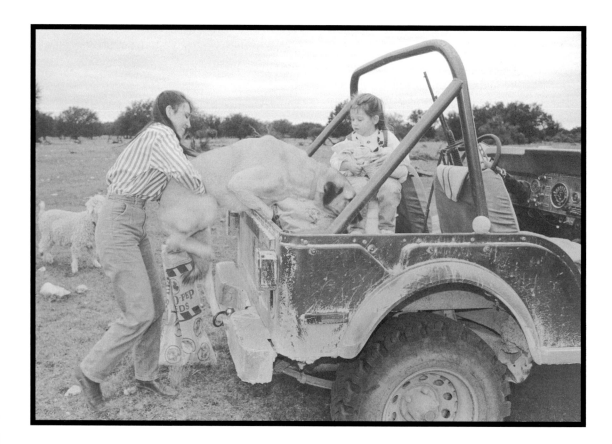

*Loading the guard dog*

*I interviewed a woman who uses guard donkeys.*

Well, everybody we've talked to says if you have cattle, the donkeys will run with the cattle. And we run goats and cattle together. We also feel that, in our terrain, a donkey couldn't get around as well as a guard dog.

We feed the dogs every other day. About once a month we go to a slaughterhouse in Brady and pick up their scraps. We bag it into feedings for the dogs and freeze it. When it's meat night, we defrost it and take it around to the guard dogs. We were spending a few thousand dollars on dog food. We figured it out: we could save $1,500, because the slaughterhouse meat's free. But it's a lot of work.

Of course, running the goats, we had to join the organization that flies the helicopters. That cost us a little bit of money. Well, we saved one way, we spent it another.

Goats eat live oak trees. So they keep them trimmed up as high as a goat is (and they'll stand on their back legs to eat). It's called goat high. That's why goats are so important for the range—they encourage the grass growth under the trees.

## WINDMILLS

Windmills are dying. People like my parents mainly pipe water from the river. Windmills require upkeep. So, if you have a strong enough pump and a good water supply, it's just smarter than pumping water from the ground.

But we have a bunch of windmills. When it's going to freeze, you turn them off, so they don't burst their pipes.

My parents still have a few windmills, but they've never turned a one off! But they live in Uvalde and it's three hours south. Like at Christmas, we're going to go down and see my parents. There will be ice hanging off the trees here and it will be seventy down there.

Of course, my parents are still in the Hill Country. We're on the northern extreme of the Hill Country and I grew up on a ranch in the southern extreme. Same type of terrain.

## PRICKLY PEAR

We have a bad prickly pear problem. Every year we burn and spray another pasture, and this one's next.

You have to be careful because the cows will eat the red pear apples. Those have seeds in them. And then they go to the bathroom and they plant them.

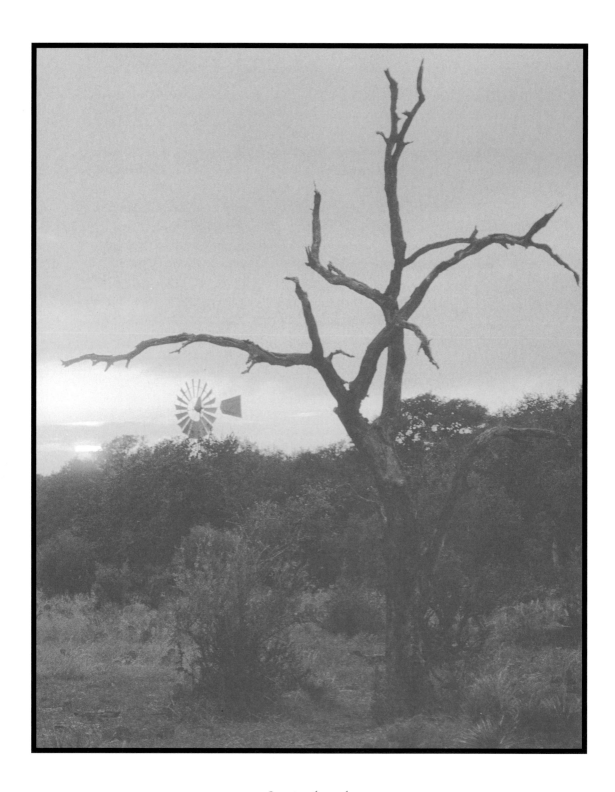

*Sunset on the ranch*

We lease some country that has mesquite trees on it and we have to always get the cows out of there before the mesquite beans come. Because if we bring them back into our pastures, they'll plant mesquite trees everywhere. A cow's just a perfect incubator for a seed.

We have to be real careful with prickly pear. You can take a leaf and chunk it and it will grow. The cattle walk through and knock a leaf off and there's a new prickly pear bush. So, after we clear this, we'll be real careful not to rotate any cattle into here from a pasture that has a lot of prickly pear in it.

Under a cedar tree, which birds plant for us, there will be little cedar trees that grow a foot a year. We go through and snip all the little cedars. You snip them at the base; that will kill a cedar.

Mesquite, if you snip them, it will make them grow more. So you don't do that to mesquite.

My father-in-law and my husband, before I came, went around and cut down all the cedars that had berries. They would leave some standing that didn't have berries, because they don't reproduce.

## HUNTING

We have hunters. It's a nice income. We do spend a little bit of money on them. In the pastures that we don't have leased out, my husband has corn feeders up so he can keep the deer in our area. We do a deer census every year. We do a day count and we do a night count.

We feed them good and we manage how they're taken. And depending on how many does we have, hunters can have one or two does. We've had a tremendous doe crop the last few years and the fawn crop is tremendous. We attribute that a lot to the guard dogs, keeping the coyotes out.

One buck and two does, that's what they take, for about $800 to $900. So, it's a nice little income. And they only come during deer season. Well, we let them come out to maintain their feeders. We encourage families. We don't charge them extra to bring their kid.

## ROCK FENCES

Here are the rock fences. At our house, we have an old German barn and a rock fence around it. I went to the library and I found letters about the rockwork. This is a German area—educated Germans. I always thought they just went around and picked up rocks to make the fences and buildings. But stacking them right is an art.

I thought the ranchers and farmers did the rockwork, and some of them did. But they had rock masons that came out and did this stuff. In general, it was backbreaking labor and it is a skill. We tried it and our wall just fell.

## MEXICAN WORKERS

My dad's a missionary and he ranches. My parents live two hours from Del Rio. They coordinate the mission efforts to Mexico, and last summer my dad went to Cuba.

My parents' ranch was on the path of—they call them "wetbacks" but I don't want to be derogatory. People knew to go to Sisi's house. (He was illegal for years and then my parents got him his papers. They had I don't know how many years of documentation that he'd been here. So, he's legal now.) But they were on the path and they'd feed them. My dad handed out Bibles and tracts. My dad's fluent in Spanish. (I wish I were.)

Just before the law passed cracking down on immigration, there'd be three hundred Mexicans a month, or more, coming through our ranch. They were trying to get over before the law took effect. But even before then we'd had a steady flow. We never had anything stolen, never had anything happen. Why, we don't know.

Robin Luce's parents were killed by a migrant worker. Very tragic.

I'm definitely against sweatshops and everything, but the rancher and farmer can't afford to hire American help. Hiring Mexican workers was the way we got things done.

I've heard rumors that they were thinking of making it less of a penalty if you were employing three or less. Because obviously, if you're employing three or less, you're not running a sweatshop. And it's not like we hire one instead of an American. It's him or nobody. And that's how most ranchers and farmers are. They're just really risking it now. Because there's too much work to be done.

## COLLEGE

I had fifty-nine hours at A&M. Now I have ninety-something because I've been going to Howard Payne. After this class I have twenty-eight hours left. I can see the light.

*What's your major?*

At A&M it was ag [agricultural] economics. I studied range science. Howard Payne does not have an ag department, so I'm getting business administration with a minor in marketing. Howard Payne's in Brownwood. I commute. It's an hour and twenty minutes from here.

*How often do you go over?*

I went three semesters and took twelve, twelve, and nine hours. I went Tuesday and Thursday. I sat in class from eight to six.

*And Havana was a baby then?*

Yes. She was almost two when I went back. She stayed with my mother-in-law until my mother-in-law broke her shoulder, and then I took Havana to daycare over there. She went with me the last two semesters and I plan on taking her next semester. My mother-in-law will probably keep Rio [her son]. I'm going to take maybe seven hours. It's a whole different story with a baby. I'm having a hard time studying and getting my work done. I guess you've never gone to school until you've gone to school with a kid.

This might seem funny, but I'm going to school so I can be respected. Because I plan on, when my kids get up, being politically active, promoting and trying to preserve our way of life. I think without an education, it would be hard for other people to respect me, even though I know what I'm talking about because I live it.

*Old German limestone barn*

I'm already a letter writer and I'm a caller. I do what I can, but I have little ones and I believe my primary job right now is to take care of them. When they're older, I'll try to become more active, like in the Texas and Southwestern Cattle Raisers' Association, the Cattlewomen's Association, even the American Hereford Association. Then we have the Hill Country Heritage Association out here. They mainly protect private property rights. My husband's on the board now.

For years ranchers just stuck their heads in a hole. They didn't fight the way they should have. But now they have great organizations that are right on top.

## GOD AND RANCHING

I go to the Baptist church, but I'd go anywhere that they believe Jesus Christ is the Lord and Savior. The church is very important to me. I guess not necessarily "the church." Jesus is very important to me. James Kelly and I both. We are active in our church. I teach Sunday school and James Kelly takes care of the books in the morning.

*The church in Mason?*

First Baptist Church in Mason. We also try to continue our Christian attitudes in everything we do. I think the Christian walk can go with anything. God set us on this earth all to function in different ways. My dad's a missionary and that's his call. My husband is not and neither am I. We function and we have our Christian role.

When we ranch in an ethical way, we take care of God's land that he loans to us (the way it's best said), and we don't harm it.

I think that because we're ranchers, we're always grounded. The minute we think we're good, God grounds us. We're very subject to weather, to drought, and to things that happen in nature. We'll lose calves sometimes and it's very hard on us. Of course, most of them live and we thank God. And we realize every day the sun rises is a miracle—and we appreciate it.

There's nothing more enjoyable and fulfilling than riding your horse on a late evening like this, with a beautiful sunset. There is nothing that gets you closer to God than that.

You don't see Christian retreats in downtown San Antonio. People realize that nature's an important way to be close to God. Everybody realizes that. We're not special; we just get to experience it, through the grace of God.

As far as percentages go, I think if you took ranchers and farmers, you would find that an enormous amount are Christians. There are bad eggs everywhere. But usually, ranchers are caring, loving, Christian, moral, ethical people.

I don't know, I have a little bit of my dad's preaching blood in me.

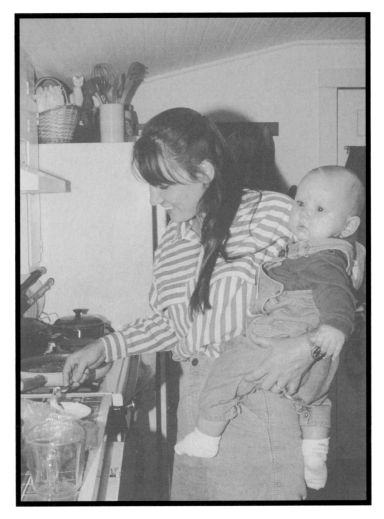

*Cooking chicken-fried steak with Rio*

## DINNERTIME

Every ranch I've ever been to, chicken-fried steak is their meal. It's not like you get in a restaurant. It's smaller and you pan-fry it. My mom did it, my mother-in-law does it, and it's all the same.

This is round steak. We also like deer; you have a ham slice and you cut it up better. It's super tender and wonderful. But this is round steak—this is what's normally used.

You tenderize it with salt and pepper. Some people put egg in their batter. I don't. And I use milk in my gravy.

*You learned this from your mother?*

Yes. I remember cooking chicken-fried steak when I was nine. My mom never had the reputation as a cook. I like cooking, but I don't know if I want the reputation of being a good cook.

    Has anybody else cooked for you?

*Come to think about it, just about everyone I've interviewed has fed me.*

Country women enjoy having people and hosting them.

    This is really informal. Lots of times I bake rolls. But I'm just going to defrost some bread. I love bread and gravy. It's one of my favorite things. I especially like it on a grain bread, like whole wheat or granola.

    James Kelly, I think we're ready.

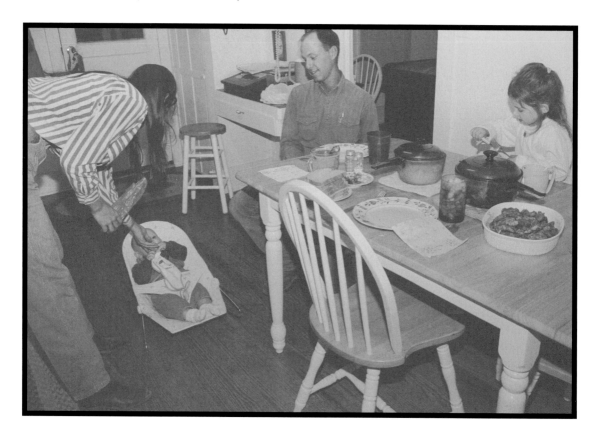

*Feeding the family*

## POSTSCRIPT

Mona Lois and James Kelly were ranching full time when I initially interviewed her. But she said that by the spring of 1996, "we could see we weren't going to make it—it didn't rain for a year."

James Kelly started working nights in town while Mona Lois completed her college degree. They thought Mona Lois would then work full time while James Kelly went back to ranching, but he was so successful in his job that he soon received raises and promotions. Their third child was born in 1997.

"We had a big decision to make," Mona Lois said. It was the choice between trying to eke out a living on the family ranch or walking away.

James Kelly took a promising job in Junction, but lived in town in a place too small for the family. Mona Lois moved back to her family's ranch in Uvalde so she would have help with the three children.

When I visited with her in 1998, James Kelly had just been promoted and transferred to Arkansas. She and the children were about to join him. "I'm kind of excited about moving to Arkansas," she said. "It's hard now with James Kelly working up there. He's a good husband and a good daddy and we all miss him.

"I've never lived in town. I'm a little nervous about that.

"In our minds, we think in three to five years we'll be back on the ranch in Mason. We'll have the kids' colleges saved for."

Mona Lois felt she and James Kelly could pass along their ranching heritage without having the children "in the dirt."

By 2004 Mona Lois, James Kelly, and their four children had moved back to Texas, but not to the ranch. We corresponded by e-mail and she wrote, "I do miss living in the country and most of all I miss the animals. Sometimes I regret that my kids are not being raised on the ranch. However, we have been really happy and we have definitely enjoyed the burden of finances lifted off our shoulders."

She said her parents were depending less on ranching and more on tourism and hunting leases at the ranch. And she still had hopes of returning to ranch life, either in Mason or Uvalde.

By 2009 Mona Lois and her family had moved back to Mason. "We lived out on the ranch for two years, but my job (I teach sixth-grade math) and all the kids' activities enticed us to move to town."

She and James Kelly had made their way back to ranching and were preparing for the Schmidt Hereford Ranch's fiftieth-annual production sale.

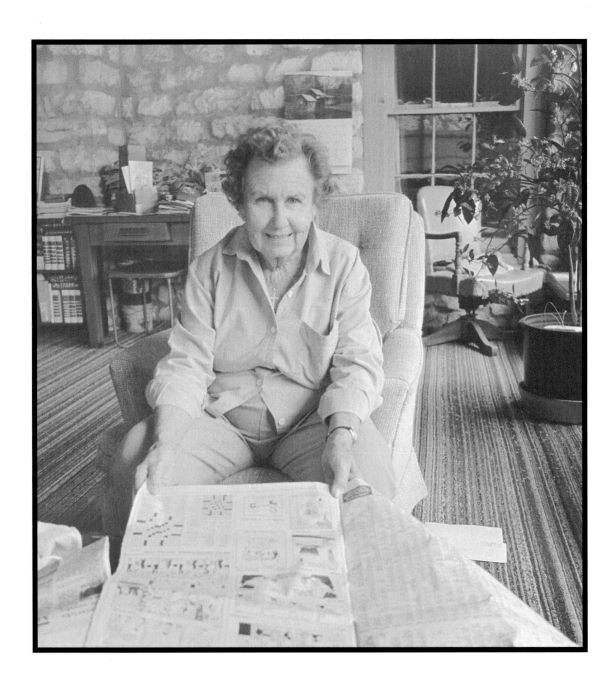

*Marguerite "Teeny" King Stevenson*

# Marguerite "Teeny" King Stevenson

## TELEGRAPH, TEXAS

B. MARCH 12, 1918; D. MAY 24, 2010

### WHAT I DO

Some people have asked what I do and I say I'm a gambler. Well, I am—it depends on whether it rains or not, whether it makes the crop. And if your grass doesn't grow then you have to buy feed for supplemental feeding for the animals. Many years, there's absolutely no profit at all.

So you have to be able to plan ahead and you have to know that there are certain years when you can't get things that you'd like to buy or you can't make trips that you'd like to make. You have to be able to plan for all contingencies, such as poor health, because nobody's going to pay your hospital bill for you if you have a ranch.

It takes a person with a good deal of self-control and self-discipline and energy to be happy as a rancher.

*How long have you lived here?*

Forty years. I love it! Sometimes I don't see another person for three or four days. And that suits me just fine. I'm never lonely. There's always too much to do. I like reading. I never get caught up on things I like to do.

When I first moved out here, we didn't have a telephone—by choice. If anybody wanted us, they could come to get us. Then, when our daughter came along, she wanted a telephone and we got her one.

I have a son, Dennis, who lives in the house next to me. He was born during World War II. At the time, his father was overseas. [Marguerite's first husband, Marshall Heap, was a B-17 pilot.] His father was killed when Dennis was three months old. My family had lived in Junction, so I moved back here.

Eight or nine years later Coke and I were married. And then we had a daughter, Jane, who lives on the other side of town.

Coke's first wife died when he first became governor. It was after he was governor that he and I married.

*Had you known him long?*

All my life. But, I started to see more of him when I was county and district clerk and he was practicing law. So, we got married.

## HISTORY

I was born in Segovia, the other side of the county. There is no town there. We lived on a ranch. At that time, children were born at home.

Off and on I've lived in a city. While my first husband was in the Air Force we lived many different places, Waco to Salt Lake City, Memphis and all around the country. Before I was married the first time I lived in Midland and worked at an oil company. But I really prefer living in a small town or the country.

*What is your maiden name?*

King.

My father's people were from the Gonzales area. His King ancestors came to Texas in the 1840s. John A. King was an engineer and surveyor who helped lay out some of the original county lines in Texas—in fact, the road that brought the Germans from Indianola to New Braunfels and Fredericksburg areas.

I am a member of the Daughters of the Republic of Texas. I'm on the Alamo Committee. It administers all of the management and money and everything else concerned with the Alamo. The Alamo is owned by the State of Texas, but it's taken care of by the Daughters of the Republic of Texas. We don't use any state money. The only money we have, the money that we use to pay all the employees and security and so on, comes from sales of items in the gift shop. We run it efficiently, with no cost to anybody. You see things in the paper occasionally that the state should take over the management of it. And people say, "The DRT ought to take over the management of the state!"

My mother's people came to Texas before it was a state. I have about fourteen ancestors who were here then. One of them, Hiram Hall, was born in Texas in 1831; he was a citizen of Mexico.

*Where were those ancestors from?*

Entirely British.

## WATER FROM THE SPRINGS

We have a unique water system for this area. See the ditch running out by the front yard there? It's spring water. The water comes from a spring across the river. The original water right, for permission to divert water from the spring to this side of the river, was granted in 1895. And in the early years it was transported from the spring through a flume across the river.

*Spring water and chickens*

Then after it got across the river, it ran by ditches to water fields both north and south. But in 1943 Coke installed pipeline under the river from that same spring and the system, as engineered then, would transport water by gravity from the spring to a level at the top of this two-story house. We still maintain that system.

As it comes out of the little spring up there, there's a dam about two or three feet high, to create the little reservoir for the water to gather in. Then it comes down through those two six-inch pipes, then goes under the river. On this side of the river it is converted into a ten-inch PVC pipe and goes underground to my son's house, which is upriver from here about a quarter of a mile. From there it runs to the south and waters several pens and a house that is sometimes used by tenants, and then runs this way and waters the fields that are in between our houses, then waters this yard and meanders on back to the river.

So, we use it to irrigate with and Dennis [her son] uses it for all household purposes. He gets the water as it comes directly from underground. We use the water to irrigate the yard and the fruit trees and the nut trees and then also for watering animals in various traps and pens.

## RANCH OPERATIONS

We run only cattle now, because of the predator situation. We used to run cattle, sheep, and goats but it got to be such a problem with coyotes, foxes, wildcats, and an occasional mountain lion. And in recent years we've had a lot of the feral hogs around and they're really hard on the lambs and kids. Also, we have golden eagles. We have a few bald eagles in the wintertime, but I don't think they bother anything in particular.

Of course, we have a big emphasis on maintaining the wildlife because leasing for hunting privileges is one of the main sources of income. We really like that better anyway, because we love the wildlife. It's mostly deer and turkeys. It's more profitable than straight ranching and people seem to enjoy it and don't seem to mind paying what we require to lease the place.

We have never attempted to raise exotic animals. A few of them come in on their own. Down in our river bottom, there are a lot of axis deer. They come and go from the neighbor's places. We don't seek to have exotic deer because they say they'll eventually take over the ranch from the native deer. We really don't want that—we like the white-tailed deer.

*Did you lease to hunters forty years ago?*

We did not lease to hunters then. A good many ranchers did. But we didn't until about twenty-five years ago. Then, we leased to friends for a while, and only on weekends. But about that time, we'd had a few good years as far as rainfall was concerned and the range was in excellent condition. The deer just multiplied. Hunting was really needed as a matter of control.

## THE RANCH HOUSE

We have some pretty good deer, as you can see around. [She gestures to the mounted deer on the living room walls.] The one in the corner was one that Coke killed several years before he and I were married. It's in the Boone and Crockett record book. It's very fine. He had an elk head that was on the mantle here. When I moved in here, I didn't particularly like having animals in the living room, but I figured if I couldn't beat him, I'd join him—I killed this one up here.

The fireplace is made up completely of fossil rock that was gathered on the place. There's a ridge about four miles east of here. When Coke was building the house, he went over there and gathered up those rocks. Each one is a petrified something or other. They're petrified wood and petrified horns . . . this is moss agate. The granite came from around Fredericksburg. The mortar was made from red sand from the east corner of the county.

These walls are solid rock and the only wood in it is in the frame of the roof and the doorframes and window frames. Coke built a house that burned in 1929, when he first went to the legislature. So he determined he'd build one that wouldn't burn. Out here is the sunroom where I work and live and create chaos all the time. I try to read the paper out here every day—*The Dallas News*. Coke started taking *The Dallas News*, and although mail in Texas is notoriously slow, I get *The Dallas News* the day it's printed. It's been doing that forty-five years. And I couldn't get the Mountain Home paper until the next day by mail. But it's not fit to read anyway.

I have a lot of peafowl. Their loud noise bothers a lot of people, but I don't mind it. The peafowl themselves like to be around people. Occasionally they'll get up in the window and look in at you.

It's about 110 miles to Mexico. Nine times out of ten, the illegal Mexican immigrants don't bother anything and they're perfectly good people. But it is close, and there are some people who are associated with narcotics. One time not too long ago a helicopter kept going up and down the river; they were looking for marijuana.

133

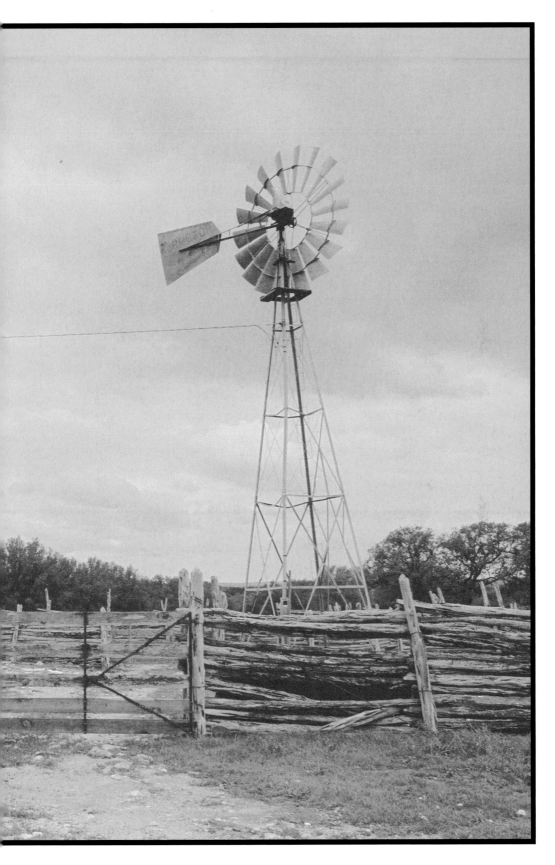

*Barn and windmill*

## THE LAND

One of our main problems with ranching is control of cedar brush. Here, we've had some pushed. You get rid of it and then in about twenty years it's up twenty feet tall again. Sometimes, if you keep at it, you can eradicate it and it won't come back. The more beneficial grass and good things you can get growing, the easier it is to control. So after we eradicate it, we try to keep livestock off of it for a full year, so we can get a good growth of grass and beneficial shrubs.

Before we're allowed to cut or bulldoze, the people from the government offices have to come out and check to be sure we're not eliminating any of the habitat of the golden-cheeked warbler or the black-capped vireo. Now, we do have some of those birds, but they nest in the big cedars in the canyons. We'd never cut any of that cedar anyway. We like to have it there. The kind of cedar we eliminate is small cedars. Those birds use cedar bark to make their nests. These little cedars don't have that kind of bark on them.

The air here is pure. That's another reason why the trees shouldn't all be eliminated—they use carbon dioxide for food. The air that we breathe is purer than that in the city.

*The Stevenson Ranch falls*

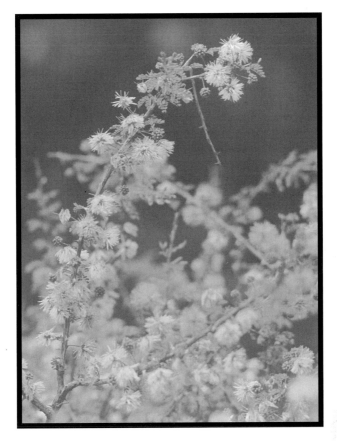

*Catclaw*

There are a good many exotic trees and plants along up in here, such as Lindheimer's silktassel and Eve's necklace, all sorts of things.

I keep calling this cedar, but it's not cedar actually, it's juniper. These are live oak. This is mountain laurel, agarita, there's some evergreen sumac in that. These are shin oaks.

*What is that purple plant?*

Catclaw. That's a beautiful one there, isn't it? I've been wanting to find a plant of that and put it in my yard. It's awfully pretty. It's thorny, as the name implies. It's so fragrant.

This is Grandma Mountain we're going around now. I have six grandchildren: My son has four children and my daughter has two. His children are sixteen years up to twenty-five. Jane's are sixteen and twelve. They all live in this area. And that's nice.

*The older ones haven't chosen to move away?*

No. I suppose Marshall [her grandson] will move away when he gets a job (he just graduated from UT with a civil engineering degree, but is working on the ranch now). That's one of the disadvantages of living in a small town: There's no place for much career if you don't have a ranch to go to. There are not many jobs left around.

Right here our elevation would be 2,100 or 2,200 feet. In Kerrville you're getting down to about 1,500. In San Antonio, it's about 700 or 800. One reason we have a strange climate is because of our high altitude and the hills. We have sort of a different environment from other places at the same latitude.

*What's your favorite time of year out here?*

Spring. But I enjoy the summer, too. I enjoy the warm months; I don't like the cold months. In fact, I really require sunshine to function.

We certainly had a lot of dark days this last winter, more than usual. In the upstairs of my house the sunroom is not artificially heated in any way. In normal winters, almost all the time, it's comfortable to sit in there and read the paper. Not this winter. It was cloudy all the time. But not as much rain as we had last year.

[Marguerite shows me her sleeping porch.]

I slept indoors only three or four nights last winter. This is where the grandchildren all like to sleep. I put a bunch of cots out.

One thing that I deplore is the fact that so many people have what we call these "booger" lights. I don't like the countryside to be all lit up at night. From my backyard I can see the floodlights over at the compressor station about halfway between our house and town. I really like the countryside to be dark at night.

## CONSERVATION

*Do you consider yourself a conservationist?*

You bet I am. Coke always was. He never would allow any cans, bottles, waste, to be thrown into the canyons. As everybody else in the country did, we always dug pits and when they were full, bulldozed them over or covered them over by hand, with spades. He was very careful about the game and wildlife conservation. We were very careful with all these springs. The streams were taken care of so they wouldn't get polluted.

A lot of people didn't practice conservation in the old days. They allowed the deer population to dwindle to almost nothing, in the Depression. They'd just go out and shoot does, fawns, and everything else, to eat. But it got to be there were hardly any deer at all and almost no wild turkeys, because they'd shoot them out of roosts.

## SEVEN HUNDRED SPRINGS

Seven Hundred Springs, which is the main source of the river, is only three or four miles upriver. And then Paint Creek comes into it less than half a mile up there. So this water is purer, as far as drinking is concerned, than almost any city water. It's what we swim in.

That rock across the river is soapstone. The big pool of water that you'll see down here is solid rock on bottom and twenty to thirty feet deep.

*Do you fish here?*

I don't really like to fish. When Dennis was little I used to take him fishing—we'd each have a pole. He'd throw in his line and pull out a fish and I'd sit there all day and never get a bite. I do like to eat them.

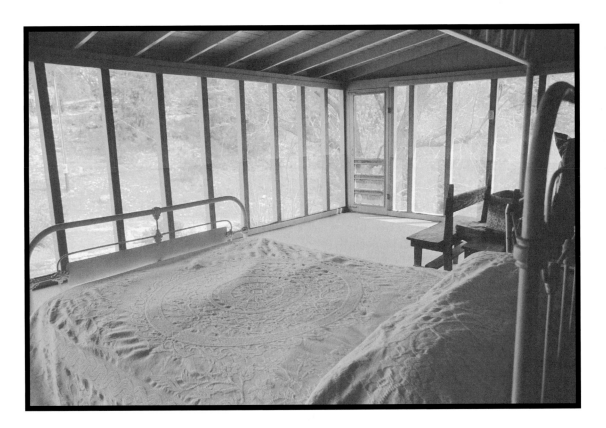

*Marguerite's sleeping porch*

We have beavers here. If left alone, they cut down huge trees. My grandchildren call this the Deep Dark Woods Road. You can almost always see deer or turkeys here.

There are springs boiling up from the bottom of the river here. It's such a big hole of water—it's like a lake.

This is the only major river in Texas that runs from south to north. This joins with the North Llano in Junction and then they run in a northeasterly direction to join the Colorado River.

Up there is where I swim to every day in the summertime. Our ranch where I grew up, at Segovia, was on a hill just above the river. I was the youngest of six children, so I learned how to swim by the time I could walk. I'm just at ease in the water as I am on land.

It's this area down here where all of the turkeys nest. We don't allow any hunting down here. Within a few feet of here are several kinds of trees: pecan, live oak, hackberry, persimmon, chinquapin, and elm. Over here is mesquite, agarita, tasajillo.

Along almost any of these ranch roads, the distance from my house to the falls is almost exactly a mile. So, when I walk up there and back, it's two miles. It's so much more pleasant to walk on than a track.

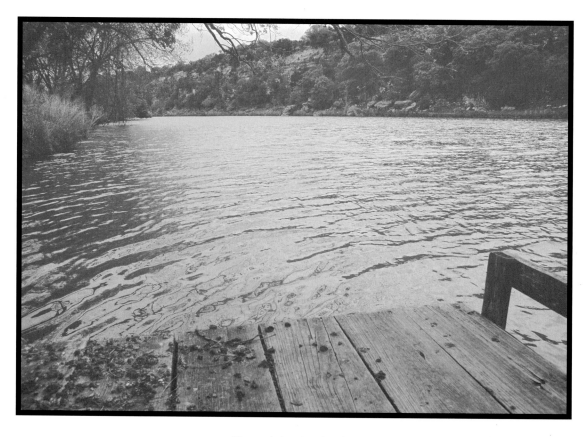

*Marguerite's swimming pier*

## FIREFLIES AND HONEY

*Do you get fireflies down here in the summer?*

Yes, and that's another reason I don't like there to be too many lights around.

In one of the little caves in the side of that hill, there are beehives that have been there since before 1900. See where there's a big overhang? They used to have a rope ladder that came down. You could get in there and Coke said they could get big wash-tubs full of honey. They are a particular kind of bee that my son, who is quite a naturalist, can identify. We don't want the killer bees to come in here and run them off.

See these remnants of a road? The first known expedition that went down the South Llano River was, I think, in the 1600s. There's been a road along here ever since.

## COKE

Coke was such a warm and vibrant personality—the easiest person in the world to get along with. And there was never a dull moment; something was going on all the time. There were so many things that he was interested in: ranching, his law practice.

He did a good bit of cedar control, chopping by hand. Anytime he didn't have anything to do, he'd go out and chop cedar.

He was member of the House of Representatives, then he was Speaker of the House. Then he was Lieutenant Governor, and then Governor. He was the only man in history who served in all those capacities.

The last years of Coke's life, he was legally blind. Then he was able to direct me in taking care of the accounting and so on. He never was totally blind, and was quite independent and, except for driving and reading, did everything he'd done before.

He was a lawyer, so when he wasn't able to do the outside work here, he spent more time on his legal business. The Thursday before he went to the hospital for the last two weeks of his life, he was attorney for a divorce suit. And the reason he was in the case was because there was a great deal of property and money to be settled, and he was able to do all that calculation in his head, better than the other lawyer could do with pencil and paper.

He's the only person I know who achieved a great age (he was in his eighties when he died) who never had so much as a corn on his foot or anything else wrong with him. He had never been in a hospital until two years before he died. He was extremely strong, with all his chopping muscles.

Last year, I got $32 that Medicare paid. The only things I've used it for have been eye examinations and skin checkups. I haven't been sick.

*Do you think living on a ranch is a reason for your good health?*

I think so. My good health is probably the reason that I enjoy the ranch. People used to talk about how we didn't have a telephone: They'd say, "What if you got sick?" Well, we didn't get sick.

## RANCHING'S FUTURE

Even in the time I've spent out here, we've had to adjust to the changes. I told you the change we made from a cattle, sheep, and goat operation to mostly just cattle and emphasizing the hunting. And oil leases have been important to us. But it gets harder and harder to make a living.

Because there are so many rocks around here, it takes a good many acres to run a head of cattle. We have maybe one cow and calf pair to twenty acres. In order to make a profit on ranching you have to have quite a number of acres. Not like some of these little places in East Texas where they have a few acres and have fifty cattle on it. You just can't do that out here.

I don't think you can buy land and make a career of ranching. But there are a lot of families that manage to keep the land in the family and, by some way or another, manage to get a job off the ranch. My son does rock work.

Jane's son, my grandson, is a wonderful, well-rounded boy. He likes so many different things. We keep talking about what he wants to do. He's interested in science and archaeology, biology, theatrics, writing and speaking. He wants to go to A&M. I said, "That's fine. Go on and do everything you want to. But then you go to law school. If you have a law practice in town, you can also have the ranch. But, you can't really depend on ranching to make a living for a family."

## WOMEN RANCHERS

*What does your daughter do?*

She lives on a ranch, about twenty miles on the other side of Junction. Up until six months ago she did work in Junction for a CPA. She has the children. She and her trust own half of this ranch, but I lease that part from her. She lives on her own ranch out there.

Her husband was killed in an accident in 1990. So, she's been running that ranch on her own.

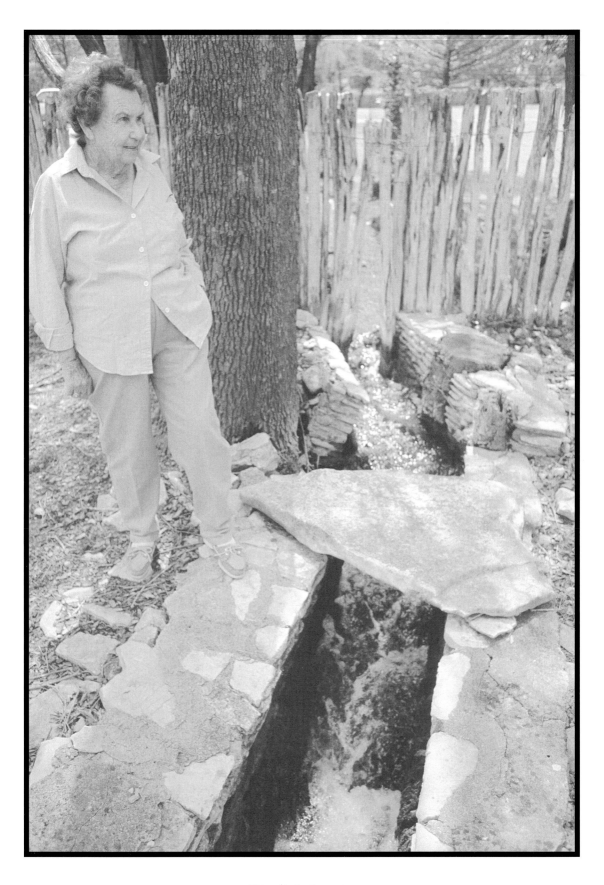

*Natural irrigation system*

Her mother-in-law lives out there and does little things, like seeing if the windmills are running and there's water for the animals. But they also have a contract Mexican working out there for them, so he does more or less what my son does here: takes care of the cattle when they need special attention, checks the calves and feeds them in the wintertime. We don't feed them in the summertime.

I have several friends who are widows. They operate very efficiently. They have some help to do the physical labor that needs to be done.

I have friends who did things like hauling and dumping hay and so on and I never did that. But what I would do was drive the pickup and let them throw the hay on or off and things like that. I made no pretense at being a muscle person.

I really believe women sometimes get along better with animals than men do. Especially with cattle and horses. I'm not so sure about the sheep and goats.

*Are women gentler with the animals?*

Calmer . . . although some men are, too. Coke was that way. Cows are so much easier if they're treated gently and you can go among them to detect anything that's wrong and then treat them.

## POSTSCRIPT

I visited with Marguerite, known by many as "Teeny," in 2003, and at eighty-five she was still living at the ranch and sleeping on her porch all but about two nights a year. "I've never been sick, never had a broken bone," she said. "I think sleeping out in the fresh air helps.

"I don't do anything excessively. I don't smoke. I do drink a glass of wine or a sip of whiskey-and-water occasionally—certainly not on a regular basis.

"I exercise.

"I'm happy to live on a ranch. I was born on a ranch. I always said, 'When I grow up I'm going to have a river in my front yard.'

"I got what I dreamed of."

Marguerite and Coke were married Jan. 16, 1954, and their daughter, Jane, was born two years later on the same day. Marguerite said she'd walked down into Telegraph Canyon the day before Jane was born. She gave birth in the front bedroom with "no drugs at all."

Her good health had continued through the years, though in recent years she developed cataracts. She said she had surgery so she could shoot her gun again. She

bought some "dime-store glasses" for reading and stopped driving to San Antonio. Marguerite said that was fine with her because she had no desire to leave the ranch, anyway.

She had just turned over the reins of the ranch to her son, Dennis, but seemed very much in touch with the goings-on of the ranch and the patterns of weather and wildlife. "It was so dry last summer, we had to sell most of the cattle in the middle of it," she said. She'd observed that the robins, which always winter at the ranch, hadn't shown up that year.

But in spite of the drought, the Llano River did not decrease in flow. "It's the strongest river in Texas," Marguerite said.

Feral hogs had become a tremendous problem. "They eat everything that moves, including fawns and rabbits," she said. "The hogs plow up the river bottom. There is not any fence that will hold them."

She had tried to control the hog proliferation with hunting and trapping, but said the population was hard to contain when the animals begin reproducing at eight months of age and have two litters every year. The "government people" had hunted the hogs from helicopters and in one day killed fifty on her ranch and one hundred more on neighboring ranches.

When I spoke again with Marguerite in 2009, she had moved from the ranch to live with her daughter, Jane Chandler, in Ozona. She was ninety-one, and as enjoyable to talk with as ever. The Stevenson Ranch was passed into the hands of Jane's son. Marguerite died May 24, 2010. She was 92.

*Lena Oehler Kothmann*

# Lena Oehler Kothmann

*with daughter, Milda Kothmann*

## RESERVATION, TEXAS

**B. MARCH 5, 1914; D. JULY 10, 2000**

I always start the day with, "This is your day and I'm your child. Good morning, God. Show me your way." It really helps you know who's in charge.

Sheep are my precious spot. They call sheep a dumb animal because it follows you. But Jesus said, "Follow me and I'll make you fishers of men." He said, "I am the good shepherd. The good shepherd cares for his sheep." You can lead a sheep. But a goat! I never did care much for goats. My husband loved Spanish goats and I told him I knew why Jesus said they belonged on the left side: they go through every fence and crack they can find!

I've enjoyed life on the ranch. I wouldn't want to trade it for the city. God forbid I ever have to do that.

### FAMILY HISTORY

I was raised in Reservation. My father moved here from Llano when I was two years old.

When I was nineteen, I left home and worked with a Methodist preacher and his wife in San Angelo. They had two little boys and I kept house, did chores, and cooked for them.

Then, when I was twenty-one, I came back because Mama was sick. I went to work in Mountain Home at the post office and that's where I met my husband. We met before Christmas and were married at Easter. It was a quick romance.

We moved to his ranch and lived there until '78. We had married in '36, on April 12. Then here came Edward, my son, and then Joycelyn. (Joycelyn teaches in Junction.) After four or five years I had Milda and then after six years I had Merle. She's in Carrollton.

*Is she a teacher too?*

MILDA: All four of us got teaching certificates. Edward taught, but now he's a mechanical engineer.

LENA: He got summa cum laude at the University of Texas and Westinghouse offered him a job. When he got up there to Pennsylvania he got his master's degree.

MILDA: And PhD.

LENA: I put the desire for education in my children because I had to quit school before I finished the fifth grade. At the time, I was the oldest of six children and Mother needed my help. (There were eventually fourteen children in the family—seven boys and seven girls—Milda later said.) Then, you didn't have to go to school after you were fourteen.

MILDA: But you didn't start school until you were . . .

LENA: Eight.

*Where did you go to school?*

LENA: At Reservation. Elna Duderstadt married Mr. St. Clair, the teacher. It had been a one-teacher school, but as the school got bigger Ella took the first and second grades. She was in the tenth grade herself.

We had forty-five students, if I remember right, and all those grades. The teachers were told, "Teach them how to read." And I guess I learned to read.

## SELF-RELIANCE

[We drove to their old home place that is now leased out to hunters. We sat inside and ate lunch they had brought: sandwiches of venison and dill pickles, chips, tea, and homemade fruitcake.]

LENA: Edward, when he was in school, didn't like the lunchroom. He liked my lunches. He liked a piece of that fruitcake with some butter on it.

MILDA: And Mother or Daddy milked the cow. We made our own butter and clabber and cheese.

LENA: We planted a garden. We canned.

*You were self-sufficient.*

LENA: Yes. It's like they said of my father: he was as stable as the rocks themselves. He lived at home and boarded at the same place.

We finally had a radio, but for a while we didn't even have that. My husband would get the mail once or twice a week. He'd ride out horseback five miles to get it.

But we nearly always had a phone.

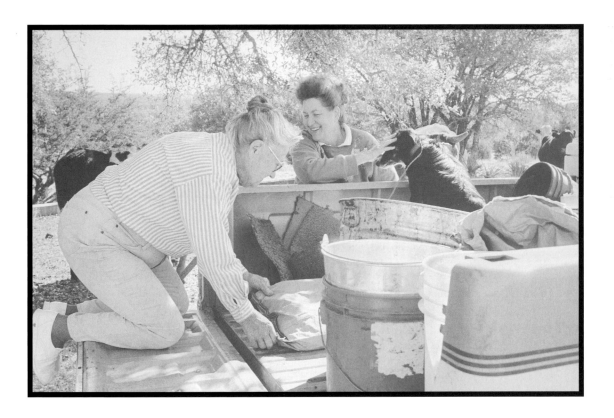

*Lena and Milda feeding cattle*

When I got pregnant for the first time, my husband said if it was a boy he'd buy me a washing machine.

MILDA: And she had a boy.

LENA: I thought that was so funny.

MILDA: You had an old black pot and you heated all the water.

LENA: We didn't have a hot water heater and all that stuff. We got a bathtub—on our honeymoon. We got a sewing machine, a dresser, and a cabinet. And I think it all came to about $60. I think I paid $10 for the sewing machine and probably $10 for the bathtub.

My husband fixed up part of the garage and we put the tub in there. We'd heat the water on the wood stove with kettles and teapots, whatever we had, and we'd pour it in the tub and add the cold water to it.

*Did you ever long for more modern conveniences?*

LENA: I didn't really see any need of it. We were involved in paying for the land. We lived in a shack until we paid for the land, and we looked forward to someday building a house.

We knew we couldn't make a living without the land. It was just everything. When the time came when we could pay off the debt and the back interest, the war started and we couldn't build. That was in '41. We didn't get to build until '48. We had all that delay because they wouldn't let us have any supplies.

My husband's father had six boys and two girls. As they got to be twenty-one or twenty-two, he gave each of them enough money to pay down on a section of land.

My husband had gone to business school after he graduated from high school. When he was twenty-two this land, old Schreiner land, came up for sale. He loved it. My husband was very optimistic about paying it out, fencing it, and digging wells on it. He paid a fourth down on 2,094 acres, which would be 500 acres' worth.

When we got married in '36, during the Depression, he owed $4,500 in back interest! Compound interest, interest on interest. Mohair was 9¢ a pound. That was the thing that made it hard to pay.

He went to Charles Schreiner and said he'd give the land back. And Schreiner said, "Oh no, I'll trust you. You'll pay it out."

So that's what he did—we did pay it out.

MILDA: Mother and Daddy had to pinch pennies for years.

LENA: Oh, yeah. That's the reason we were here. That's the reason he rode to the mailbox. We just didn't buy anything.

I remember the times we stopped by the grocery store. When my husband passed away in 1971, I went through some of the old bank statements. I found we'd paid only a dollar at a time to the grocery store. We had to buy sugar and flour. The rest we had here or we did without.

We had a garden and were always ready to preserve or take care of everything we got. It may have been a time when we didn't have very much need, but still I can't imagine buying a dollar's worth of groceries. Our principle was: we would not charge for groceries and such. We had to have the money to pay the interest on the land.

We had chickens, eggs, and milk, which is the main thing of the grocery bill now. So we cooked our own biscuits and light bread and had milk and cheese, eggs, and chickens. We had a good diet.

MILDA: You made your own soap too.

*How did you do that?*

LENA: Well, you use your black pot and you use three cans of lye and seven pounds of grease. You could use the old cracklings you boiled (you wouldn't know how to do that either, I guess) out of our hogs. We'd dress our hogs and render the lard and if any of the lard got old, well, we'd use that old grease to make the soap. I boiled it all together. It's like cooking syrup for popcorn. After you boiled it for a while, it acted like it was going to thread. Then it was ready to take out. You'd put it in a tub, wait for it to get hard and then you'd slice it.

MILDA: You'd put a segment of that bar in the washing machine. It was a wringer type washing machine.

LENA: Yes, it would get them clean, I can tell you that! That old Maytag was the real thing. When electricity came, we put it on electricity. I think that old motor is still in the garage.

*How did it work before electricity?*

LENA: It had a motor on it like lawnmowers.

*It ran on gasoline?*

It just had a motor under it and you cranked it.

151

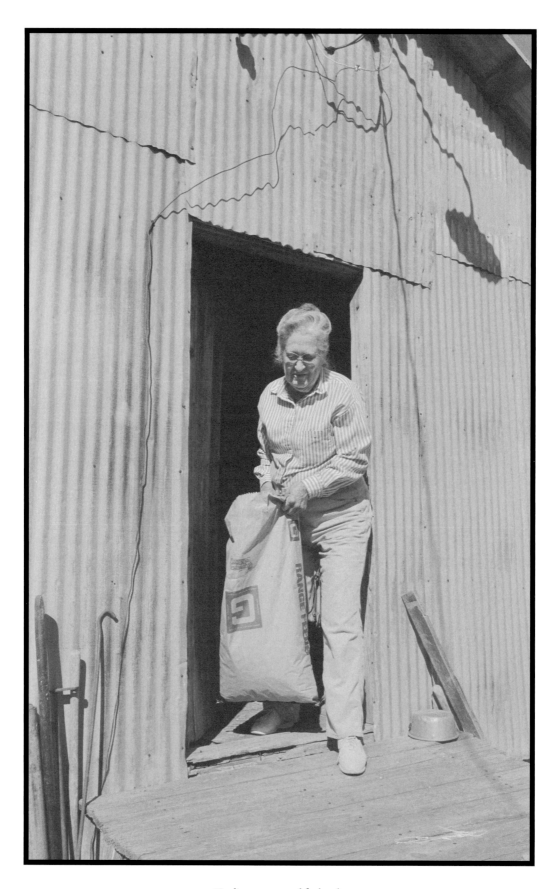

*Hauling a 50-pound feed sack*

*You didn't have a dryer?*

Goodness no, we hung it on the fence, or the line.

*Fresh-smelling laundry.*

Yes it is. I still like to dry mine mostly on the line.

*Did you buy clothes?*

LENA: I sewed all three daughters' clothes through college.

MILDA: She tried to sew Edward's shirts, but finally said, "Forget it." She was so embarrassed; she sewed the pocket on wrong or something. Bless her heart. I wish she had a dollar for all the garments she's sewn for us. And she sewed for herself.

LENA: Why sure.

*Were your kids born at home?*

MILDA: I was the only one born on the ranch.

*With a midwife?*

No, at that time we had Dr. Wiedemann living in Junction, and he made house calls. Can you imagine, twenty-five miles on a house call?

*Did you work from dawn until dark?*

Well, probably. It just depended on what was going on at the ranch. Of course, there were always fences to repair. Most of the time it was ordinary things that happen on a ranch. You had to raise 'em, sell 'em, round 'em up, shear 'em, and all those things.

*Do you consider it a hard life?*

No, I loved it! I was raising my family at that time, putting them through school. They didn't get to go to the football games like kids do now.

MILDA: Or the movies.

LENA: Or the movies.

MILDA: And we didn't have a television.

LENA: Well, we really don't get good reception out here.

MILDA: Daddy wasn't going to be out the expense to put up an antenna.

LENA: We had a radio and that was a big thing.

MILDA: It was. We weren't slighted in the least.

LENA: We got the newspaper. And Milda was going to the mail every day. We had an old '41 Chevrolet that they learned to drive.

MILDA: And we all learned to drive using it. We'd drive out to meet the bus and we'd just leave it out there while we were at school.

*How old were y'all when you learned to drive?*

MILDA: About twelve or thirteen.

LENA: When the older ones left and had their degrees, then the younger ones started driving.

MILDA: Daddy and Mother taught us to work and that's been something to be proud of. I think that's important nowadays, too.

LENA: Children should be made to work, to clean up their own rooms and all that stuff. They shouldn't be allowed to not do anything. When the labor laws came in, they were after anyone who had their children working. I think that's what brought about all this rebellion, shooting, and gangs. Children need something to do.

154

When my husband died I stayed out at the ranch and took care of it for twelve or fifteen years. I built the new house, on land I inherited from my family, in '75, but I didn't move there until '79.

I moved on to the new place thinking one of my children would take the ranch and run it, but they haven't.

MILDA: I'm helping now.

LENA: There you go. Milda's pretty good help. She always reminds me what I'm supposed to be doing.

So, I continue to be in charge of the ranch—I have been for twenty-two years.

*When your husband was living did you help with the ranching?*

Oh yes, with everything. That's the reason I knew how. He had shoulder problems; therefore, I took the shoulder work lots of times, even digging postholes. I was always there when he fed the stock and this, that, and the other.

*When you were raising children, did you still help with ranch work?*

Oh, yes. And we never had babysitters.

## FRIED TURKEY BREAST

*What kind of livestock did you have?*

Sheep, goats, and cattle. And then, of course, we have deer. My husband was a great lover of deer. He came from London—London, Texas—and they didn't have deer there. He really loved wildlife.

He taught me how good that turkey breast was when it was fried instead of baked.

*Wild turkey?*

Yes. You'd boil the rest of it and have all kinds of good salads and sandwiches out of it. But the breast is what we loved.

You can buy the breast now, you know, by itself. The skin and the bones in that, you boil for your dressing. Then you slice the breast meat just like steak. Bread it and fry it.

MILDA: After frying it, drain your grease off and put it back in the pan. Add water and stew it for thirty minutes to an hour and it's really tender that way.

LENA: And it's juicy and nice, not all dried up.

MILDA: Daddy taught us that.

LENA: When he was raised over in London they went out and killed wild turkeys. They looked forward to having that breast.

## THE WILD HOG AND THE PREACHER

[As we're riding through a pasture, Milda suddenly says]: Should we put the rabbit out here?

*What did she say?*

LENA: The rabbit. She picked up a dead cottontail on the highway. We use them for bait.

MILDA: Only if they're not mangled and they're easy to get. We're being inundated with hogs and we need things to bait our hog traps with.

LENA: When my husband passed away we were really beginning to have problems with hogs. We called them Russian hogs—they had such terrible teeth.

So my first experience after taking over the ranch was dealing with the hogs. I'd hide near the turkey feeder barrels. The hogs would come to the feed at night. I'd strap a flashlight on my .30-.30 and wait. I got a few, but it was kind of a hard thing to do.

Then I got the traps, and I could catch a whole bunch of them instead of just one.

But I always remember one experience that was so wonderful. I drove around the field over there, and just as I drove by, there were two big old sows right there. They ran over the hill and didn't see me. I got my gun and went down there and killed both of them and they had eighteen pigs in them!

*Do you still have a problem with the boars?*

We have a whole lot of them.

[She points to large areas where the ground has been disturbed, especially around prickly pear.]

See where they've plowed the pasture up? They just root the ground up. There was a fellow that ranched close to Segovia and he took a fancy to penning up those wild hogs—I don't know what he intended to do with them. But he lost his health and then opened the gates and let them out. So that's the reason we've got them. Before then, we had kept check on them most of the time.

MILDA: Now that hunting season's started we hope to bait the traps more.

LENA: I want to drive up here and see if I've got one.

[The trap is empty.]

The pastor of the Pentecostal church in Harper had pens. If I caught the hogs he'd come get them and fatten them and then they'd butcher them. I'll never forget this: he brought another preacher with him and this other preacher had his camera and tried to take the hog's picture. He put his camera through one of the slots in the pen and . . . [She breaks down laughing.]

MILDA: It charged at him!

LENA: Boy, he got away from that fast! It was so funny! He really jumped!

## SHEEP

Our fields are barren because we need some rain. We still have sheep and goats and cattle. Milda gets in the back of the pickup and pours out feed during the winter months when we're feeding. The sheep are supposed to lamb next month.

*They look fat.*

Aren't they pretty?

    I take half of my ewes and breed them to Suffolk bucks so I can hit the early market with them. Then I breed the other half to Rambouillet rams to replenish my ewes. I don't run crossbred Blackface ewes.

    [She calls the sheep] Ewetie, ewetie, ewetie!

*Do you still help with marking lambs and so on?*

Simon and I did it for quite a few years. But now I don't. He has somebody to help him. But I lead them in the pickup and the workers, on horseback, bring them into the pen. It's real easy.

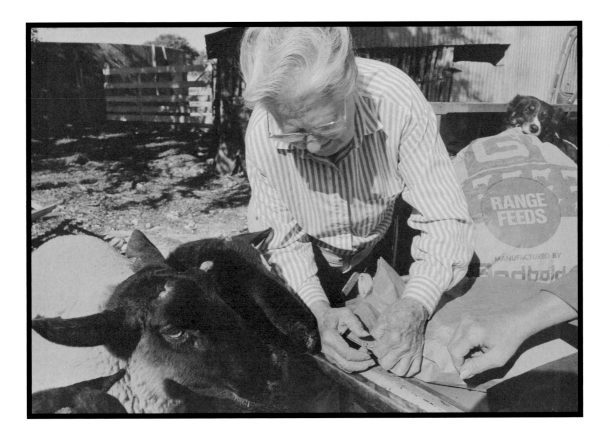

*Impatient sheep*

The thing that I've found is: you always raise your own, and that way they're used to you and they come. I can feed them and I can handle them. But if you have somebody else's stock that hadn't been handled like that, you just can't work them.

That's the reason all mine are gentle; I raised them.

## PREDATORS

We have guard donkeys. My son in Pittsburgh asked me what the donkeys do to keep away the coyotes, and I said, "They bray and I pray."

I used to stay out here quite often, maybe I'd feed on Tuesday and then feed again on Friday and I'd stay between times. I'd be awake at four o'clock and I'd hear those donkeys braying. But they really attack the coyotes.

MILDA: We used the Compound 1080 collars when we had coyotes so severely.

*What's that?*

MILDA: They're collars that had rubberized pouches with poison concealed in them. The collars are put around the lambs' ears and chins. The coyotes attack the throat of the animal where the pouches of poison are. The only time you use them is when you know the coyotes are attacking your herd. Mother had a target group in which she'd lost four of eight lambs. The collars seemed to stop the killing. We haven't had to put the collars back on.

LENA: We had to go to El Dorado to take a class on using the collars. It was all day long, to educate us about the coyotes. I'd lost about eighty lambs that year. We had a trapper for about nine months and he never did catch one.

[Lena calls the sheep, loudly, as ranchers do.]

There again, the Bible says, "My sheep hear my voice and they know me." And they do, they know you.

*Do you have different calls for different animals?*

Yes! For goats it's "Wootie, wootie, wootie!"

*How about sheep?*

Ewetie, ewetie, ewetie.

*And cows?*

Sook, cows. Sook, sook, sook.

158

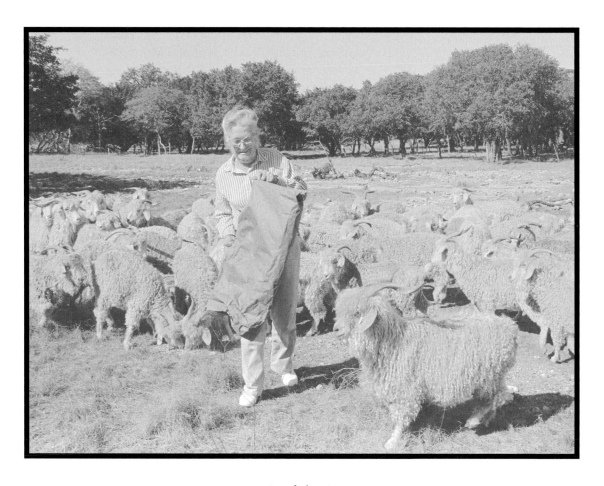

*Lena feeding Angoras*

It took me a long time to learn the way my husband did it: "Woooo-oh! Woooo-oh!"

I've quit running nannies because I lost nearly all the kids when I had coyotes. I just sold the nannies and bought muttons. You get grown ones so the coyotes don't have an easy chance to get them.

MILDA: The coyotes really attack the baby goat kids. Anyone who raises kids has a difficult time if they don't keep on top of it.

LENA: We raise muttons for the hair.

MILDA: You shear them twice a year. That's where the incentive comes in—the wool and mohair incentive.

*Does the abolishment of the incentive put a kink in your ranching?*

LENA: Well, it would have many years ago. We'd bought the Heffernan place and we used the incentive program to pay the interest. I don't know if we could have made it without the incentive. We had a drought, and for three or four years we spent everything feeding.

MILDA: It seems like the government's trying to get rid of the ranchers and farmers in more ways than one. I don't know why.

LENA: When they get hungry, they'll change their minds.

The coyotes cleaning us out made it where we just didn't raise enough wool. So the government was trying to make an incentive for people to raise sheep.

MILDA: She said we don't raise enough sheep. But some environmental groups don't want us to kill the coyotes. They want the wolves and coyotes and everything to run wild. But they're predators to us. If we are not allowed to shoot them or kill them with poison, how are we going to make it?

LENA: They're not very easy to trap, I can tell you that.

*Is the poison illegal now?*

MILDA: You have to be licensed to use it.

LENA: You can't lose eighty or one hundred lambs a year and make a go of it, out of two hundred.

They ought to serve coyote meat instead of lamb to the EPA.

MILDA: When they were trying to save the warbler and everything, Mother's solution was . . .

LENA: I told them I'd like to see some EPA men dropped in these cedar breaks and see if they could find one [a golden-cheeked warbler]. I bet they'd be so concerned about getting out of there, they wouldn't *want* to see one!

## PRICKLY PEAR

MILDA: We've got a lot of prickly pear here. Daddy had it all dug about forty years ago, but now it's all grown back.

LENA: If they leave a leaf or a root, it comes back. It doesn't take much.

MILDA: During the drought, Daddy burned the thorns off.

LENA: You burn the thorns off and the cows eat it.

## HUNTING

*Do you hunt?*

LENA: [gesturing toward Milda] She loves it. I used to, but I just dress them now.

MILDA: We make a team. I go hunt them and kill them. Then both of us can hoist the deer on to the tailgate and get it in. Then we help each other.

   We do everything from start to finish. We have a grinder and we process our own meat. The venison we debone and make steaks and sausage. We love straight venison sausage.

LENA: If you don't cook it too much, it's real good.

## FIRST HEREFORDS IN TEXAS

LENA: [pointing out one of the bulls] Isn't he a big one?

   My husband was a Kothmann. They were the first to have the Hereford cattle in Texas, over in Mason. It was a big deal. That's all we had for many years. We just started, before he passed away, to crossbreed them. We put black Angus bulls with them and now we have all kinds. They crossbred the Angus because they grew faster than the Herefords did.

161

## LIFE ON THE RANCH

*Would you trade your life on the ranch for another kind of life?*

No, I love it. Some people say, "Aren't you afraid?" And I say, "No, I'd be afraid if I was in town." Out here there's no need to be afraid. The thieves could hardly find you.

*I bet you have a gun with you, too.*

LENA: Not really. Well, I have one under the seat [in the truck]. But really, we all thought it was the safest place to be, out on the ranch. And I think it still is.

We like the quietness. There's so many people that don't like it.

You have to do what you like to do and this was one of the things my husband wanted. His father was a rancher and he just wanted to be a rancher.

I was raised on a farm. There's a lot of difference between a ranch and a farm. Very much! Because on a ranch you're making your living with stock. You have to see to it they're watered and fed. It's something alive.

When you're planting fields, it's a different thing. There, you have to see to it they're weeded and hoed and planted, all at the right time.

Really, farming and ranching don't mix that well together. Most of the ranch work comes on in March, April, May, and June. Well, you have to take care of the stock when the stock needs it and that's when the fields need planting.

Here, all we did was plant the winter crops—oats, barley, wheat—for the deer. So it wasn't really farming.

Where I was raised Papa did have stock but it was a minor thing because there wasn't much acreage. Most of the acreage was used to farm.

MILDA: You might say mother is a daughter of the soil. She's grown to love it, all her life.

*Do you prefer farming or ranching?*

I think ranching is better. There's a lot of pros and cons either way. My father was a cotton farmer; he also raised corn and hay. We didn't have a big farm—it was kind of a small place.

*Were you ever lonesome out here?*

Not really. When you're sewing for the children and waiting on them and ranching with your husband, there's really not any time to be lonesome.

162

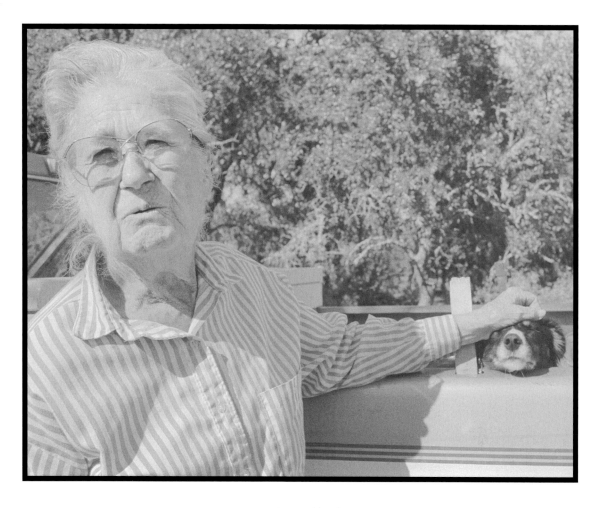

*Lena and her dog*

I did miss not going very often to things. I did in later years go to the Missionary Society, but that's about it. That is, if my husband wasn't needing me on the ranch, I went. But it's just one of those things—you just accepted it.

*Have you gotten respect from men?*

I didn't have much problem with that because I'd always ranched with my husband: I didn't *feel* inferior.

When he was here he had the responsibility of making the decisions when to sell and when to buy and when to breed and when to pasture and when to feed. When all those things came into the picture after he died, I had to make up my mind. My brother (Carl Oehler) helped me when he was alive, and then Simon [a Mexican ranch worker].

I've always had Simon. He worked for my brother-in-law for years and would help me when I really needed it. So I never really hired anyone to live on the ranch and help, because it was too expensive, and with the IRS and all we had to pay when we settled the estate . . .

I was always able to manage alone. The way it's situated, you can just drive all over the place and see about the stock. If I have any problem, I call Simon to fix it.

We have a windmill man now—we used to fix it ourselves. All those things are different. Nobody does their own windmills now.

MILDA: Mother had to do a lot of things by herself. If a fence needed repair, she learned to do it.

LENA: Yes, I learned to do a prop-up job at least.

*I bet you're strong.*

LENA: Yes, I have very strong arms.

## FUTURE OF RANCHING

*Do you think this way of life is going to be gone?*

LENA: Well, I don't know. My daughter, Joycelyn, and her husband run their ranch. She got 500 acres in the division of the estate. And Milda's learned to work with a helper. They can run the place. My son's in Pittsburgh, Pennsylvania, and he may decide when he retires to come down here.

The thing is, ranching is so much easier now than it used to be. We have a lot of what they call drugstore cowboys: they work in town but are still able to take care of their ranch over the weekend, or lease it out. When one person does something at shearing time, lambing time, when all those things come about, it's just a community affair, everybody does it. Therefore it's not anything specific that you have to learn how to do.

Except you have to know your stock and when it needs feed and when it doesn't. You can go broke pretty quick in ranching if you don't feed at the right time. One thing you have to realize is that you can't make any money off poor stock. You have to take care of it, put it in the barn and let it heal and then turn it back out. It's those kinds of things that make a difference in what you make off the ranch.

A lot of times if we had a hard year and we had to feed a lot and we had orphans to feed, sometimes those lambs and kids we saved were our only profit. If a person's not willing to go to that extra trouble, he shouldn't work with stock. You have to recognize an animal that's not doing good and take care of it.

MILDA: Daddy always said you couldn't make any money off of anything dead.

LENA: I had a ewe over yonder, she was one we fed with the orphan lambs, who was very ill and got completely better. Where I'd had her before, she had learned to eat prickly pear. I wasn't feeding her because she was with the bucks. When I discovered she was going downhill I separated her so she wouldn't have that much pear to eat, and she's as well as she can be right now. Those are the kinds of things you have to learn how to do. And over time, it becomes natural.

*Does it take a certain kind of personality to make a rancher?*

I think you have to love animals. And you have to see animals as a profit-making thing. And if you don't, why there's no way you can make it. You can't say, "Oh, that's just a sheep or that's just a cow and I don't have to worry with her today." You do—if you're going to make a living off of it.

*I think you have to be sturdy.*

Yes, you have to be able to grab a hold of things. I was threatening today to catch that stray goat and put it over the fence, but I wasn't brave enough. Ordinarily, I would have, but after my fall this summer I'm a little more cautious. I don't want to fall again.

*What happened?*

LENA: I fell at the fitness center during my weekly swim.

MILDA: She also has that old injury from when she fell off a horse. But the doctors don't want to operate because she can still use her shoulder.

*When did you fall off the horse?*

MILDA: Years ago.

LENA: Well, it's the rotary cup that's leaking and they say they'd operate if I was an athlete and a young person. But at seventy-nine, they don't think it's worthwhile.

I had a heart attack about seven years after taking over the ranch. I knew there was something wrong with me, but I went to the third doctor and he didn't find anything. He gave me some pills for my high blood pressure and the next day I had a heart attack in church.

I said, there again, it was true what God had said to me, that he would provide the help for me. There was a preacher who believed in healing, Carlos Parker, in Harper, and he prayed for me and I was raised from the dead.

I went back to the doctor and he said I had heart damage and put me to bed! I said, "After the horse was stolen they locked the barn!"

The Lord healed me. I still have an enlarged heart, but the Bible says that's good. Paul wrote to the Corinthians, "You have an enlarged heart."

The heart attack happened fifteen years ago.

I just tried to change my diet, not eat a lot of salt and soda and stuff like that. You just stay with simple foods—they're good for you. Especially root crops, always remember that. They're not so subject to spray. I eat carrots and beets and turnips. Turnips and carrots cooked together are just delicious. Cook them together and put just a little sugar in them and a little bacon grease and they're delicious!

## POSTSCRIPT

Lena died in 2000. The heart problems she spoke of when I first interviewed her persisted, and Milda gradually took over more of the ranch work. By 1999 Lena was no longer able to go out in the pickup to do ranch chores, but she wanted to know all the details when Milda got back from doing the rounds.

Milda had polio when she was younger and has some trouble getting around. She said there were times when Lena was still alive that Milda did not think she could

keep up with the ranch work. "Mother would say, 'let's pray,' and then she'd come up with a solution."

After Lena died, the ranch was divided among her four children. Lena felt that leaving it in one piece with joint ownership could cause problems, Milda said.

When I spoke with Milda in 2004, she had suffered several falls and decided she should live in town; she sold her part of the ranch and moved to Fredericksburg. Her brother sold his portion, as well. People from Houston who hope to move to the Hill Country bought Milda's section. They were running cattle and leasing to hunters, Milda said. The folks who bought the other section were ranching, as well. "Mother would be happy," Milda said.

Lena's other daughters, Joycelyn and Merle, retained their portions of the land, with Joycelyn at that time doing the ranching on both parts. They were running only cattle. The predator situation, particularly the threat from feral hogs, made raising sheep and goats too difficult.

In 2009, Milda was still living in Fredericksburg.

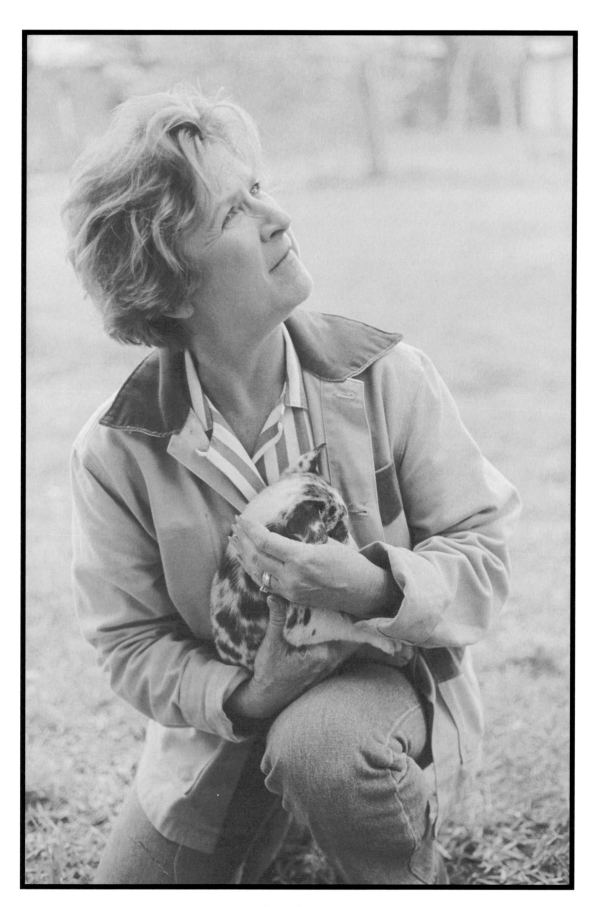

*Joan and puppy*

# Joan Wagner Bushong

## MOUNTAIN HOME, TEXAS

〜〜〜〜〜〜〜〜〜〜〜

### B. APRIL 10, 1970

## HISTORY

Perry is a fourth generation rancher. And with our grandchildren out here, we're six generations.

His great grandparents were some of the first Texas pioneers to bring Angora goats into the Texas Hill Country. They were pretty well Scotch—his grandmother was an Auld. I'm all German on both sides. My mother was a Meyer and my dad, a Wagner.

Perry always kids me and calls me his hard-working German girl. I don't watch TV. I'm not a sitter at all. I'm happiest just doing.

Last night Perry said that my friend had called and I needed to call her back. But I didn't come up from the barn until late. By the time I took my shower and cooked supper, it was 9:30.

I was born in San Angelo and raised in Eden. We moved to Kerrville when I was ten. I always loved the country.

My daddy was a Lutheran minister and we'd have a lot of people in church that had ranches. We'd go out and stay with them. I'd hunt with them. I just loved going to the country—to the ranches. I always said, "Someday I'm going to live out."

But at the time, I didn't dream that I'd marry and raise a family out here. Perry and I met in junior high. We were Tivy High School sweethearts. We used to have all our dances and parties at the Bluebonnet Hotel in downtown Kerrville. The hotel's long gone and should have been left.

When Perry and I married in '57 we were in Alpine one year and then moved out here. I've lived here all these years.

You know, when I first moved out here thirty-five years ago, our oldest daughter was a tiny baby. We didn't have hot water or a bathroom. Even at that time, I never remember being lonesome. Perry's granddad and his dad were still alive and we were cutting cedar, building roads, building fences. I can remember being on a bulldozer, pregnant with our second daughter. My mother-in-law just had a fit.

But I loved every bit of it. I can remember going when we were fence building. I'd have Laurie [her daughter] in one of those little papoose seats while I'd go with Perry to do the work.

For a number of years Perry taught school in Rocksprings. When he was gone, I had to help take care of things,
and I really enjoyed it. I have always
enjoyed being outdoors. The older I become, the more I prefer being outside
to being inside.

We used to get mail every other day—for years and years. It was a real treat to get it. But now we get it every day.

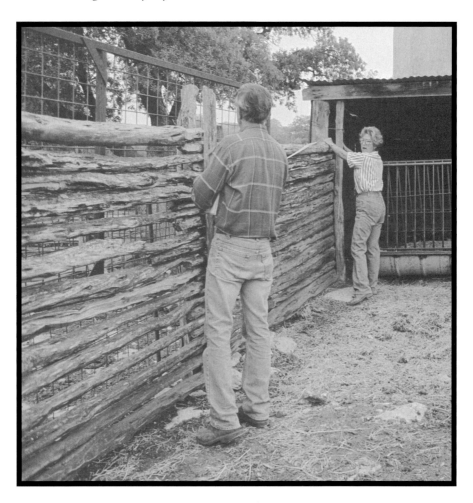

*Measuring with the fence man*

*Joan's grandson, Cole*

We had electricity, but we didn't have a telephone. The telephone now in the kitchen was our first one. We had lived here for about a year when we got it. We only had about three neighbors we could call. And I tell you what, it was fun when we could. Two longs and a short with that old crank phone. It really makes me sound ancient, but that's the way it was.

## DON'T MAKE ME GO TO TOWN

Daddy always said physical work—hard work—never hurt anybody. And it's so true. There are a lot of nights, especially during the winter when we don't have help, when we are working from daylight to dark. I drag in at night and I am so physically tired I don't know where to turn.

I think that keeps your body's metabolism going a lot better than aerobic exercises. Besides, if I went to aerobics I'd have to go to town. And I don't want to do that.

Perry says every now and then, "Well, I can hardly get her to town." I just dread the days I have to go. My life is so full. I have the livestock to tend to plus all the other things. I can stay out here three or four weeks and be happy.

But it's not that way. There's always some reason you have to go to town. We try to go in to church once in a while. Then you have to go and get your groceries. A lot of times we have to go to a vet. And there are two things a woman should always allow herself to have done: hair and nails.

We buy most of our groceries in Rocksprings and Kerrville, and some in Leakey. We love to go to Rocksprings because it's a ranching community. We buy food and do our banking up there. That's where our children went to school. But we have family in Kerrville, so we do some grocery shopping there.

*How far are you from Rocksprings?*

Thirty-five miles. We're sixty miles from Junction, Uvalde, and Kerrville. But we really go to Kerrville most. The livestock auctions we use are in Junction and Fredericksburg.

## PREDATORS

We have to keep our predators under control. That's a severe problem. We have coyotes and Russian boars. We also have feral hogs. They kill our sheep and goats. That's one reason we have donkeys.

If you put one donkey in a pasture, it becomes so lonesome for companionship it'll just adapt itself to the goats or the sheep and run right with them. The donkeys

become very protective of their flock. They really help with the coyotes. They will bite and kick like crazy.

Donkeys have become a part of our lives. Since 1985, we've had donkeys. We lost practically all of our kid crop one year to coyotes. We had marked a whole bunch of kids and the next time we rounded up there were hardly any. Perry came in one day and said, "We're going to have to do something or we'll go out of business. So I'm going to try donkeys."

He went down to Leakey and bought ten: nine older jennies and a jack. Several of those older jennies worked out, but some of them were too old and too set in their ways. So, we just kept them for a little while. We kept their babies and sold the old mama jennies off. We've got little jennies all over the ranch. We really depend on them.

We use jacks only for breeding. We don't run jacks, because they're too mean. When we're first starting to kid and have little bitty baby kids or our little bitty baby lambs, we'll take our jennies out for a while. We had one donkey that was so protective of the mama goat, we weren't sure she was letting the baby nurse.

*The expectant guard donkey*

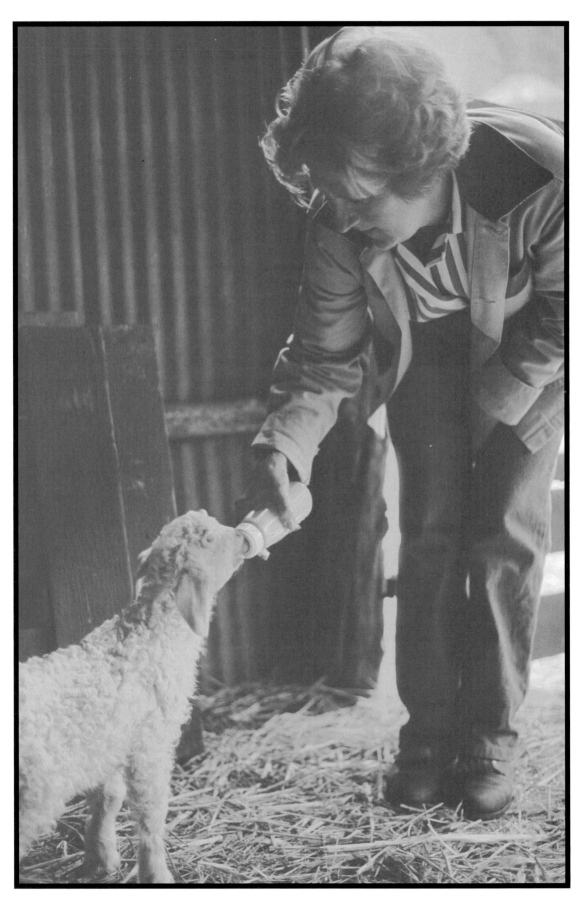

*Feeding a sancho (orphan lamb)*

Donkeys are very economical. Guard dogs are wonderful, but our country is so scattered, and it's just very expensive to buy them. Also, the feed situation is a problem, whereas the donkeys graze with the goats.

The only thing is, they don't solve the predator problem; they're just a tool.

Those Russian boars and coyotes will kill fawns, too. The Russian boars are sweeping the country. They tear your fences to pieces, especially in the draws. And when we set a snare to catch them, they'll just rip the fence up.

The boars can weigh 300 to 400 pounds. They're huge and not easy to kill. They get in this cedar and move like rats: at night and very early in the morning. When the weather is cooler they'll move until later in the morning. They are very hard to get. You can see them and then they're gone, just like rats.

We'd find a nanny goat who had a nice bag on her and she'd be all cut up on her sides, all on her belly, up on her neck and her face, and we'd wonder what in the world did it. We realized what a strong Russian boar problem we had. One of our trappers was here one day and I showed him a mutilated nanny. He said she wasn't cut up by a male, but by a female teaching her babies to kill. The male boars kill and consume the whole animal.

It's dreadful. Sometimes we've had them get well but sometimes they die. That kind of stress is unbelievable. Sometimes they won't even claim their kids after something like that.

I've had them charge me before. They'll rip you open. A couple of years ago . . . honestly, I knew that was going to be the end of me. I had my gun, but that day I only had my shotgun, I didn't have a rifle. I walked in the house after the encounter and my legs and knees were knocking against each other—that's how frightened I was. They are vicious. They have those real long tusks.

We have county trappers and that helps. Our trappers are real good but they have lots of work and they're spread few and far between ranches.

## SHEEP, GOATS, CEDAR, AND THISTLES

You can see the goats over there. They're all in the brush. This pasture has lots of shin oak in it—that's the low brush. Goats really do well on it.

Texas is the top mohair-producing state in America.

Now, it's not going to be long 'til those lambs are going to be ready to be marked. See, they're getting a little size on them. The only thing bad about marking them when they're too young is when you round them up, it sometimes separates the mamas from the babies. And then you have a real problem. So we like to get a little more size on them so that, when we round them up, the babies can follow their mamas.

*Joan Wagner Bushong*

A *sancho* is an orphan. It could be a calf, a lamb, or a goat. But they require high maintenance and it is expensive to have all of that powdered milk. So we try to have as few as we can. Sometimes we have ten or twelve, and that's just too many.

We sell our lambs for meat. So we castrate the little males. We cut their tails off because they would get too dirty. Then we mark their ears for identification, like you brand your cows in case they get into another pasture. Those ewes have been tagged [partially sheared]. If we hadn't tagged them, they'd have a lot of hair around their bag. A lot of times, when lambs or kids are first born, they'll nurse on that mohair or wool without realizing they're not getting milk. So we shear our goats and tag our sheep.

A cedar tree here and there or even in a yard, if it's trimmed up nice, is not bad. But when you have cedar after cedar, first of all you can't see to round up your stock. Second, you have no grass. Cedar and mesquite are known for sapping up the water and taking the moisture away from the grass. Cedar has to be removed. It just doesn't serve any purpose. As far as protection for deer, they have plenty of other protection; and clearing the cedar gives the deer more to eat.

The thistles are getting really bad. We're going to have to spray up here soon. A day like today is not a good day, though. You don't want to go to the expense and the time to spray and then have them get rained on.

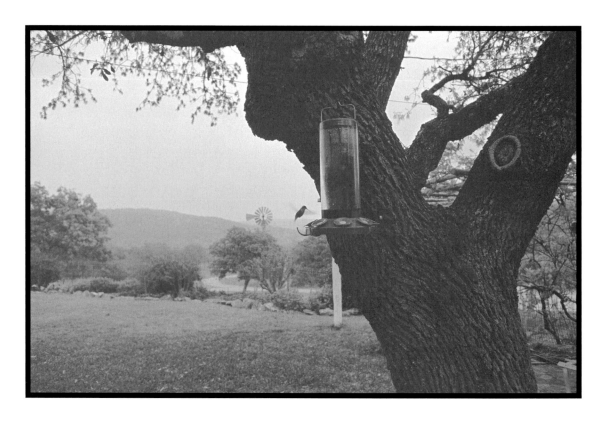

*Joan's old oak*

## THE LAND AND WATER

This pasture has a long draw that follows its whole length. The draw goes clear to the outside fence. We get severe winds in this pasture and it takes a lot of our trees. Our elms are in this pasture. Isn't that a beautiful one? They're the first to leaf out in the spring and the first to turn gold in the fall. I killed my first deer out of that tree. That was in '58.

That tree was just taken up by the roots during a high wind. This dry creek bed goes all the way through the pasture. The wind and water rip through here like crazy.

*So the water sometimes flows here?*

Does it ever! It can be wicked. We have those two draws and we can't get out when we get a great big rain. If there's an emergency, you can't go anywhere until the water goes down. Through the years many, many people in the Hill Country have made mistakes by going into high water. It's extremely dangerous.

When you have these big rains, they wash away your roads. Then you've got to go in and bulldoze so you can get through.

My mother-in-law tells me you cannot imagine what it was like before Highway 41 came through. They just had dirt roads. That's when they had such problems. If they were going from Rocksprings up to Leakey and a big rain came up, they would have to stay with the neighbors.

See that fence that's rickety? That's a water gap. And boy, do they go! And they've got to be repaired. We always repair our outside fences first, and then the inside fences.

Last year, during our grandchildren's spring break, we all went on a long ride. We were coming up along here with all the horses. We had just had a big rain, and there was water all along here. And I said, "Children, I tell you, Oma and Papa need rain so bad so many times, it's not very often that you're going to see all that beautiful water." And you know, those children know how important rain is because they've grown up that way.

This spring is what the ranch is named after: Cedar Springs. Perry's grandfather named it. It never stops. And this little waterfall—isn't it pretty?

This is really a special place. The Indians came here. It's beautiful and I love it. It's so peaceful. Isn't nature unbelievable? Just look at all those trees. The white settlers camped here too, because of the water.

An old man in town tells a story about robbers that came here in the old days and buried their gold at Cedar Springs. He tells Perry that it's true, that it's not just a legend.

## THE IMPORTANCE OF FAMILY

We're really privileged to be able to have our daughter and our grandchildren out here. It is very rare, because so many times the children want to leave the ranches. It just so happens that our girls both love the ranch.

We just hope that in the future we can hold on to all the land that we own and lease so that we can all continue to live out here.

We're glad that the grandchildren like it, too. Because during real busy times of the year when we don't have any hired help we all depend on one another. That's just all the help we have.

[Cole, Jane's son, has been riding around with us, and I ask him what he wants to be when he grows up.]

COLE: I know what I want to be for Halloween: Batman!

## THE FUTURE OF THE RANCH

We feel so strongly about protecting our landowner's rights. In order for us all to live and make a living out here, we have to maintain our private property rights. And we all know what we're faced with—holding on to the land our forefathers worked so hard for us to have and wanted their great-grandchildren's grandchildren to have.

Ranchers are the original environmentalists. We conserve our land and resources through wise management. Who but the landowner himself wants to love and protect and care for the land? I would die on this place protecting our land. It means that much. I just think about what Perry's forefathers did so that we could live here. If it weren't for them, we wouldn't be here. That is a real sentimental issue for me.

The thing that people don't stop and think about—agriculture is the foundation of this country. I mean, think what agriculture does and has done all these years for our land and for our people. We have to have it to keep our country going, to keep our people fed. We must have agriculture.

This is our life and our livelihood. It's a wonderful life, but it's not an easy life. It's hard work and it's just a constant battle with government regulations and animal rightists. We must hold on to the land we love so much.

I love these low areas where the elm trees are. I also like the area by the windmill and topping that hill before you come into the house. That's a real special spot because that's where I've spent so much of my lifetime. That was where we raised our kids. And I love the barn and pen area because I've spent so many hours there. I say to the grandchildren, "Y'all want to go to the barn?"

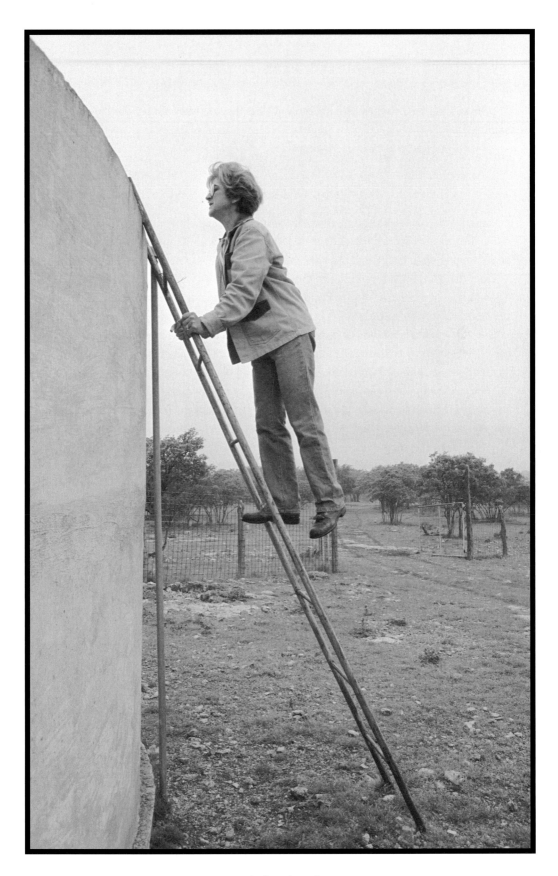

*Checking the tank*

"Oh, yes, yes, yes," they say. No matter how little they are, they always want to go to the barn.

What better thing can you teach them?

## POSTSCRIPT

In January 1995, Joan was thrown off her horse along a rocky bluff. She had been out riding the ranch with the horse and her dog. All her family went looking for her and finally found her. "It just wasn't my time," she said.

Later that year, on May 7, the worst tornado in the history of Real County hit the headquarters of the ranch. "The tornado hit at dark," Joan said. She was in the house and heard the terrible noise.

The twister destroyed thousands of trees, killed animals, and flattened the big hay barn. The winds moved the hired hands' mobile home ten feet, and blew the hired hands about one hundred yards. "By the grace of God, they were fine," Joan said.

"The erosion on the mountains was devastating," she remembers. "The trees looked like you'd sanded them. All that was left were the trunks." Trees were piled four feet high around the house, and Joan could get out through only one door.

*Joan and the Longhorn*

Two days later, she had surgery for cancer.

For days, friends and neighbors helped clean up the ranch. "You don't ever forget that," Joan said.

In the end, Joan's home had suffered only broken windows and roof damage. "It could have been so much worse," she said.

Joan gave credit to her parents for their moral character and integrity, and said she never could have made it through such a difficult time without the strength they handed down to her.

By 2004 the grass was growing again on the hills. "Our land has healed because we've had sufficient rain," Joan said.

At that time, Joan was not doing as much hands-on ranch work as when I first interviewed her. She had stopped raising Angora goats and sheep, in part because of the problem with feral hogs and coyotes, she said. She was instead raising Brangus cattle and leasing to hunters.

Joan had become increasingly involved in political activism, mainly promoting private property rights. She was the legislative chairman for both the Hill Country Cattle Women and the Texas Sheep and Goat Raisers Association Auxiliary. She advocated "conserving land and natural resources through private ownership of land."

"It's a big job," she said.

Joan's daughter, Jane, and her two children, were living on the ranch and Jane was training horses. Her other daughter, Laurie, lived in Boerne and had two children. "She loves ranching," Joan said.

Joan said she felt "very confident" that her children and grandchildren would continue the ranching operation. "That's why I work so hard to take care of the land and protect private property rights," she said.

When I talked to Joan again in late 2009, she had suffered another tragedy—her daughter Laurie had died the year before from lymphoma.

Joan was still living on the ranch and fighting for private property rights.

# RANCH
# TERMINOLOGY

## CATTLE

*Breeds*

ANGUS: black, polled (hornless) cattle that originated in Scotland, introduced into the United States in 1873

BRAHMAN: commonly pronounced *brimmer* in the South, humped cattle that originated in India and thrive in hot climates, introduced into the United States in 1849

BRAFORD: mixed Brahman and Hereford

BRANGUS: mixed Brahman and Angus

CHAROLAIS: white cattle, originated in France

DURHAM: also known as Shorthorn, originated in England

HEREFORD: red cattle with white face and markings, originated in England, introduced into the United States in 1817

LIMOUSIN: golden-red cattle native to France

LONGHORN: cattle thought of as "native" to Texas, descended from cattle brought here by the Spaniards and characterized by their small, thin build as well as their long horns

*Terminology*

BULL: adult male

COW: adult female

HEIFER: female that has not calved, or given birth

STEER: castrated male

## GOATS

*Breeds*

ANGORA: long-haired white goats raised primarily for their silky mohair, although low mohair prices have increasingly forced ranchers to sell the animals for meat

SPANISH: multi-colored goats raised for meat

BOER: exotic goat raised for meat that gained popularity in the Hill Country during the past decade

186

*Terminology*

BILLY: adult male

NANNY: adult female

KID: baby

MUTTON: goat raised for meat

## SHEEP

EWE: adult female

RAM: adult male

LAMB: baby

## DONKEYS

JENNY: adult female

JACK: adult male

## MISCELLANEOUS TERMS

CAPE: four-inch strip of mohair left along a goat's backbone during early shearing to give the animal protection against cold rain or hail

CHIP: dried cow manure, frequently used in the past for fuel in places where firewood was scarce

CUBES: hard, cylindrical protein pellets used as feed for livestock

CUT: as in "cut the calves," to separate by herding, either on foot or horseback

DRAW: a long, narrow, natural ditch where water flows after a rainfall

DRENCH: to administer an oral dose of wormer to an animal

DRILL IN: to plant seeds in a field using a tractor

EARMARK: pattern of notches cut in a cow's ears for identification, like a brand

MARK: to castrate lambs or kids

MOHAIR: silky hair from Angora goats

PEAR: fruit of the prickly pear cactus. Many ranchers, during dry weather, "burn pear" (singe the thorns off the pear with fire) so cattle can easily eat it.

PUSH CEDAR: to bulldoze ground in order to kill cedar trees

SANCHO: an orphaned animal

SECTION: 640 adjoining acres

TAG: to shave the wool from around a ewe's teats so her lamb will have an easier time nursing

TRAP: small pasture

WATER GAP: the gap between the fence and the ground where a fence crosses a draw, through which water and debris flow during heavy rains. Ranchers put some type of

screen across the gap to prevent livestock from escaping, but since the rushing water often tears the screens off, the water gaps must be checked and often repaired after heavy rains.

WINDMILLS: In the past, windmills were used to pump water from wells underneath them into holding tanks, where gravity provided the force needed to channel the water into troughs or irrigation lines. Now, ranchers more often use electric pumps, and the windmills visible throughout the Hill Country frequently are not in use.